EVA

men's adventure
supermodel

A PICTORIAL AUTOBIOGRAPHY OF EVA LYND

EDITED BY ROBERT DEIS & WYATT DOYLE

MensPulpMags.com

new texture

For
WARREN MUNSON,
who has provided me with a
safe haven for over 40 years.

A New Texture book

Copyright © 2019 Subtropic Productions LLC

All Rights Reserved.

With gratitude to Rich Oberg, and thanks to William Rossi, TJ Duke, Jeff Keane, Scott Shaw, Jimmy Angelina, and Albert Genna

Designed by Wyatt Doyle

The archival materials reproduced herein are included by arrangement with The Robert Deis Archive and the author's personal collection, except where noted.

Cover painting by Norm Eastman, courtesy The Rich Oberg Collection
Back cover photo by Norm Eastman

 @NewTexture @ThisIsNewTexture NewTexture.com

MensAdventureLibrary.com MensPulpMags.com

Booksellers: *Eva: Men's Adventure Supermodel* and other New Texture books are available through Ingram Book Co.

ISBN 978-1-943444-39-7

First New Texture deluxe hardcover edition: 2 September 2019

Also available as an abridged softcover

Printed in the United States of America

10 9 8 7 6 5 4 3 2 1

Photo by PHILIP E. PEGLER

In the years between 1956 and 1970, pin-up photos and magazine illustrations Eva Lynd modeled for were seen by millions of American men. Millions also saw her on television—on early variety shows taped in New York City, in action and drama programs filmed in Hollywood, and as the seductive siren featured one of the most famous TV commercials ever broadcast: the Brylcreem "Girl in the Tube" ad.

Eva continues to act occasionally in TV shows, movies, and plays. She has also done various TV commercials, including several featuring her and her husband of 41 years, Warren Munson.

But Eva remains best known for the classic glamour girl photographs and men's adventure magazine (MAM) illustrations she once modeled for. Indeed, in recent years she has gained new fans thanks to a growing number of internet posts that feature her in those photos and illustrations. Some of them are posts I did on my blog at MensPulpMags.com. And Eva was one of the people who noticed those initial posts.

In 2013, Eva sent me an email to let me know

she enjoyed them, and was alive and well and living in L.A. That sparked an ongoing correspondence that bloomed into a friendship. I discovered that, in addition to being a legendary beauty—one of only a few who modeled for both pin-up photos and artwork featured in the MAMs I collect—Eva is extremely bright, warm, and witty.

It wasn't long before we asked Eva if she'd let us publish a book about her, and she graciously agreed. She shared her personal archive of photos, artwork, and news clippings, and spent hours sharing stories from her life and career.

Another member of our creative "E-Team" is art collector Rich Oberg. Rich owns scores of original paintings by Al Rossi and Norm Eastman (the two artists who Eva modeled for most frequently), and was able to help identify artwork Eva modeled for.

It has been a great honor and great fun to get to know Eva and work with her to create this book. I hope and expect it will generate more new Eva Lynd fans. She is truly one of a kind.

—Robert Deis

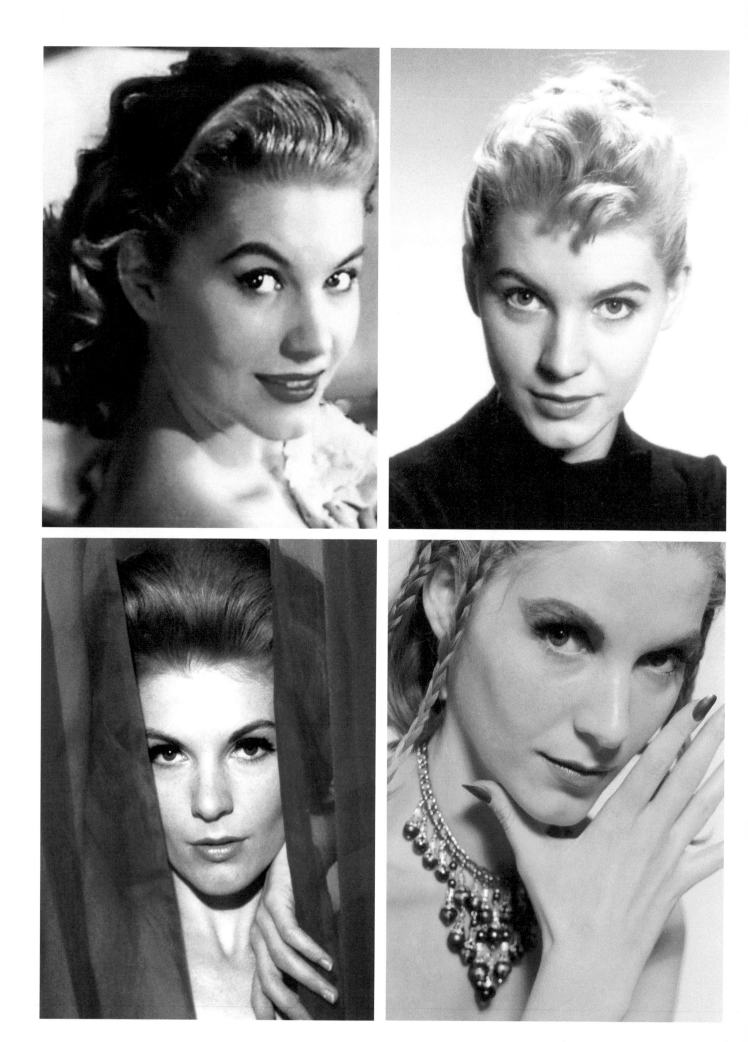

faces of EVA

ON SEPTEMBER 2nd, 1937, I was born Eva Inga Margareta von Fielitz to Countess and Count Asti von Fielitz, in the city of Göteborg, county of Örgryte, Sweden.

My mother was born in Sweden. My father was born in Oslo, Norway. My father's family came to Norway from Riga, Latvia shortly before he was born, and both of his parents died in their early 40s. Though he had a brother who was five years older, he was basically an orphan. He was taken in by a trio of old Swedish ladies who raised him until he could manage his own life.

The royal title is from my father's side. *Von* is spelled with a small *v*, and anyone who has it in their name is royalty. From what I understand, his family did have a castle in Latvia at one point; it seems they had to flee the country for some reason and we never went there. I am not totally aware of all the facts, because my parents were divorced when I was eight years old.

My mother was a professional singer. She sang with Herbert von Karajan when she was young; he was very famous, even then. She sang on the radio and sang in various groups in Sweden. So she traveled here and there, and she left me with my grandmother a lot. My maternal grandparents had a big house outside of Göteborg, in a small town called Mölnlycke.

Those are my best memories, growing up there. In Sweden, we lived near the woods, which were partially owned by my grandfather. I spent a lot of time in those woods, playing and climbing trees. It was a joy to find special trees with branches made

for climbing up near the top.

My cousin Kjell (pronounced *shell*), who is a couple of years younger than I, also lived on the property, and we were more like sister and brother. He's still in Sweden. I talk to him on the phone every other month. We share an enormous amount of memories, and we remind each other of things that happened when we were growing up.

Our grandmother would say to us quite often, *"Don't forget to be grateful!"* That turned out to

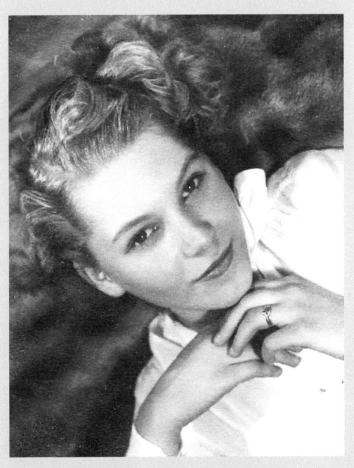

1950: Eva Inga Margareta von Fielitz, age 12.
Photo by TRUDE FLEISCHMANN

Photos by (clockwise from top left) PETER BASCH, LESTER KRAUSS, DON BECK, unknown

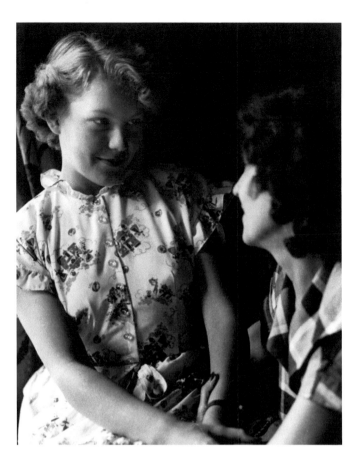

Eva and her mother, 1950.
Photo by TRUDE FLEISCHMANN

I arrived in New York City June 8th, 1950, at the age of 12. Coming from a small town in Sweden, the first thing I noticed was all the yellow taxicabs. An enormous amount of taxicabs! I couldn't believe that. And the other thing, of course, were all the tall buildings. It was just absolutely amazing to come from a tiny sort of farm town to something like that. It's difficult to even imagine.

I came all by myself. They put me on a plane, and I flew over and landed. I had to change planes in Norway, and I just followed everybody else. It's just amazing to me now that I actually managed it. I went to live on a farm in the summer and learned English, because nobody there spoke Swedish. By the time I started school in the fall, I could speak pretty well.

This is when the famed photographer Trude Fleischman took the first set of photos of me and my mother; she took another set of us in 1956 when I came back to NYC after graduating from high school. I don't precisely remember what she told me, but I remember that she directed me in what she wanted me to do, where to look, and what to think when I was looking directly into camera. At that time, I had no aspirations as a model, but since that was my first professional modeling experience, I think it helped me later on.

Between 1950 and 1955, I went to 7 different schools, including a year in the High School of Music & Art in NYC, where I had to audition to get into the art program. I was about 14 at the time, and that Christmas, while crossing the street, I was hit by a city bus and ended up with a concussion and a broken collar bone. I was in the hospital for six weeks with a sandbag on my

be very good advice, because throughout my life, no matter what was happening, there was always something to be grateful for.

My mother always wanted to go to America, and she did so in 1948, and lived in NYC with her half-sister for a while. But it didn't work out very well. She was too old at the time, I think; she was in her 40s then. I stayed with my grandparents until she sent for me in 1950.

PROGRAM NOTES

One of the youngest Misses with the theater this year is Miss Eva von Fielitz of Ashtabula, New York, and Sweden. Eva was one of the earliest to arrive at the theater when it opened and has been one of the hardest working and happiest members of the company. She is the one who has painted the interesting signs advertising our coming attractions. She has built and painted scenery, she has carried props, sewed costumes and pressed them. The lovely blond apprentice is always smiling no matter how heavy the load she carries in the work of the theater. But she has also been seen on stage. She was Miss Johnson in "Harvey", and Therese in "Our Hearts Were Young and Gay" and this week she plays the part of Mrs. Bagatelle.

* * * * * * *

shoulder. That accident is why you can see a bit of a bulge on the left clavicle in some of my photos.

During my last two years in high school, we lived in Ohio. I graduated from Harbor High School in Ashtabula Harbor in 1955. I was in my high school's plays, and was voted Best Thespian.

In 1954, I was accepted into Rabbit Run Theatre as an apprentice for the summer. I was in heaven. At the time it was exactly what I wanted to do, and I loved learning everything from the ground up. The man in charge of sets and lighting was Leo B. Meyer, who became famous in NYC for his sets for Broadway shows and operas. He took me under his wing, and I loved working for him. He was an extremely patient and giving person, but he was only there for the first season. I kept in touch with him throughout my life, and we'd meet now and then. I will always remember him as the person who was instrumental in teaching me about the theatre, and making me love it.

Charles Grodin was there also in 1954, and all the girls loved him and thought he was the cutest thing ever! Later in life, after he became famous, he wrote about Rabbit Run Theatre and his experience there…and not very kindly.

And then we moved back to New York.

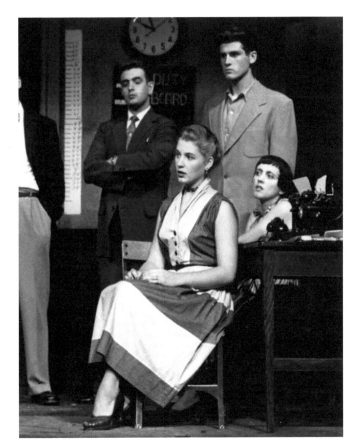

Eva with Charles Grodin in the Rabbit Run Theatre production of *Detective Story*, 1954.

Eva at Schrafft's, 1955.

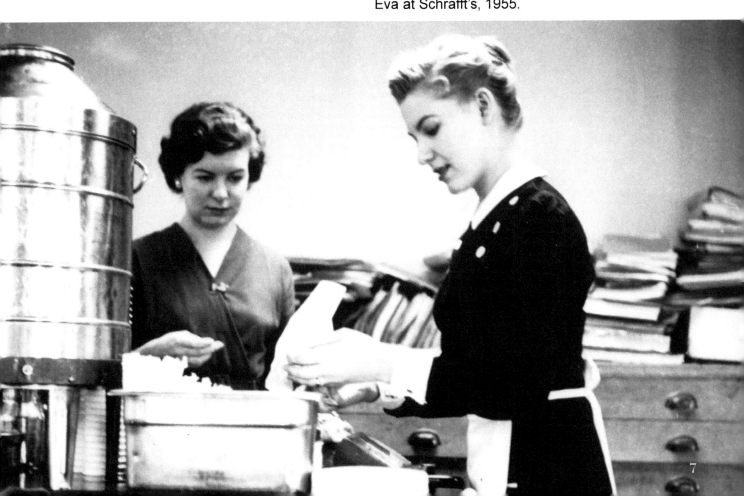

7

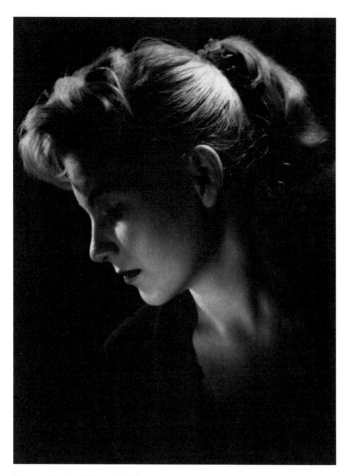

New York City, 1956. *Photo by* TRUDE FLEISCHMANN

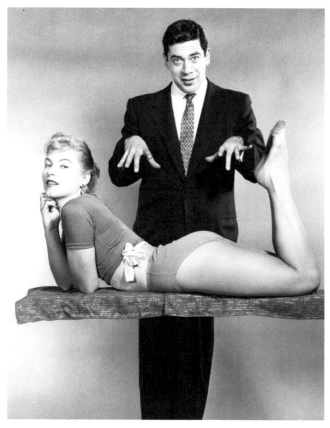

An unidentified magician levitates Eva in a publicity photo for the *Festival of Magic* TV special hosted by Ernie Kovacs, 1957.

I graduated High School at 17 in 1955, and came back to New York City. This is when I entered my first beauty contest—and won.

It was determined that the name *Eva von Fielitz* was too complicated, and probably sounded more German than Swedish—which, in the postwar years, was not a good idea. Long or unusual names were not in vogue; a lot of actors' names were changed to those considered easier to remember. So I picked *Eva Lynd*, since that sounded more Swedish—which course, I am.

I did some modeling and I worked at Schrafft's as a waitress. Don Bullock, who'd been in summer stock with me the previous year, got into television production, and he started using me for various shows: *The Steve Allen Show, The Garry Moore Show, Perry Como...* I did several appearances on those, doing various small roles at first, and eventually appearing many times on live TV.

In my first appearance on *Garry Moore*, I was in a comedy sketch with Carol Burnett; it was one of her first appearances, too. We pass each other on the street, see we're wearing the same dress, then give each other *that* look. In another one, I played Miss Sweden. I was sitting there all bundled up in a chair, and somebody comes by and I slowly take off my glasses, then my clothes, until I finally end up in a bathing suit. *The Perry Como Show* had a segment called "We Get Letters," and I was the letter girl. Between 1955 and 1958, I made similar appearances on *The Ernie Kovacs Show* and *The Jonathan Winters Show*. I was also on *Secret Storm* and Ernie Kovacs' *Festival of Magic* special.

I worked in a lot of industrial shows and did various commercials, both live and on film. (Believe it or not, they actually had some live commercials at that time.)

Starting in 1956, I also became a photo model. I worked for a multitude of photographers, including Peter Basch, Charles Kell, Earl Leaf, Wil Blanche, Barry Blum, Leo Fuchs, Herb Flatow, Curt Gunther, Emil Herman, Phil Jacobson, Morris Kaplan, Lester Krauss, Ed Lettau, Gary Wagner, Jerry Yulsman, and many more. I ended up on the covers of, and in, a lot of men's magazines until about 1958. It was a very good thing for me.

Opposite, l to r: Portrait by Morris Kaplan; photographer unconfirmed; Eva with magician Milbourne Christopher, from *Festival of Magic*.

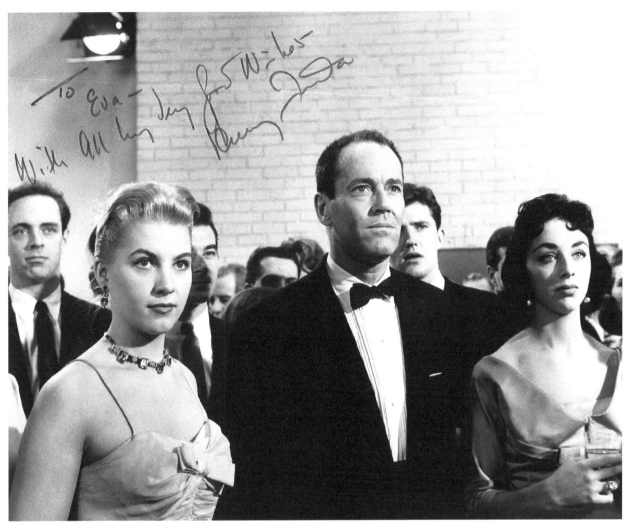

I ended up standing next to Henry Fonda when I appeared in the party scene in the 1956 film *Stage Struck*. We were all watching Susan Strasberg performing Shakespeare from a staircase. Henry was very gracious, and every time the makeup person came to powder him, he would nod to me and say, "Do her, too." It made me feel very special. He signed this photo for me when my husband Warren Munson worked with him on an informercial—thirty years later.

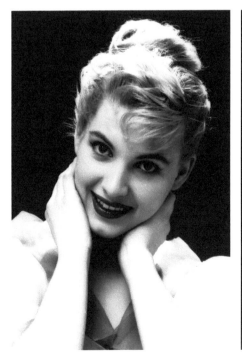

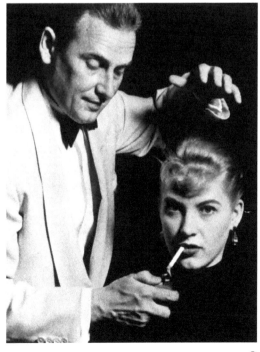

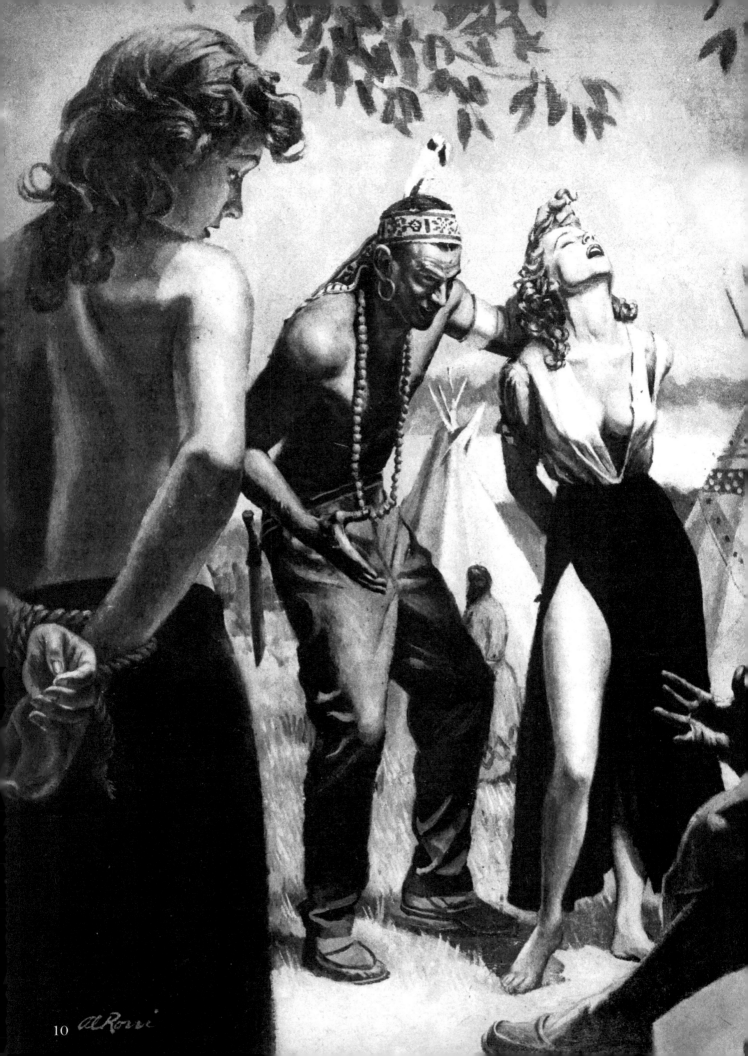

My modeling for artists just sort of came about. Somebody said I should do it, and people started calling me. I had several agents who sent me out to things. At the time, you could have several agents. Whoever sent you out and got you the job, that's the one you paid commission to. But when it came to the artists, I think they just talked to each other and said, *"I've used her, and she's good."* It was word of mouth from one artist to another, I guess. They liked me and they used me for various things, and told other people about me.

In glamour photography, you are yourself, and mostly you are asked to make love to the camera.

Working with illustrators, you are playing the part of the person to be depicted on the cover or in the story, hence more acting is needed—as in, looking scared or horrified (without screwing up the way your face looks, of course).

Whether working with photographers or illustrators, if I had what the session needed, I would bring my own things to wear. If a costume was important to the image, they would supply it. Illustrators could change or enhance whatever was worn, so it wasn't all that important to wear exactly what they had in mind, as long as it showed enough of the body to make a good reference.

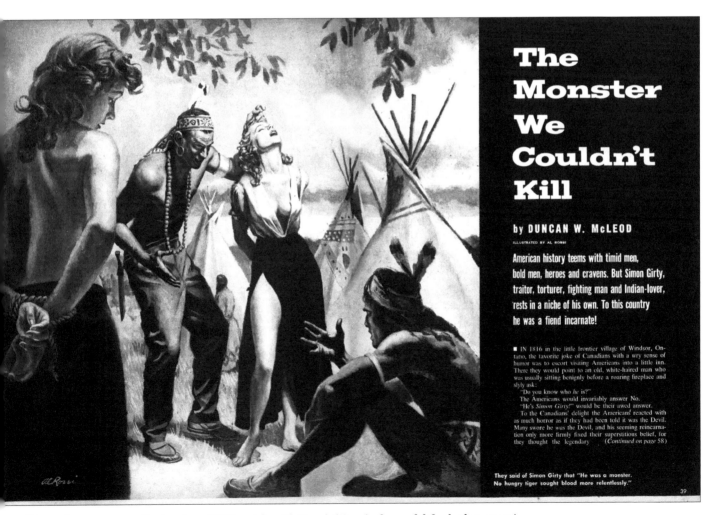

The Monster We Couldn't Kill

by DUNCAN W. McLEOD

ILLUSTRATED BY AL ROSSI

American history teems with timid men, bold men, heroes and cravens. But Simon Girty, traitor, torturer, fighting man and Indian-lover, rests in a niche of his own. To this country he was a fiend incarnate!

■ IN 1816 in the little frontier village of Windsor, Ontario, the favorite joke of Canadians with a wry sense of humor was to escort visiting Americans into a little inn. There they would point to an old, white-haired man who was usually sitting benignly before a roaring fireplace and slyly ask:

"Do you know who *he* is?"

The Americans would invariably answer No.

"He's *Simon Girty!*" would be their awed answer.

To the Canadians' delight the Americans reacted with as much horror as if they had been told it was the Devil. Many swore he *was* the Devil, and his seeming reincarnation only more firmly fixed their superstitious belief, for they thought the legendary (Continued on page 58)

They said of Simon Girty that "He was a monster. No hungry tiger sought blood more relentlessly."

39

TRUE ADVENTURES, September 1956; art by Al Rossi *(Eva is the model for both women.)*

11

High fashion photography—as in *Vogue*—I know nothing about. Those models so often look as if they hate what they are doing and can't wait for it to be over. It seems that a bored look is what the photographers have asked for in most instances. Also, it seems that they must be very, very thin—which I have never been. In fact, I have struggled with weight all my life. I have been on every diet there is, which is not fair for someone who loves food.

I took dancing lessons several times a week and walked everywhere, which kept my body in shape. I am a fairly disciplined person when it comes to most things; I quit smoking instantly when I was told I would lose my teeth if I didn't. I have been a vegetarian from birth, and even now I have a good food regimen. I don't eat junk food or drink sodas, but my downfall is bread—or anything baked, for that matter! So I have always had to fight to keep my weight steady. It hasn't been easy.

Photo by DIAZ

12

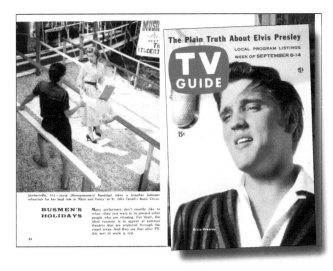

A September 1956 *TV Guide* feature on TV personalities' off-season theatre work references a Sea Cliff, NY production of *The Seven Year Itch*, starring Gene Rayburn and Eva...but Eva says there was no show: "Gene Rayburn was the announcer for *The Tonight Show*, and I remember doing this publicity shot. However, neither of us was doing *The Seven Year Itch* in summer stock, so..? As you can see on many of the other captions, magazines printed whatever they felt like." Not even Eva's name was safe, as evidenced on one of her earliest pin-ups *(below)*.

Sea Cliff, N.Y.—Gene (Tonight) Rayburn, Eva Lynd in 'Seven Year Itch.'

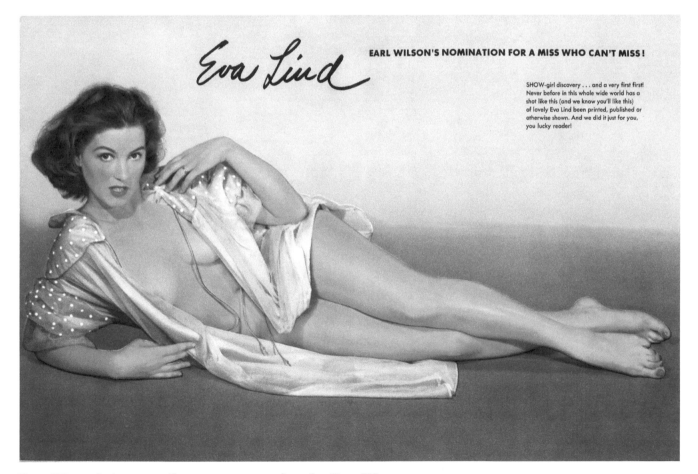

Eva Lind

EARL WILSON'S NOMINATION FOR A MISS WHO CAN'T MISS!

SHOW-girl discovery . . . and a very first first! Never before in this whole wide world has a shot like this (and we know you'll like this) of lovely Eva Lind been printed, published or otherwise shown. And we did it just for you, you lucky reader!

EARL WILSON'S ALBUM OF SHOWGIRLS, 1956; photo by Gary Wagner

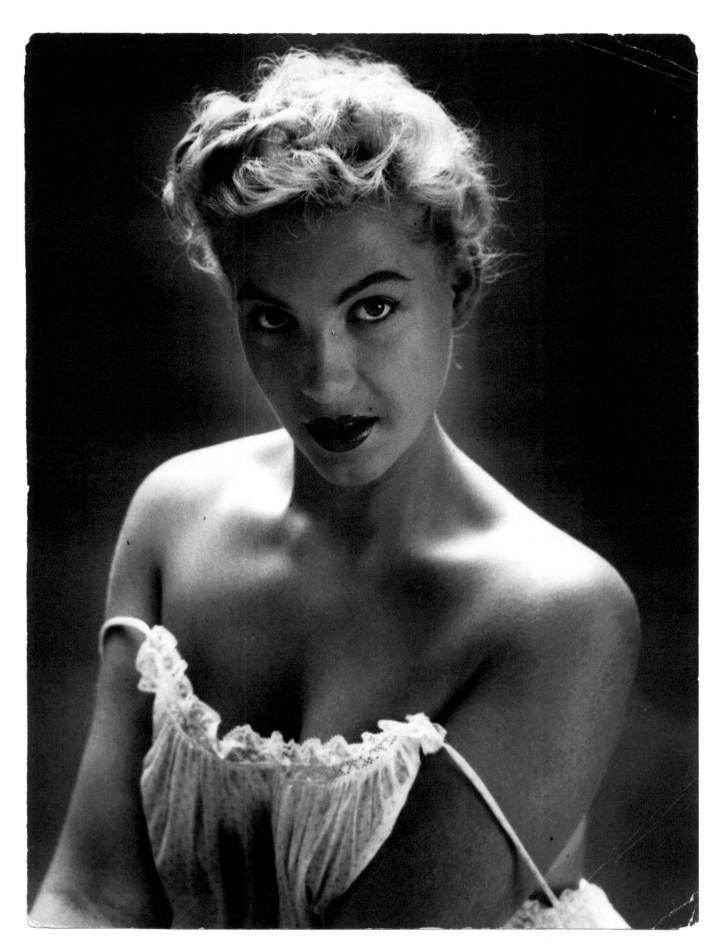

Photos by LESTER KRAUSS

14

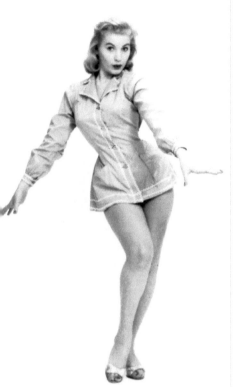
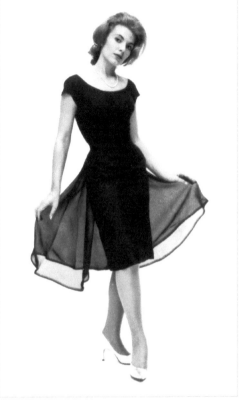
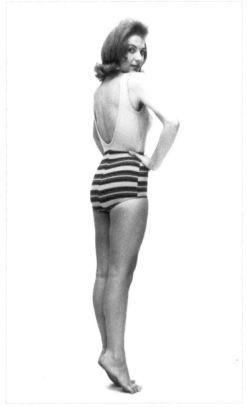

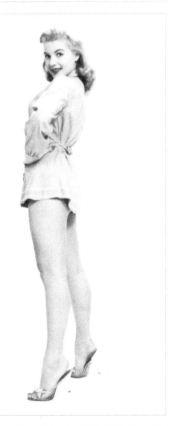
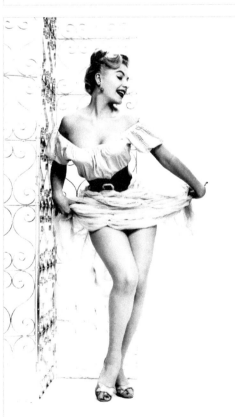

Lester Krauss was possibly the first photographer I worked for, and my relationship with him went on for years. He would suggest various poses and outfits… I wish I knew what of the many, *many* shots he took of me ended up published somewhere!

He was a remarkably interesting person to work with, and I learned a lot about photography—even how to develop photos in the darkroom.

I don't remember what he looked like, which makes me sad. I just remember him as a kind person who helped me along the way.

15

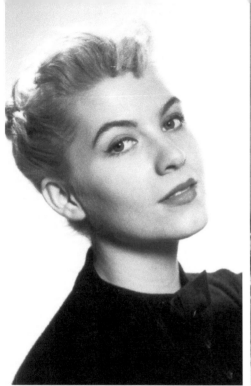 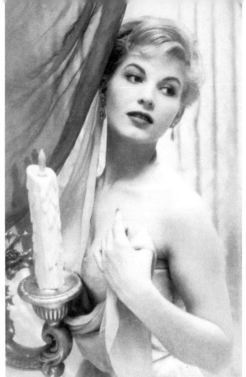 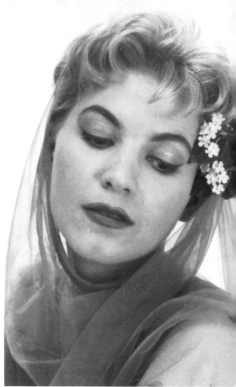

Photos by LESTER KRAUSS

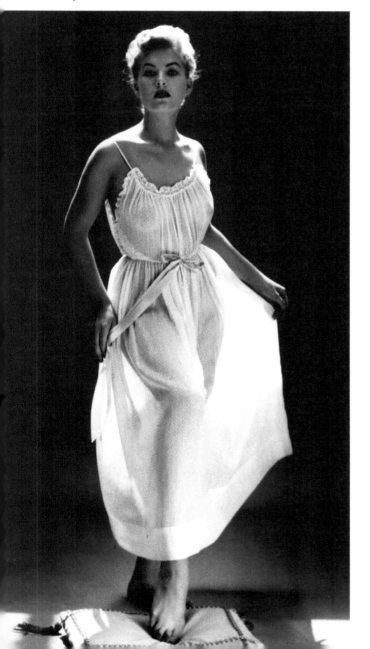

EMOTIONS
Featuring Richard Shores and His Orchestra
Photography by Lester Krauss
Mercury, 1956

Around 1956, I did some nude modeling for Lester Krauss, with the proviso that I would not be recognizable. So he had me in shadows, and obscured my identity. On the cover of *Emotions*, the LP by Richard Shores, there is a double image of me in the nude, which you wouldn't recognize as me unless you knew it was me. The other nude images were for possible use as record covers, but I haven't seen them on anything.

SCHEHERAZADE
Vienna State Opera Orchestra
Conducted by Argeo Quadri
Photographer unknown
Westminster Hi-Fi, 1956 *(reissued 1959)*

CUSTOM
HIGH
FIDELITY

Mercury
MG 20130

Emotions

FEATURING
Richard Shores
AND HIS ORCHESTRA

LOVE
HATE
SORROW
GAY
BLUES
SURPRISE
FRUSTRATION
NOSTALGIA
FEAR
HYSTERIA

XWN 18278

Rimsky-Korsakoff
Scheherazade

Vienna State Opera Orchestra Conducted by Argeo Quadri

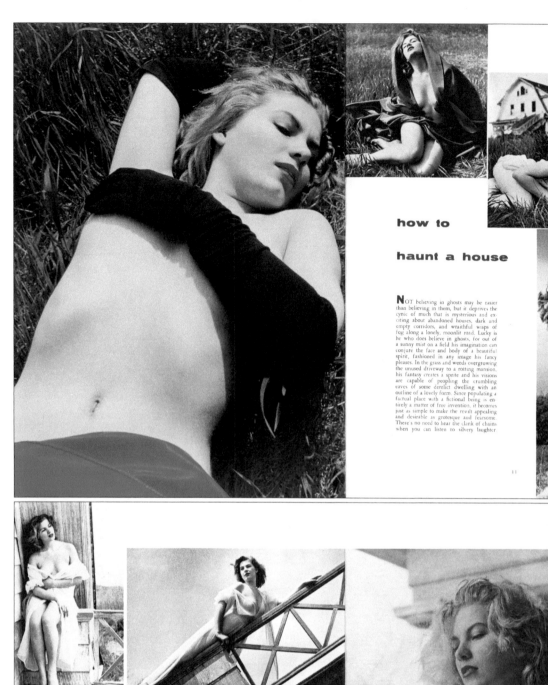

how to

haunt a house

NOT believing in ghosts may be easier than believing in them, but it deprives the cynic of much that is mysterious and exciting about abandoned houses, dark and empty corridors, and wraithful wisps of fog along a lonely, moonlit road. Lucky is he who does believe in ghosts, for out of a sunny mist on a field his imagination can conjure the face and body of a beautiful spirit, fashioned in any image his fancy pleases. In the grass and weeds overgrowing the unused driveway to a rotting mansion, his fantasy creates a sprite and his visions are capable of peopling the crumbling eaves of some derelict dwelling with an outline of a lovely form. Since populating a factual place with a fictional being is entirely a matter of free invention, it becomes just as simple to make the result appealing and desirable as grotesque and fearsome. There's no need to hear the clank of chains when you can listen to silvery laughter.

11

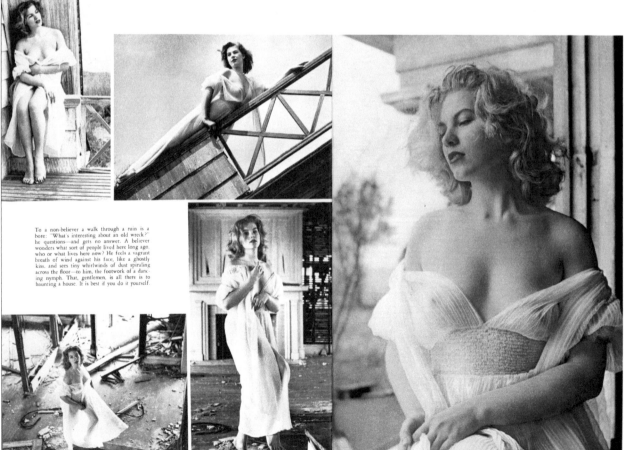

To a non-believer a walk through a ruin is a bore: "What's interesting about an old wreck?" he questions—and gets no answer. A believer wonders what sort of people lived here long ago, who or what lives here now? He feels a vagrant breath of wind against his face, like a ghostly kiss, and sees tiny whirlwinds of dust spiraling across the floor—to him, the footwork of a dancing nymph. That, gentlemen, is all there is to haunting a house. It is best if you do it yourself.

NUGGET, December 1956; photos by Wil Blanche

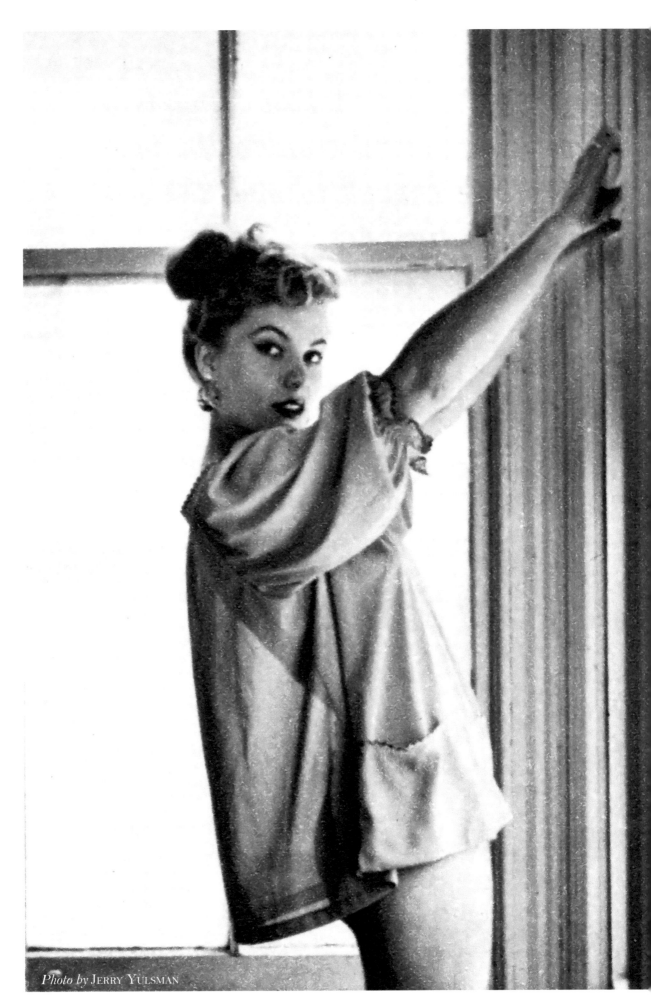

Two Queens—Eva Lynd of New York and Elizabeth of England top the news items this month. Eva is queen of cameras while Elizabeth is "queen with camera." Eva, seen in the photo by Morris Kaplan, below, is a most curvacious model who hails

Beauty pageants were usually in a bathing suit, competing with other models on a runway. I did a lot of those, and won a lot of them. I have photos of me as Miss this or that. Miss Steel Pier… Miss Merkel Meats (which always amused me, since I am a vegetarian since birth)… Miss Title Fight… Miss White Russia… Miss Kenseal of 1957 for a Kentucky Club ad in *Playboy*….

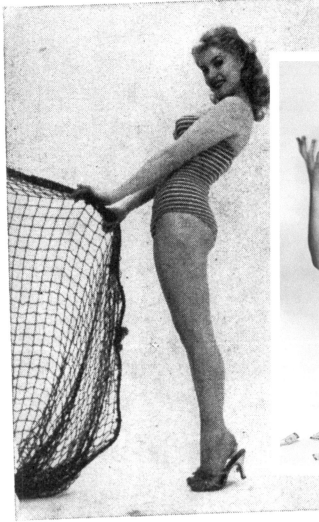

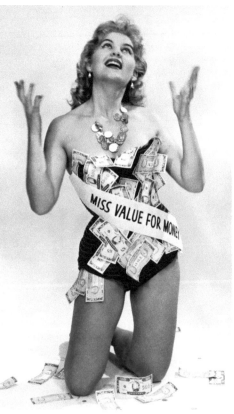

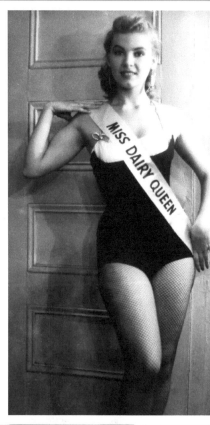

from Sweden. Just a couple of weeks ago she won the coveted title of "*Miss Steel Pier*" in a beauty competition with many of New York's prettiest models.

As "Miss Steel Pier" she will be on hand every Friday afternoon during the summer months to pose for camera fans who visit Atlantic City, N. J.'s very famous attraction—*Hamid's Steel Pier*. Eva will be only one of the numerous attractions on the Pier—which includes a circus, a horse which dives from a tower into the Atlantic Ocean, vaudeville acts, big name bands and vocalists, and many other features.

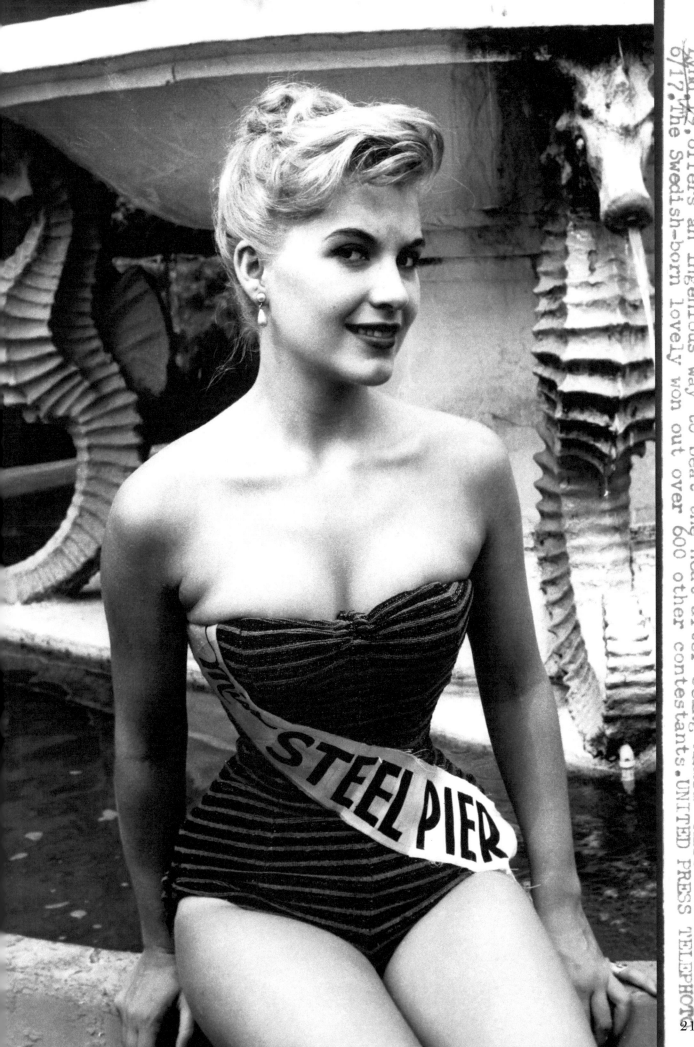

22

Earl was special.

I spent quite a bit of time with him after I came to Los Angeles in 1958. I can't quite remember how it happened. I honestly don't remember when or where I first met him, but when he started taking pictures of me, we quickly became great friends. We instantly bonded. He took tons of pictures of me.

He invited me along to various parties, costume parties and other happenings, where he would photograph me. One costume party, I was wearing a fishing net (and not much else), and he was dressed as the captain of a fishing boat. He posed himself in some of those photos. Photos of me in the fishing net appeared in several Swedish newspapers, maybe elsewhere.

He photographed me with celebrities like Charles Chaplin, Jr., actor Steve Cochran, musician Ray Anthony, and Hollywood gossip columnist Sidney Skolsky. At one party, I met James Mason, who was a favorite actor of mine, and luckily, he turned out to be very nice.

Earl lived in an interesting house in the Hollywood Hills. The entrance to his property was hard to find, as it was covered with greenery, and it always felt like I was entering a secret, mysterious place when I visited him.

Often, he would take me to the top of the Hollywood Hills and shoot me outside. I also remember he had a neat cat, who allowed herself to be photographed with me in one set of photos. (Actually, she didn't have a chance to complain.)

He took some of the best pictures anyone has ever taken of me, many of my favorites. But besides that, I used to go over and just hang out with him at times.

He taught me how to use oil paints, and I remember painting a portrait that got left at his house and never recovered by me. He liked my sketches, especially the comical ones, and asked me to draw his Christmas cards two years in a row—with him at the center of a bunch of semi-clad girls!

I loved spending time with him, both as a model and a friend. He was a kind, caring person, and I had the feeling that he had decided to help me with my career and make sure that I was safe... I felt that I could be myself with him, without any pretenses.

I knew that Earl was a popular photographer of women, including Marilyn Monroe, but I didn't really know any of his background, or about his exotic career. I just knew that he was an amazing photographer and a good friend to me. With all the beautiful women he had photographed, I felt honored that he considered me one of them.

"One day in 1959, Earl told me to put on a bathing suit, because we were going to shoot a postcard for the Roosevelt Hotel. He asked me to lie down on a pad by the pool and wave to a non-existent friend in the distance. The people sitting in lounge chairs on the other side of the pool also made it into the picture!" The hotel provided the oversized (6" x 9") souvenir postcards *(below)* to guests. *Below right:* Sea siren Eva in her notorious fishing net at the Publicists' Ballyhoo Ball, accompanied by "Captain" Earl Leaf.

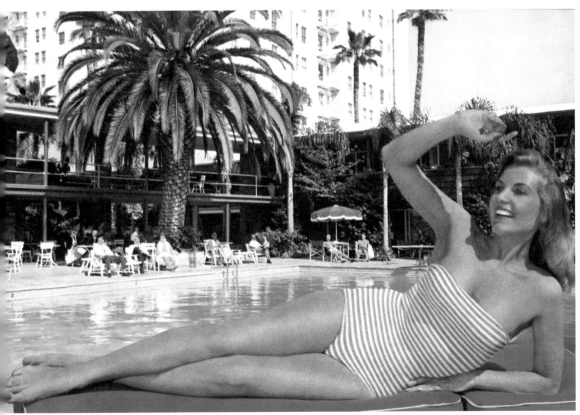
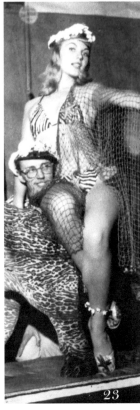

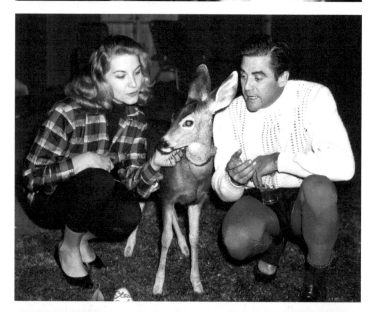

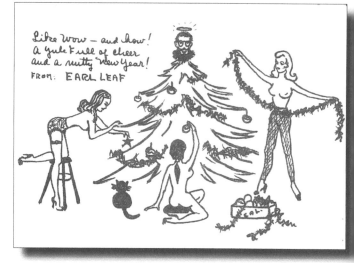

One of the Christmas card drawings Earl commissioned from Eva.

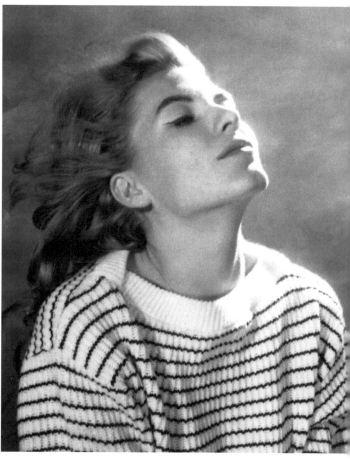

Left, from top: Eva with musician Ray Anthony; actor James Mason, unidentified woman, Eva; befriending a fawn with actor Steve Cochran; Eva and Earl on the scene. "I met James Mason at a party and he chatted with me for 20 minutes, to my total delight. I don't know why I was at that party, other than the fact that Earl Leaf was trying to help get my career going. He did a lot for me in that respect." *All photos by* EARL LEAF

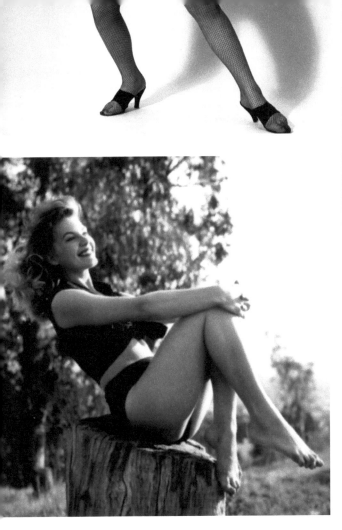

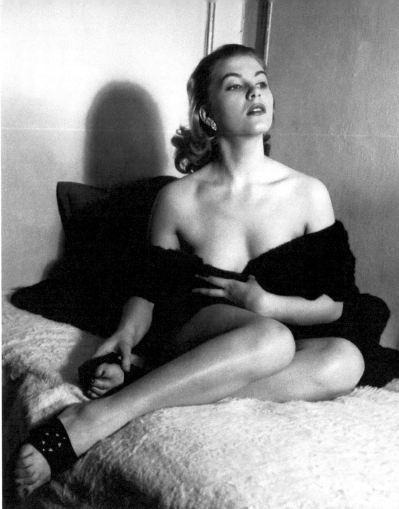

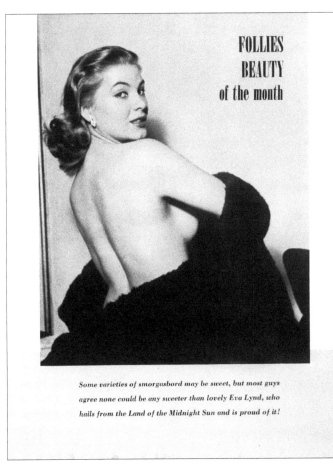

FOLLIES
BEAUTY
of the month

Some varieties of smorgasbord may be sweet, but most guys agree none could be any sweeter than lovely Eva Lynd, who hails from the Land of the Midnight Sun and is proud of it!

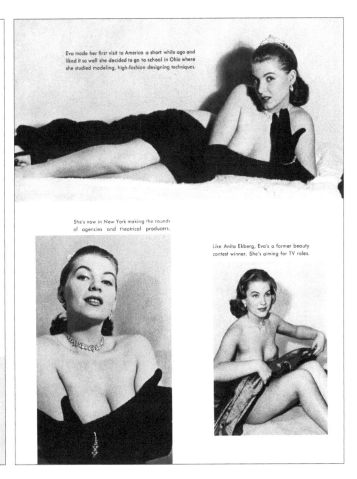

Eva made her first visit to America a short while ago and liked it so well she decided to go to school in Ohio where she studied modeling, high-fashion designing techniques.

She's now in New York making the rounds of agencies and theatrical producers.

Like Anita Ekberg, Eva's a former beauty contest winner. She's aiming for TV roles.

FOLLIES, November 1957; photos by Earl Leaf

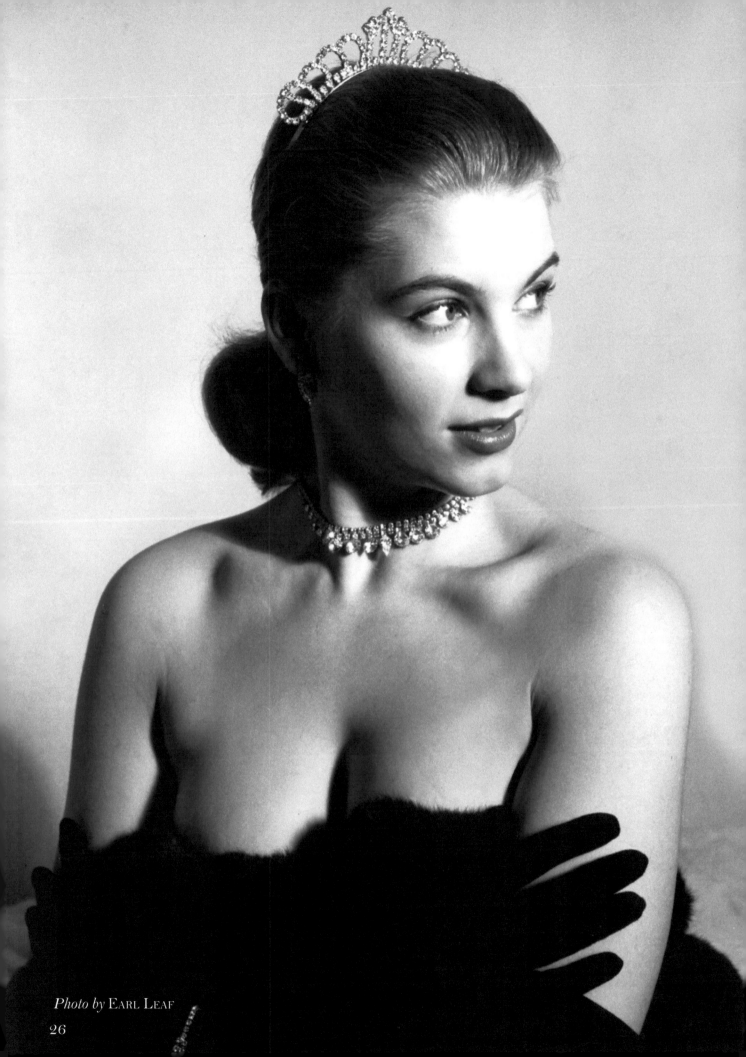

26

The fact that my father was a count makes me a countess. But I never thought much about that, since my idea of being a countess was that I should be rich and live in a castle. Since none of that was true, I never used my title, or thought it was important. Some friends used to call me *Countess* as a nickname, and my brother, who still lives in Sweden, uses his title, I believe: *Count Asti von Fielitz*. My paternal grandfather was born in Riga, Latvia. Legend has it he lived in a castle until the family moved to Norway.

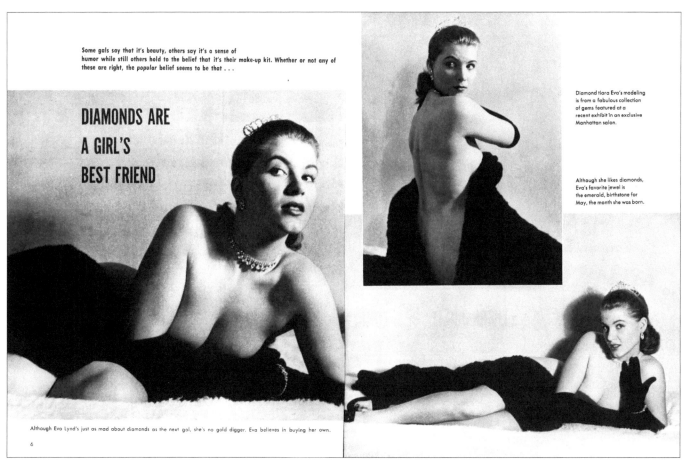

Some gals say that it's beauty, others say it's a sense of humor while still others hold to the belief that it's their make-up kit. Whether or not any of these are right, the popular belief seems to be that . . .

DIAMONDS ARE
A GIRL'S
BEST FRIEND

Diamond tiara Eva's modeling is from a fabulous collection of gems featured at a recent exhibit in an exclusive Manhattan salon.

Although she likes diamonds, Eva's favorite jewel is the emerald, birthstone for May, the month she was born.

Although Eva Lynd's just as mad about diamonds as the next gal, she's no gold digger. Eva believes in buying her own.

6

GALA, January 1957; photos by Earl Leaf

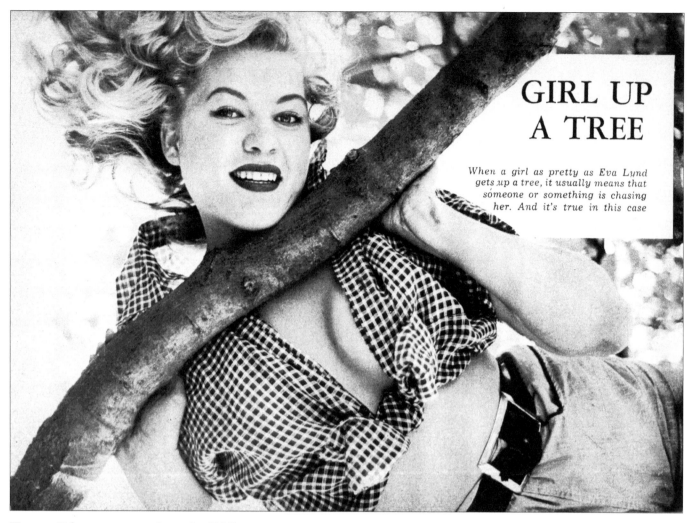

GIRL UP A TREE

When a girl as pretty as Eva Lynd gets up a tree, it usually means that someone or something is chasing her. And it's true in this case

TEMPO, February 1957; photos by Ed Lettau

It isn't easy to explain how *Eva* is pronounced in Sweden. It is somewhere between *ee-va* and *aay-va*...like *eh-va*—which most people can't manage, in which case I prefer the pronunciation closer to *aay-va*. Throughout high school I was known as Eva *(ee-va)* and I let it go, so I answer to whatever anyone can come up with.

I learned English the first summer I was here, enough to go to school in the fall. But it took a while to become *familiar* with this language, where a word can have several meanings. I was very often misunderstood, because I used a word that meant something to *me*, but something totally different to someone else. I think it is one reason I have become a very good listener.

Listening has also become a good tool in my acting career, where it is very important to *listen* to what the other person has to say.

Photo by JERRY YULSMAN

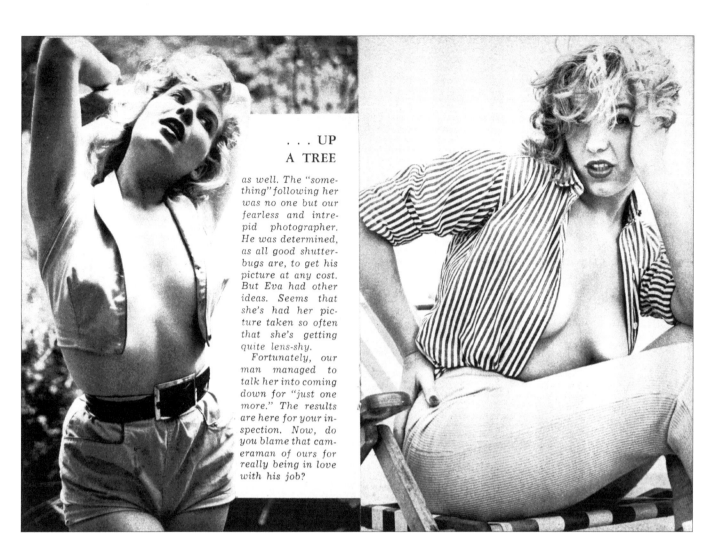

. . . UP
A TREE

as well. The "some-thing" following her was no one but our fearless and intre-pid photographer. He was determined, as all good shutter-bugs are, to get his picture at any cost. But Eva had other ideas. Seems that she's had her pic-ture taken so often that she's getting quite lens-shy.

Fortunately, our man managed to talk her into coming down for "just one more." The results are here for your in-spection. Now, do you blame that cam-eraman of ours for really being in love with his job?

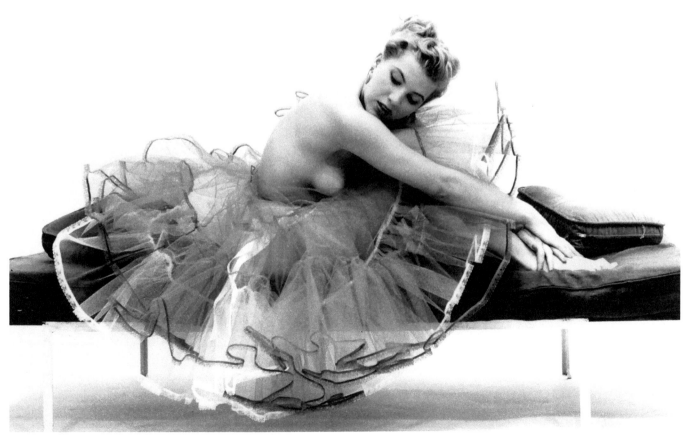

Next pages: "Lily Brazil: Week-End Girl" **STAG**, February 1957; art by Al Rossi

LILY BRAZIL:

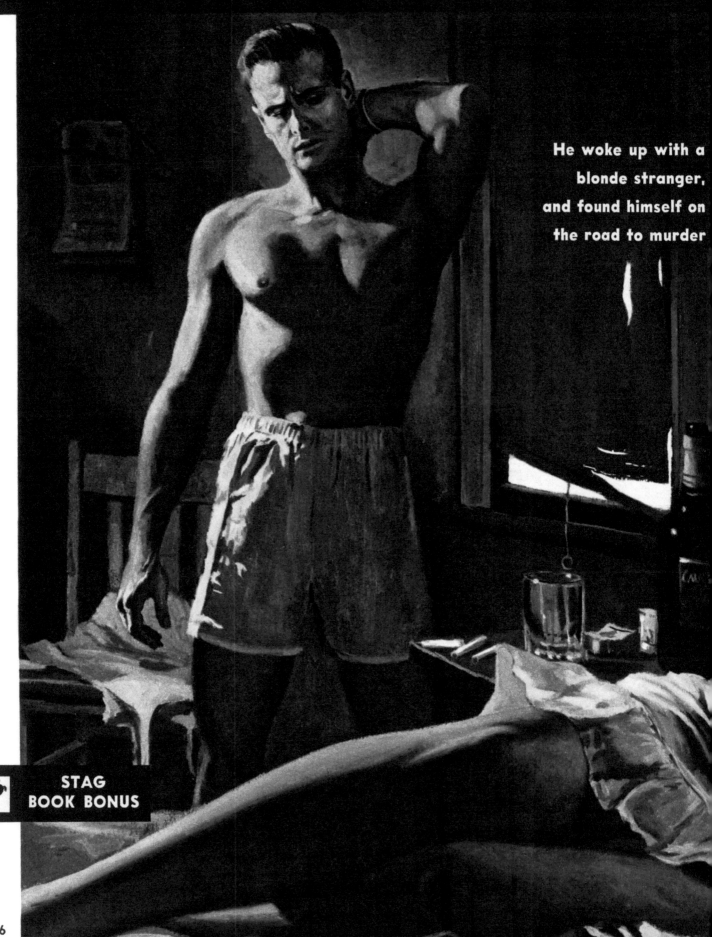

He woke up with a blonde stranger, and found himself on the road to murder

WEEK-END GIRL

by Wenzell Brown
ILLUSTRATED BY AL ROSSI

COWAN stirred restlessly on the bed. He opened his eyes and stared at the scabrous green walls, the stained chintz curtains, the cheap worn carpet. They were unfamiliar, meaningless, and a stab of fear shot through him. He swung his bare legs over the side of the bed. Jerking into a sitting position, he gave a moan of pain and cradled his head in his hands. A steady throbbing beat at the temples.

A rustling sound behind him made him swing around. A girl lay on her side on the far side of the bed, her face almost buried in the pillow. All that he could see was a

CONTINUED ON NEXT PAGE

"You really do look beat," she said. "I bet you don't remember about last night."

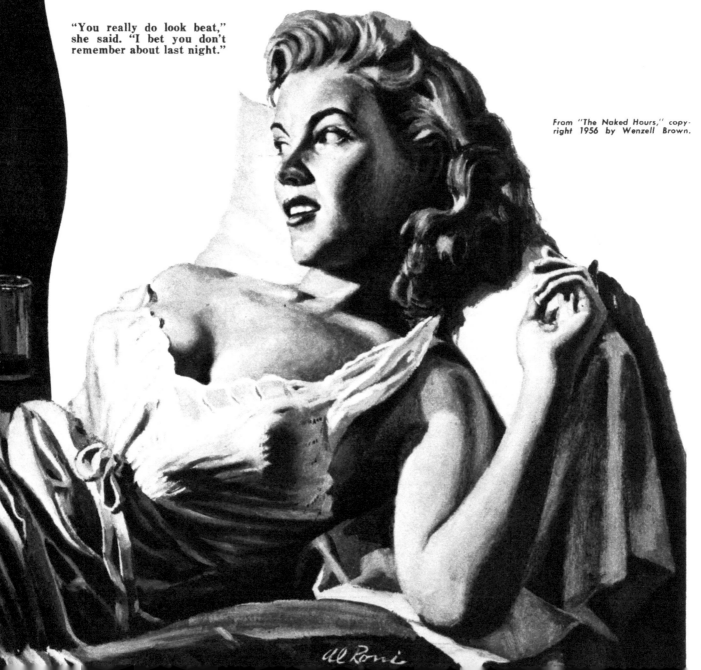

From "The Naked Hours," copyright 1956 by Wenzell Brown.

27

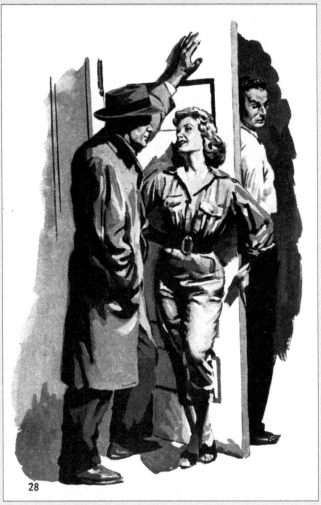

28

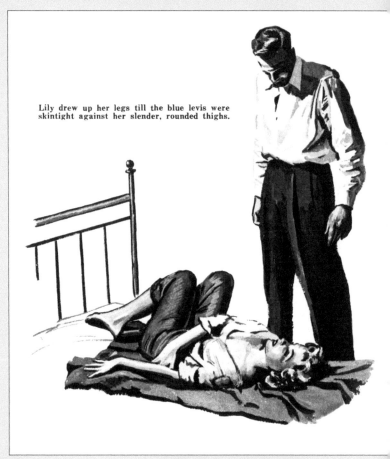

Lily drew up her legs till the blue levis were skintight against her slender, rounded thighs.

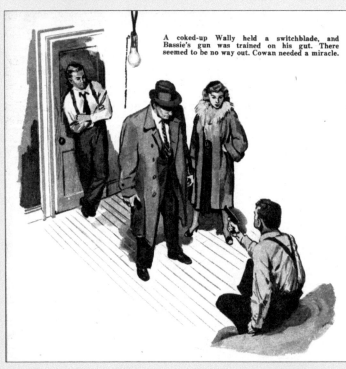

A coked-up Wally held a switchblade, and Bassie's gun was trained on his gut. There seemed to be no way out. Cowan needed a miracle.

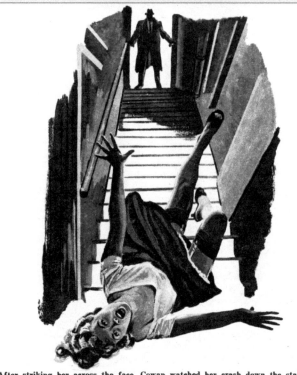

After striking her across the face, Cowan watched her crash down the stairs.

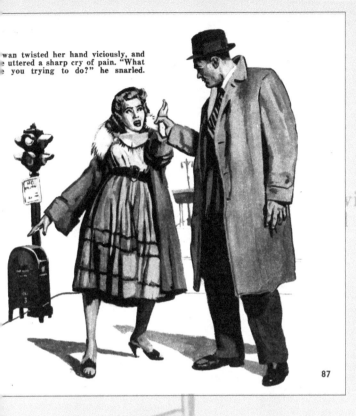

wan twisted her hand viciously, and
e uttered a sharp cry of pain. "What
e you trying to do?" he snarled.

87

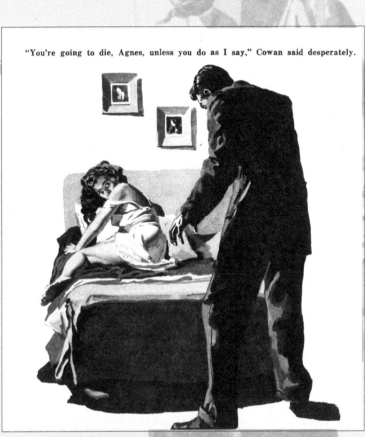

"You're going to die, Agnes, unless you do as I say," Cowan said desperately.

STAG, February 1957; art by Al Rossi

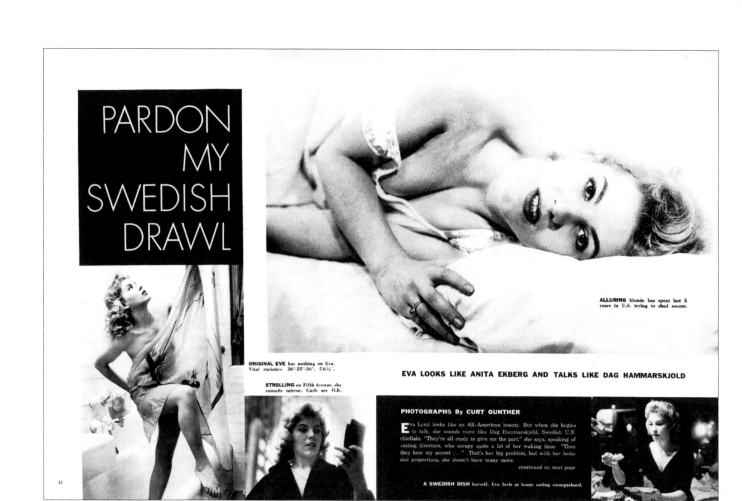

PARDON MY SWEDISH DRAWL

ORIGINAL EVE has nothing on Eva. Vital statistics: 36"-25"-36", 5'6½".

STROLLING on Fifth Avenue, she consults mirror. Curls are O.K.

ALLURING blonde has spent last 5 years in U.S. trying to shed accent.

EVA LOOKS LIKE ANITA EKBERG AND TALKS LIKE DAG HAMMARSKJOLD

PHOTOGRAPHS By CURT GUNTHER

Eva Lynd looks like an All-American beauty. But when she begins to talk, she sounds more like Dag Hammarskjold, Swedish U.N. chieftain. "They're all ready to give me the part," she says, speaking of casting directors, who occupy quite a lot of her waking time. "Then they hear my accent . . ." That's her big problem, but with her looks and proportions, she doesn't have many more.

continued on next page

A SWEDISH DISH herself, Eva feels at home eating smorgasbord.

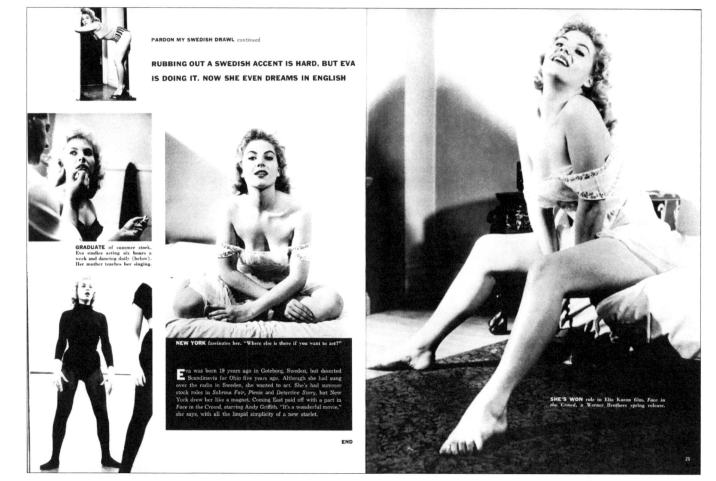

PARDON MY SWEDISH DRAWL *continued*

RUBBING OUT A SWEDISH ACCENT IS HARD, BUT EVA IS DOING IT. NOW SHE EVEN DREAMS IN ENGLISH

GRADUATE of summer stock. Eva studies acting six hours a week and dancing daily (below). Her mother teaches her singing.

NEW YORK fascinates her. "Where else is there if you want to act?"

Eva was born 19 years ago in Goteborg, Sweden, but deserted Scandinavia for Ohio five years ago. Although she had sung over the radio in Sweden, she wanted to act. She's had summer stock roles in *Sabrina Fair*, *Picnic* and *Detective Story*, but New York drew her like a magnet. Coming East paid off with a part in *Face in the Crowd*, starring Andy Griffith. "It's a wonderful movie," she says, with all the limpid simplicity of a new starlet.

SHE'S WON role in Elia Kazan film, *Face in the Crowd*, a Warner Brothers spring release.

END

SEE, May 1957; photos by Curt Gunther

The most obvious misconception is "the dumb blonde," which is just taken for granted, it seems. Totally wrong, of course! I have known some gorgeous blondes who were very much the *opposite* of dumb… Sometimes playing that part because they were hired to do so.

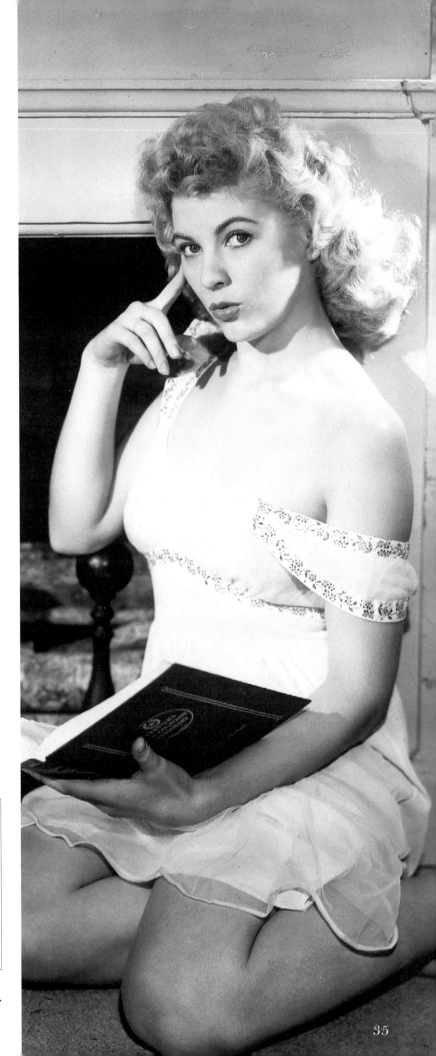

STEVE ALLEN STAR

Eva Lynd, who is a frequent guest on the Steve Allen Show, ponders a Websterian interpretation of part of her script. Miss Lynd is planning to extend her television activities in the near future, and will likely be a guest on several of the big comedy shows.

Publicity photo for *The Steve Allen Show*, 1957

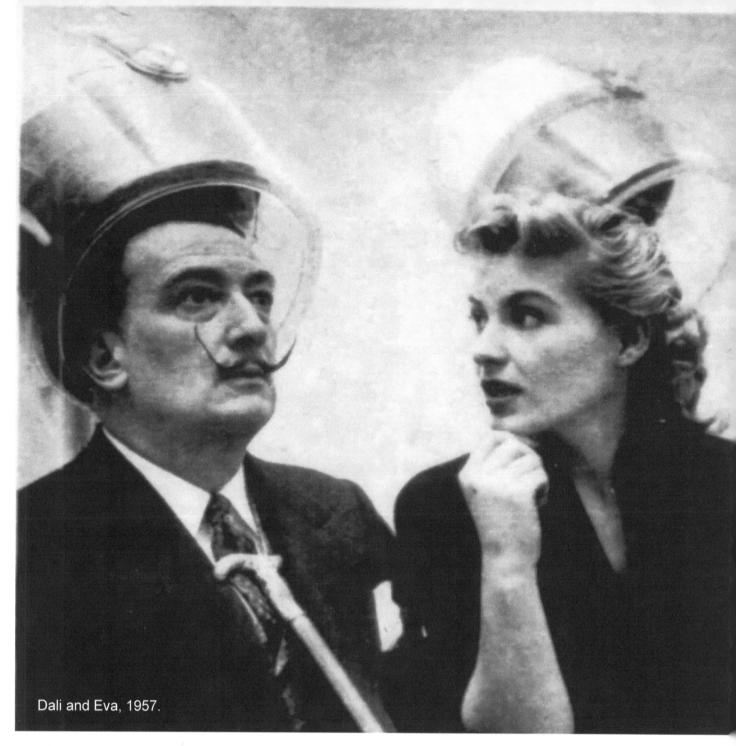

Dali and Eva, 1957.

Photographers often staged publicity photo shoots to sell to newspapers. Peter Leonardi was my regular hairdresser in NYC, and when he asked me to model in a story about hair, I told him I would love to. Then he said that it would have to do with styles that Salvador Dali would create... and Dali would be there in person.

Wow! Salvador Dali, in person! Since he also lived in NYC, I had seen glimpses of him here and there. He was quite a character, with his very special mustache and cane.

I didn't know what to expect, but when we arrived and I met him, he seemed to be a very relaxed person, and not at all what you'd expect

him to be. He quietly told Peter what he wanted of us—me, and the other two models. He sat and watched, leaning on his cane while Peter styled each of us. It took a couple of hours, and he was there the entire time. There were photographers there, and the photos appeared in various newspapers. Everything went very well, and he left the studio before I had the idea that I should ask him for an autograph.

At the time I met him, I wasn't all that familiar with who he was, but he has since become one of my favorite artists. Now I realize what a privilege it was to have met him, and to have been able to work with him.

36

Eva models Dali's "French Bread" design, styled by Peter Leonardi. The other looks are "Miss Sea Urchin" and "Bullet," respectively.

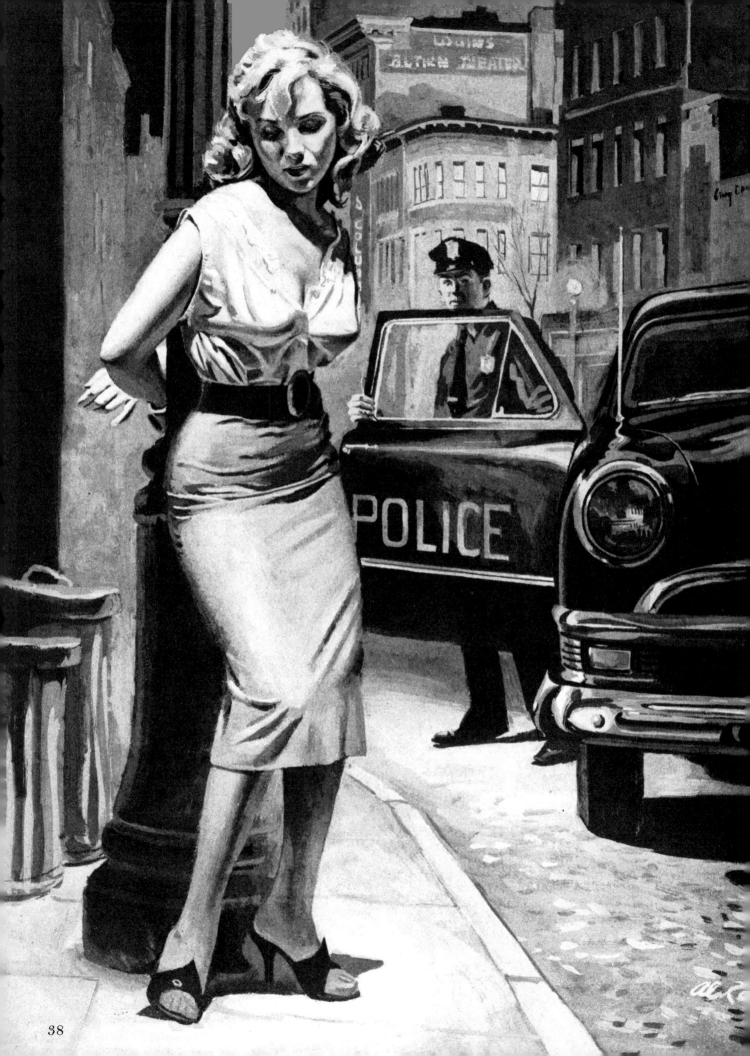

There seems to be a feeling with some people that because you are posing as a pin-up girl, partially dressed, you are about the same as a prostitute. Just to set the record straight: If we wanted to be prostitutes, that is what we would be!

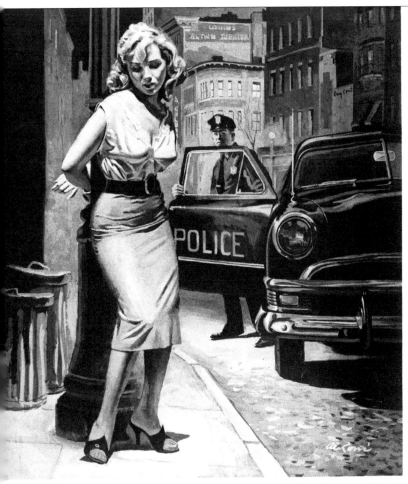

You've Lived – Too Long

The kid from Milwaukee was beautiful—the cops didn't know how dumb—and they couldn't figure out whether to book her— or turn her loose to be shot to death!

■ THE PHONE rang and Detective Sergeant Wally Austin reached for it, swearing under his breath.

"All right, doc, I'll do that for you," he said and swung around to look again at Sergeant Clancy, a gigantic man of uncertain age.

Clancy stirred in his chair. "Something wrong? Kids?" he said.

Austin shook his head. "It's an emergency," he said. "The doc has a deal on an' I guess you're in on it, more's the pity. He says he's got some rye that isn't half bad, and would I like to take a snort. Come on, slob, and we'll drink for free. Eddie can watch the phones till we get back."

They ascended to the top floor of headquarters, entered the room of Emergency Hospital and padded to the interne's office. The young doctor waved to a flask and glass on his desk. Austin poured himself two fingers, sampled it, licked his lips.

"Not bad, Doc. Not bad at all," he said. "How come?"

I took it off a man they just brought in," the interne replied. "It smelled good, so I tried it. Not like the usual stuff that eats a hole in the pipes if you throw it down the sink. This fellow must be Park Avenue."

Austin finished his sample, passed the glass to the veteran sleuth, who smelled the empty tumbler, poured himself a man-sized dose and tossed it down.

"Wah!" he commented, "a guy that packs liquor of that class has no business in Emergency at all. He should be in a private ward, with a jar of roses and a pretty nurse."

"He soon will be," answered the interne, carefully putting the flask in a drawer of his desk. "The report on him says 'dead drunk at Park and Daley.' They brought him up here for me to say officially that he was drunk, as the new rules provide, before they tossed him in one of the tanks."

by DAVID CREWE

ILLUSTRATED BY AL ROSSI

Before she knew it she was neatly locked to the tall light standard, her hands cuffed behind her. Some unladylike remarks came from her mouth

25

True Adventures, March 1957; art by Al Rossi

39

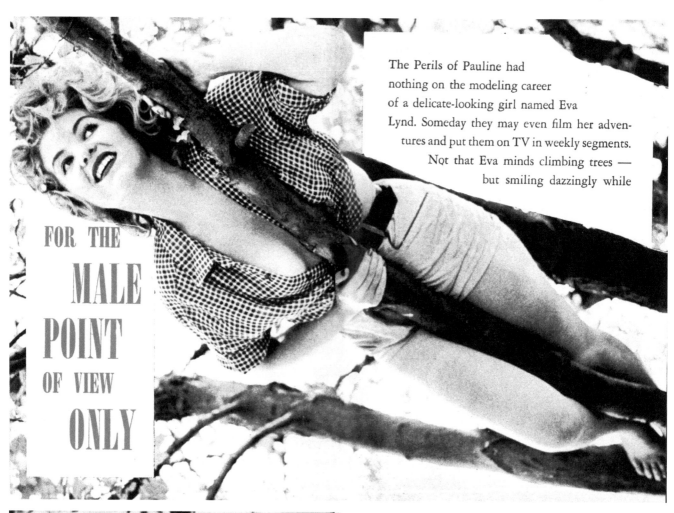

The Perils of Pauline had nothing on the modeling career of a delicate-looking girl named Eva Lynd. Someday they may even film her adventures and put them on TV in weekly segments. Not that Eva minds climbing trees — but smiling dazzlingly while

FOR THE MALE POINT OF VIEW ONLY

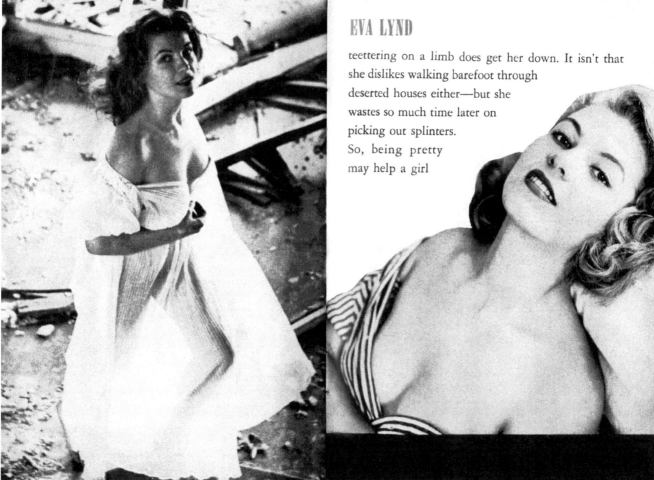

EVA LYND

teettering on a limb does get her down. It isn't that she dislikes walking barefoot through deserted houses either—but she wastes so much time later on picking out splinters. So, being pretty may help a girl

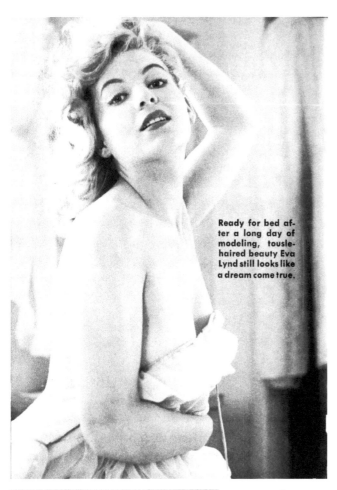

Ready for bed after a long day of modeling, tousle-haired beauty Eva Lynd still looks like a dream come true.

Trust is the most important factor in a photographer/model relationship. There you are, wearing very little, doing the pin-up poses that are asked for. If you are worried about the photographer attacking you, there won't be the proper communication that is needed for a good shoot.

Something like that happened in the beginning of my career. It made me leave the studio before the shoot, with the thought that I would never get another job. And I didn't—from that photographer, which was just as well.

MALE POINT OF VIEW, April 1957; photos by *(clockwise from left)* Phil Jacobson, Wil Blanche, Earl Leaf, undetermined, Wil Blanche, Ed Lettau

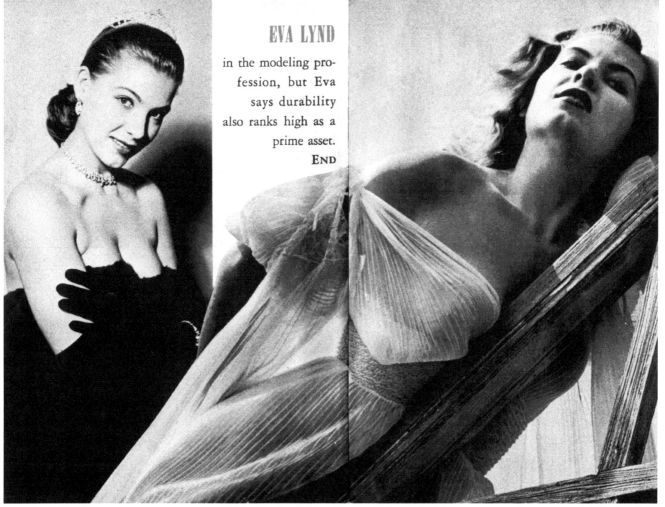

EVA LYND

in the modeling profession, but Eva says durability also ranks high as a prime asset.

END

It takes one week for 700 women to separate 12,000 flyboys from a million dollars in cold cash

Kimono Girls Check in Again

By STEVE LEE
ILLUSTRATED BY AL ROSSI

THE evening of December 22, 1955, was clear and cool in Montgomery, Alabama. In New York or Chicago they would have said that the weather was mild, but in Montgomery they called it cool.

Johnny Davis, owner of the Plantation Club, a night-spot on Luverne Highway, was reading the Montgomery *Advertiser* in an easy chair in the living-room of his four-room apartment up over the club. He'd just polished off a steak dinner and was enjoying a good cigar. In the next room his wife was wrapping Christmas presents.

Business had been good; Johnny had an oversize roll amounting to exactly $4,054 in his left hand

CONTINUED ON PAGE 36

The madam bellowed and the girls stepped out to mingle with waiting customers.

42

43

Previous pages: "Kimono Girls Check In Again" **KEN FOR MEN**, May 1957; art by Al Rossi (*Eva is the model for all four* "kimono girls;" *Steve Holland, for both men.*)

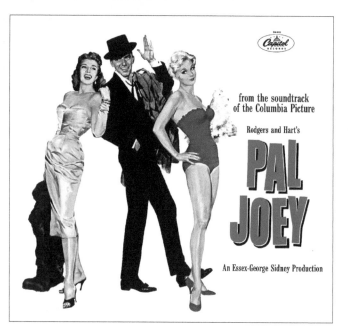

A few months ago, Eva was asked to pose (body only) for pictures to be used of Monroe advertising The Prince and the Showgirl.

"They put me through a lot of tests and maybe ten, fifteen different poses, until they selected one," Eva said.

"Then they used Marilyn, body and all, for the final ones.

Kim Novak and Rita Hayworth were both in California, when, in the mysterious ways of the movies, it was decided to shoot all the ad photos of them for their movie Pal Joey in New York. Hayworth's head went on the body of a model named Tony King, and Novak's head went on the body of Eva, and the pictures went all over America.

Even more mysteriously, Eva was summoned to sub for Deborah Kerr for the promotion photos of Heaven Knows, Mr. Allison.

The poses called for Eva crawling along the ground in some desolate Pacific jungle. And she had to go through the poses time and time again. The whole thing was a complete puzzle to her.

"At thirty dollars an hour, they were making me crawl along the ground with my hand outstretched," she said.

What's so puzzling about that?

"Deborah plays a nun. So I was dressed in a nun's habit. Anyone could have done it."

— From a 1957 installment of Sidney Fields' show business column

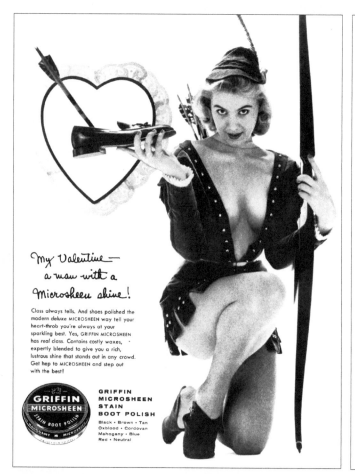

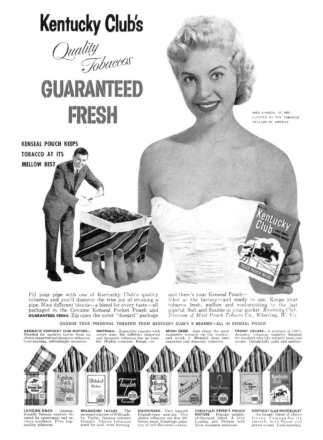

PLAYBOY, February 1957

PLAYBOY, December 1957

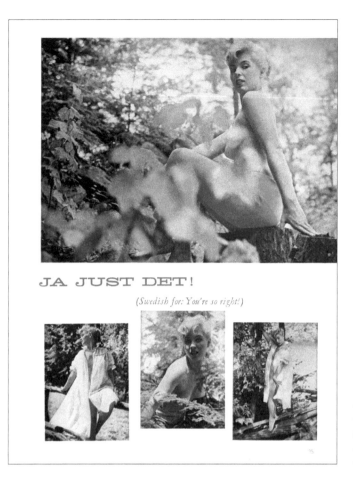

JA JUST DET!

(Swedish for: You're so right!)

 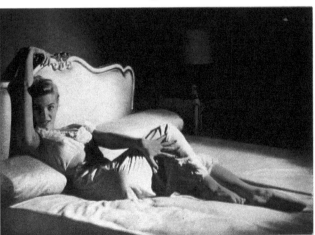

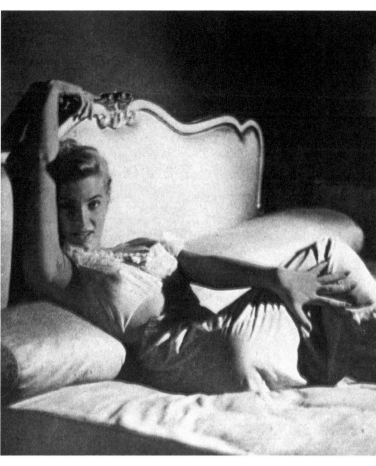

Up in Sweden, the nights are long, the girls are eager, and love is a national pastime.

Eva Lynd is a *racksa Svenska flicka* which is just another way of saying, she comes from Sweden and is an extraordinarily pretty girl. Like so many of her sisters, she has a long-limbed, smooth-muscled look that comes from fresh air and exercise. But what really gives Swedish girls that something extra, is their knowledge that it takes lots of warmth to make up for the rigors of a cold and dreary climate.

CAPER, May 1957; photos by Phil Jacobson

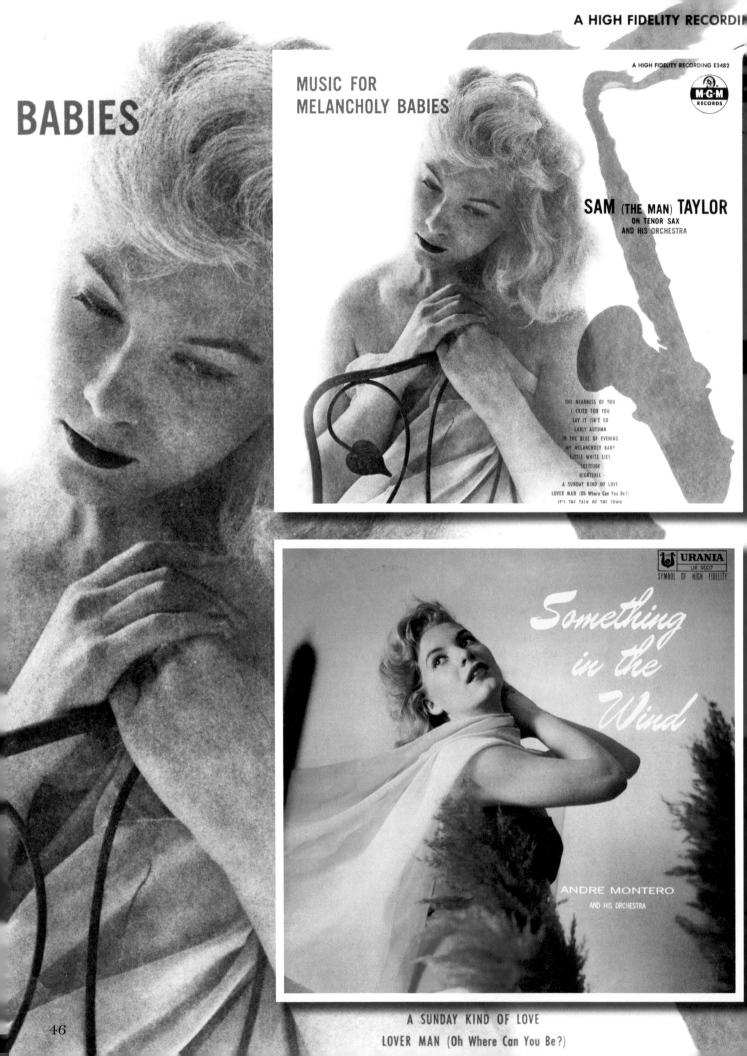

BABIES

MUSIC FOR
MELANCHOLY BABIES

A HIGH FIDELITY RECORDING E3482

M-G-M
RECORDS

SAM (THE MAN) TAYLOR
ON TENOR SAX
AND HIS ORCHESTRA

THE NEARNESS OF YOU
I CRIED FOR YOU
SAY IT ISN'T SO
EARLY AUTUMN
IN THE BLUE OF EVENING
MY MELANCHOLY BABY
LITTLE WHITE LIES
SOLITUDE
NIGHTFALL
A SUNDAY KIND OF LOVE
LOVER MAN (Oh Where Can You Be?)
IT'S THE TALK OF THE TOWN

URANIA
UR 9007
SYMBOL OF HIGH FIDELITY

Something
in the
Wind

ANDRE MONTERO
AND HIS ORCHESTRA

46

A SUNDAY KIND OF LOVE

LOVER MAN (Oh Where Can You Be?)

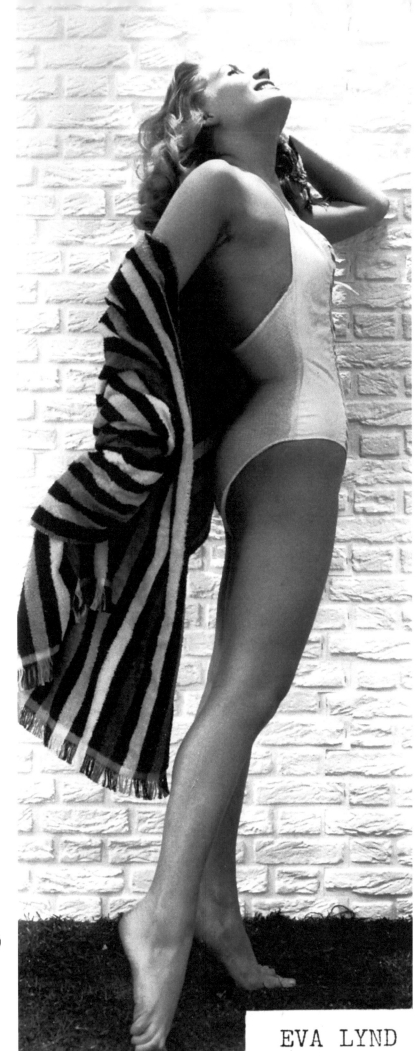

MUSIC FOR MELANCHOLY BABIES
Sam (The Man) Taylor and His Orchestra
Photography by Lester Krauss
MGM Records, 1957

SOMETHING IN THE WIND
Andre Montero and His Orchestra
Photographer uncredited (possibly Lester Krauss)
Urania, 1957

Photo by LESTER KRAUSS

EVA LYND

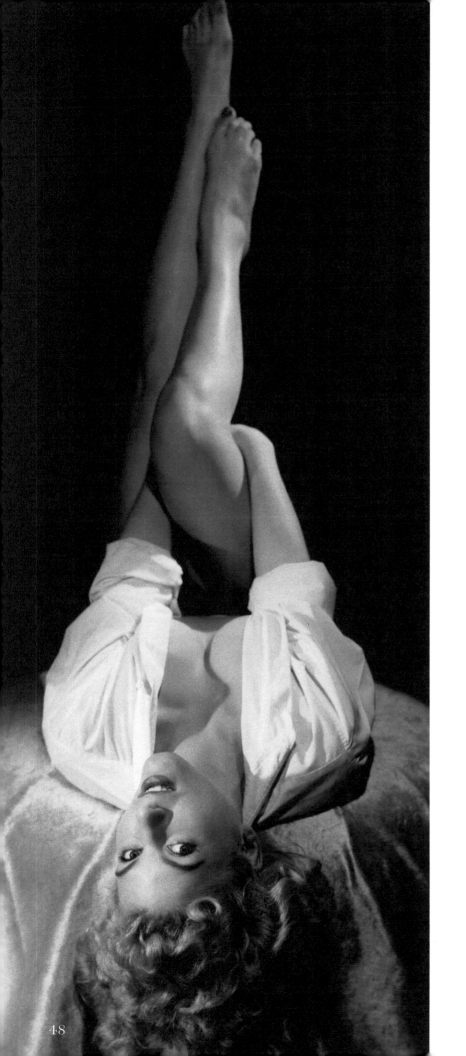

DREAMS OF A CONTINENTAL AFFAIRE
Marcel Guillemin and His Orchestra
Photographer unknown
Urania, 1957

RAZZ-MA-TAZZ
Phil Moody and Nick Fatool
Photography by Jerry Tiffany
& Stan Sternbach
Urania, 1957

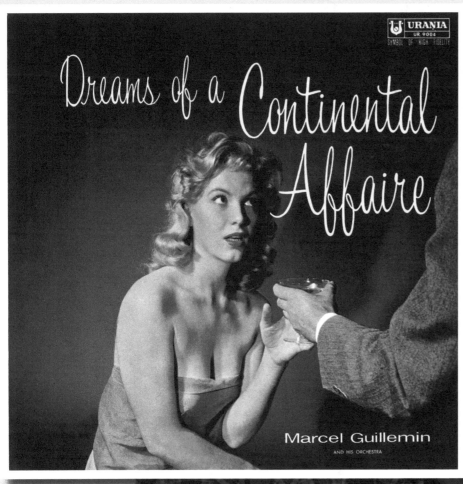

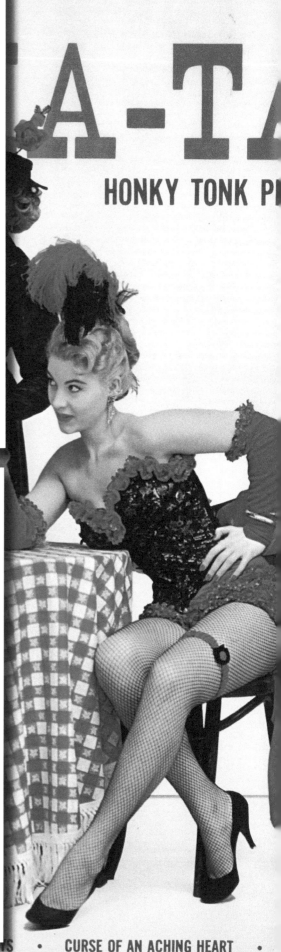

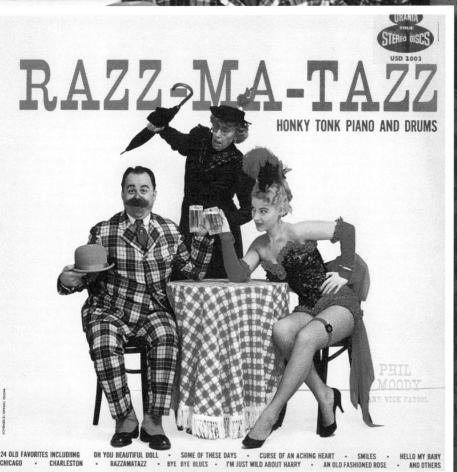

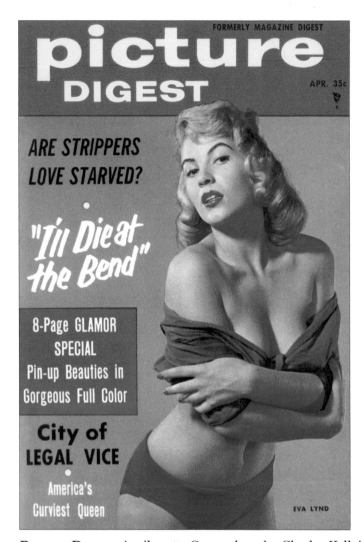

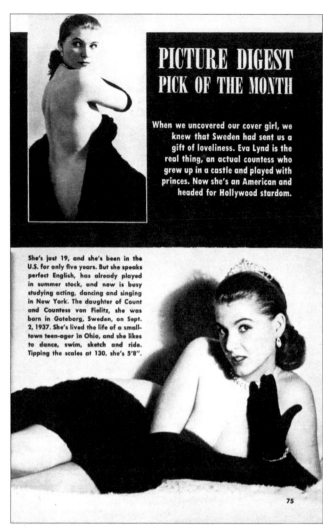

PICTURE DIGEST PICK OF THE MONTH

When we uncovered our cover girl, we knew that Sweden had sent us a gift of loveliness. Eva Lynd is the real thing, an actual countess who grew up in a castle and played with princes. Now she's an American and headed for Hollywood stardom.

She's just 19, and she's been in the U.S. for only five years. But she speaks perfect English, has already played in summer stock, and now is busy studying acting, dancing and singing in New York. The daughter of Count and Countess von Fielitz, she was born in Goteborg, Sweden, on Sept. 2, 1937. She's lived the life of a small-town teen-ager in Ohio, and she likes to dance, swim, sketch and ride. Tipping the scales at 130, she's 5'8".

75

PICTURE DIGEST, April 1957. Cover photo by Charles Kell; interior photos by Earl Leaf

I did some live lingerie modeling for a place that would invite their buyers in to show their new inventory. I really didn't care for that, because I would be wearing bras and girdles mostly, and I felt uncomfortable with people staring at me up close while I was not dressed…

There is a big difference in posing for the camera semi-dressed, and walking around in a bra and girdle with people inspecting you.

Photo by CHARLES KELL

SWANK, August 1957; photo by Barry Blum

50

Swank

AUG. 35c

summer resort story:

HOW TO BE NAUGHTY IN A NIGHTSHIRT

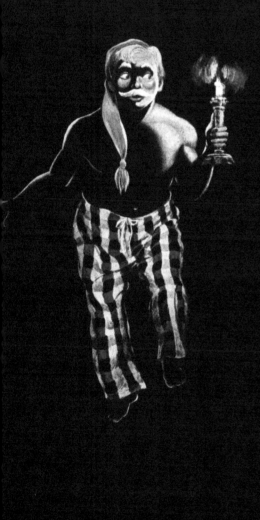

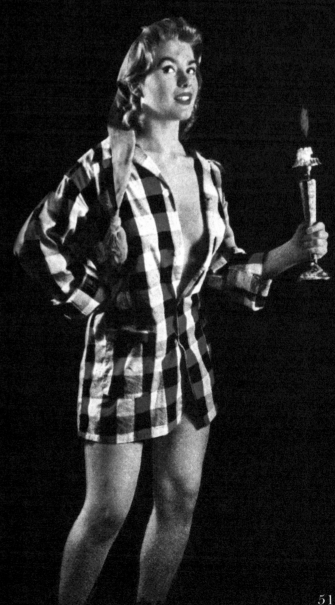

COVER MY DAMP GRAVE

A VIOLENT AND POWERFUL
NOVEL OF SUSPENSE

TV'S CALL-GIRL

The trade is as old as the Seven
Hills of Rome, but the way
they pitch it now, it comes all
wired for sight and sound

I have met and worked with some amazing people in my life—photographers, illustrators, actors, and people in the business in various jobs. A lot of them have become permanent friends who I would love forever, and who I would not have wanted to be without. There have been a few who were disappointing to me, because they weren't on the up-and-up; especially at the beginning of my career.

There was one agent early on who told me that he could make me a star, but I was only to go to bed with the people he told me about. I think you know how that interview ended—I am not a star! I am certainly not a prude, but I don't want to be told to whom I should make love.

TV'S CALL-GIRL RACKET

The trade is as old as the Seven Hills of Rome, but the way they pitch it now, it comes all wired for sight and sound.

EDITOR'S NOTE: Only a small number of U.S. disc jockeys are involved in the sordid new call-girl racket which employs platter spinners as contact men. This article is aimed at that minority—not at the great majority of ethical and honorable DJs.

by Richard Statler White

ILLUSTRATED BY AL ROSSI

There was a blonde in a turquoise sweater waiting at the hotel newsstand, all right, pretending to read. Either that or she was good at reading upside down.

Disc jockey Jack Jackson sauntered across the lobby toward her. Now he could see the face. Not bad at all. He held up a white rectangle of paper.

"This yours, honey?" he asked. He handed her a note that'd been passed up to him about a half-hour before, midway in the question-answer segment of his DJ show from the cocktail lounge of the Imperial Hotel.

"PLEASE DON'T READ THIS ON THE AIR," it began. "I'M BLONDE, WEARING AN AQUA SWEATER, AND I'LL BE WAITING FOR YOU AT THE LOBBY NEWSSTAND AFTER THE SHOW. LET'S TAKE A DRIVE. IT'LL BE WORTH YOUR WHILE, I PROMISE YOU."

She nodded—gave him a sultry smile.

He smiled back. "Sorry," he said. "Can't do it."

(Continued on page 52) 13

STAG, May 1957; art by Al Rossi

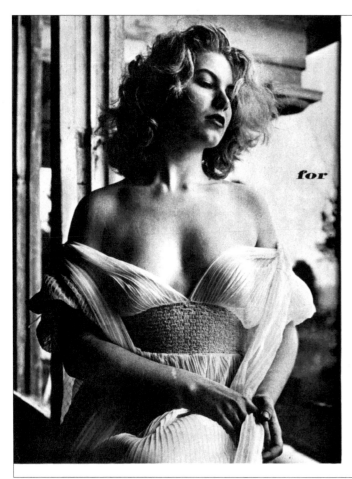

for **easy looking...**

EVA is the daughter of the Swedish Countess Margaretta von Fielitz, a concert singer who is well known in Europe and recently gave a concert at Town Hall. Eva arrived in the United States about seven years ago and settled for a time in Ohio where she studied dramatics and appeared for two years in stock. Eva is often mistaken for Anita Ekberg on the street and elsewhere. A vegetarian all of her life, Eva credits her beautiful skin and her unlimited energy to this way of life. Exercise is a part of her daily living as it

PHOTOS BY WIL BLANCHE OF PRANGE PICTURES

27

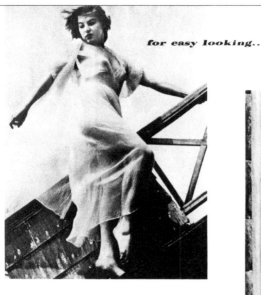

for **easy looking..**

is with most Swedish people. Eva has appeared on TV and at present is trying for a part in a Broadway show. While waiting for her big chance she does much modeling. Her ambition is to go to Hollywood, but she feels that, while waiting, her best bet is New York TV. ∎

28

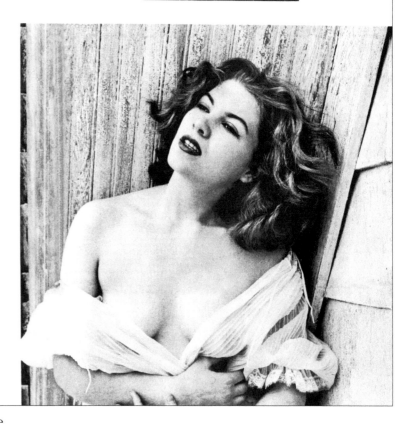

ADVENTURE, June 1957; photos by Wil Blanche

54

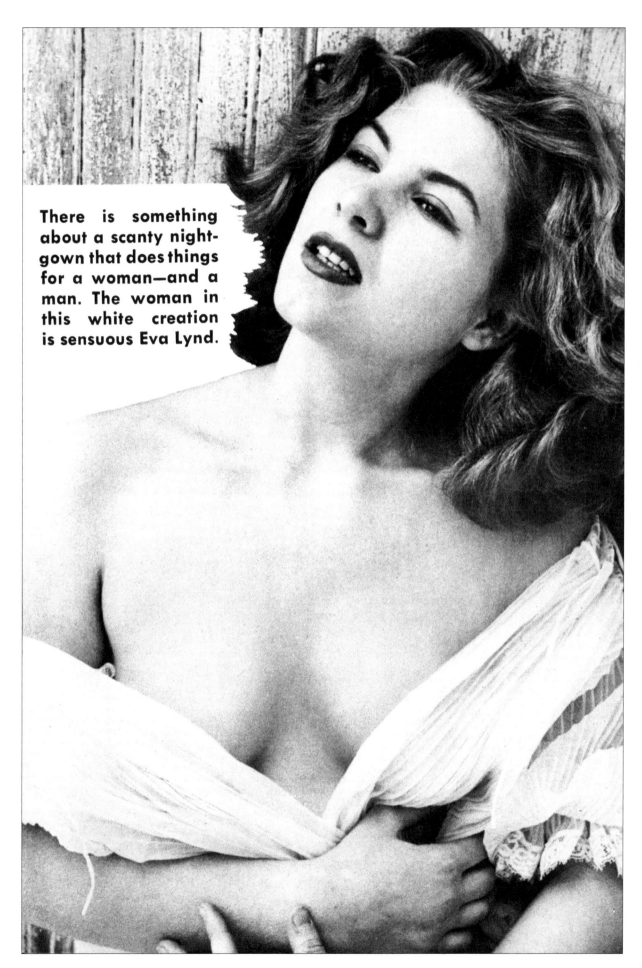

There is something about a scanty night-gown that does things for a woman—and a man. The woman in this white creation is sensuous Eva Lynd.

TV GIRLS AND GAGS, July 1957; photo by Wil Blanche

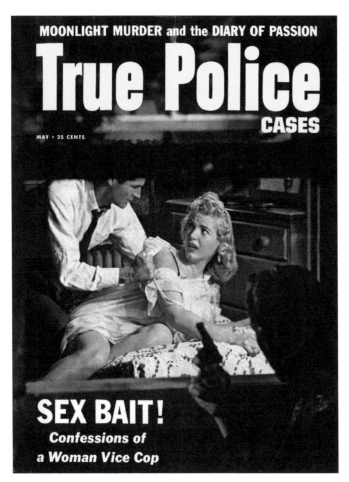

TRUE POLICE CASES, May 1957

STARTLING DETECTIVE, June 1957

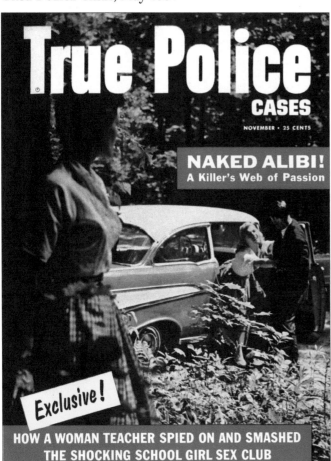

TRUE POLICE CASES, November 1957

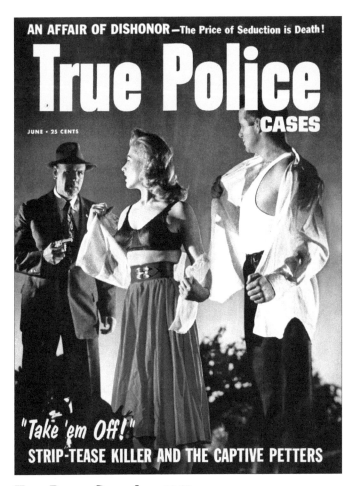

AN AFFAIR OF DISHONOR—The Price of Seduction is Death!

True Police CASES

JUNE • 25 CENTS

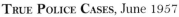

"Take 'em Off!"
STRIP-TEASE KILLER AND THE CAPTIVE PETTERS

TRUE POLICE CASES, June 1957

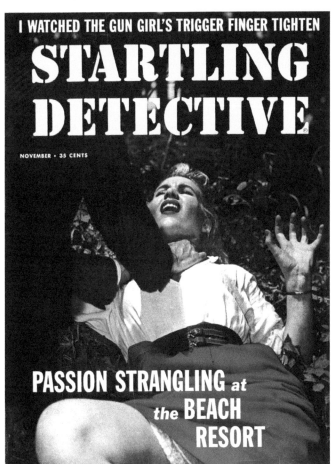

I WATCHED THE GUN GIRL'S TRIGGER FINGER TIGHTEN

STARTLING DETECTIVE

NOVEMBER • 35 CENTS

PASSION STRANGLING at
the BEACH
RESORT

STARTLING DETECTIVE, November 1957

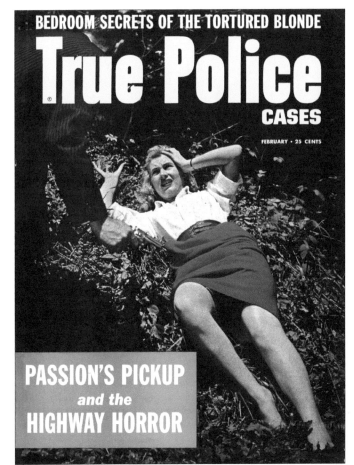

BEDROOM SECRETS OF THE TORTURED BLONDE

True Police CASES

FEBRUARY • 25 CENTS

PASSION'S PICKUP
and the
HIGHWAY HORROR

TRUE POLICE CASES, February 1958

In the 1950s and '60s, "true story" magazines of various kinds were extremely popular. One of the earliest genres to ride this wave was the *true crime magazine* aka *detective magazine* genre, which often focused on grisly crimes. To enhance the perception that the stories were true (though many were either highly embellished or pure fiction), true crime and detective mags tended to use photos as interior illustrations and, from the mid-1950s on, featured photos rather than artwork on their covers. Although true crime stories are one of the elements that *men's adventure magazines* (MAMs) incorporated into their formula, and MAMs often used photos for *interior* illustrations in stories, MAMs maintained the tradition of painted covers into the 1970s. And since many MAM stories involved action and adventure scenes that were hard or impossible to depict with existing or staged photos, MAMs also used interior artwork longer and more frequently than most other genre magazines, rivaled only by science fiction mags.

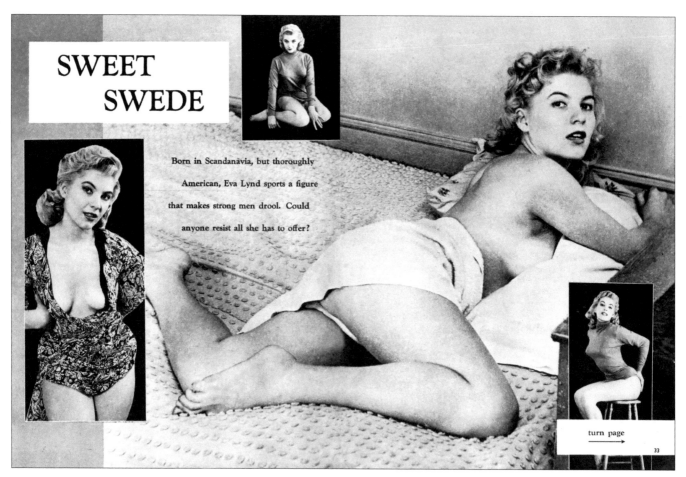

SWEET SWEDE

Born in Scandanàvia, but thoroughly American, Eva Lynd sports a figure that makes strong men drool. Could anyone resist all she has to offer?

turn page →

33

REAL MEN, July 1957; photos by Leo Fuchs

Photo by LEO FUCHS

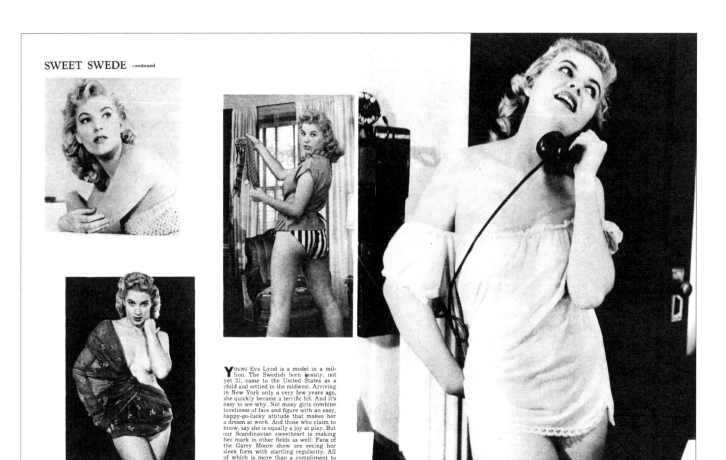

SWEET SWEDE continued

YOUNG Eva Lynd is a model in a million. The Swedish born beauty, not yet 21, came to the United States as a child and settled in the midwest. Arriving in New York only a very few years ago, she quickly became a terrific hit. And it's easy to see why. Not many girls combine loveliness of face and figure with an easy, happy-go-lucky attitude that makes her a dream at work. And those who claim to know, say she is equally a joy at play. But our Scandinavian sweetheart is making her mark in other fields as well. Fans of the Garry Moore show are seeing her sleek form with startling regularity. All of which is more than a compliment to Garry's judgment. Eva has it. ●●●

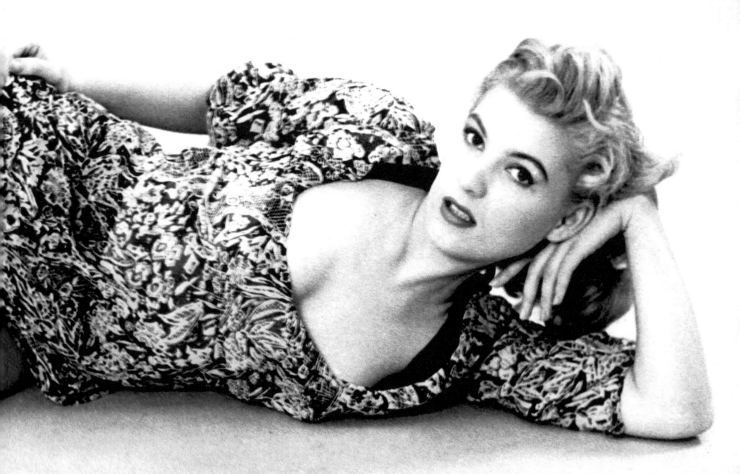

James Bama is another highly regarded illustrator of that era. I worked for him only once; perhaps that's why I remember that session so vividly.

I arrived at the studio and it was set up as a living room, with a couch and an easy chair. In the chair sat an elderly gentleman; there were also other people in the room.

I was asked to stand in front of him and take off my dress—start to step out of it. I was wearing a black bra and panties. This was one of the fastest bits I ever did. It took no more than fifteen minutes, because I remember asking, "Is that it?" and was told that it was. It was obviously prepared completely before I arrived, and all I had to do was step out of my dress to complete the picture.

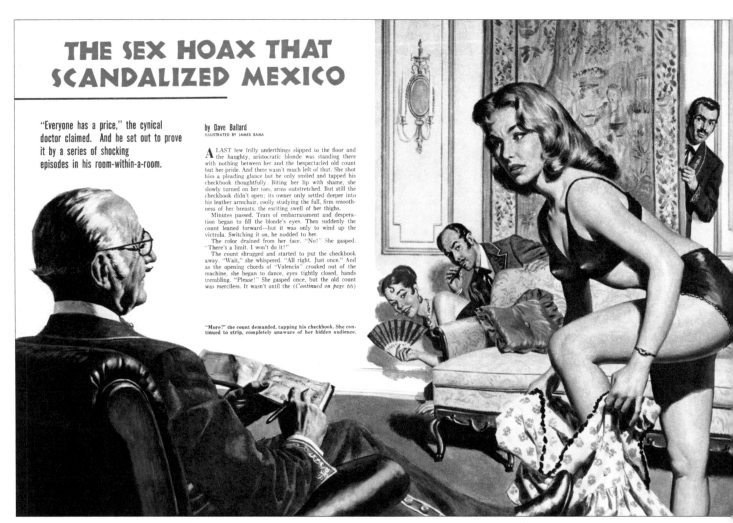

THE SEX HOAX THAT SCANDALIZED MEXICO

"Everyone has a price," the cynical doctor claimed. And he set out to prove it by a series of shocking episodes in his room-within-a-room.

by Dave Ballard
ILLUSTRATED BY JAMES BAMA

A LAST few frilly underthings slipped to the floor and the haughty, aristocratic blonde was standing there with nothing between her and the bespectacled old count but her pride. And there wasn't much left of that. She shot him a pleading glance but he only smiled and tapped his checkbook thoughtfully. Biting her lip with shame, she slowly turned on her toes, arms outstretched. But still the checkbook didn't open; its owner only settled deeper into his leather armchair, coolly studying the full, firm smoothness of her breasts, the exciting swell of her thighs.

Minutes passed. Tears of embarrassment and desperation began to fill the blonde's eyes. Then suddenly the count leaned forward—but it was only to wind up the victrola. Switching it on, he nodded to her.

The color drained from her face. "No!" She gasped. "There's a limit. I won't do it!"

The count shrugged and started to put the checkbook away. "Wait," she whispered. "All right. Just once." And as the opening chords of "Valencia" croaked out of the machine, she began to dance, eyes tightly closed, hands trembling. "Please!" She gasped once, but the old count was merciless. It wasn't until the *(Continued on page 66)*

"More!" the count demanded, tapping his checkbook. She continued to strip, completely unaware of her hidden audience.

STAG, August 1957; art by James Bama *(later reprinted in* **MAN'S WORLD**, *October 1960)*

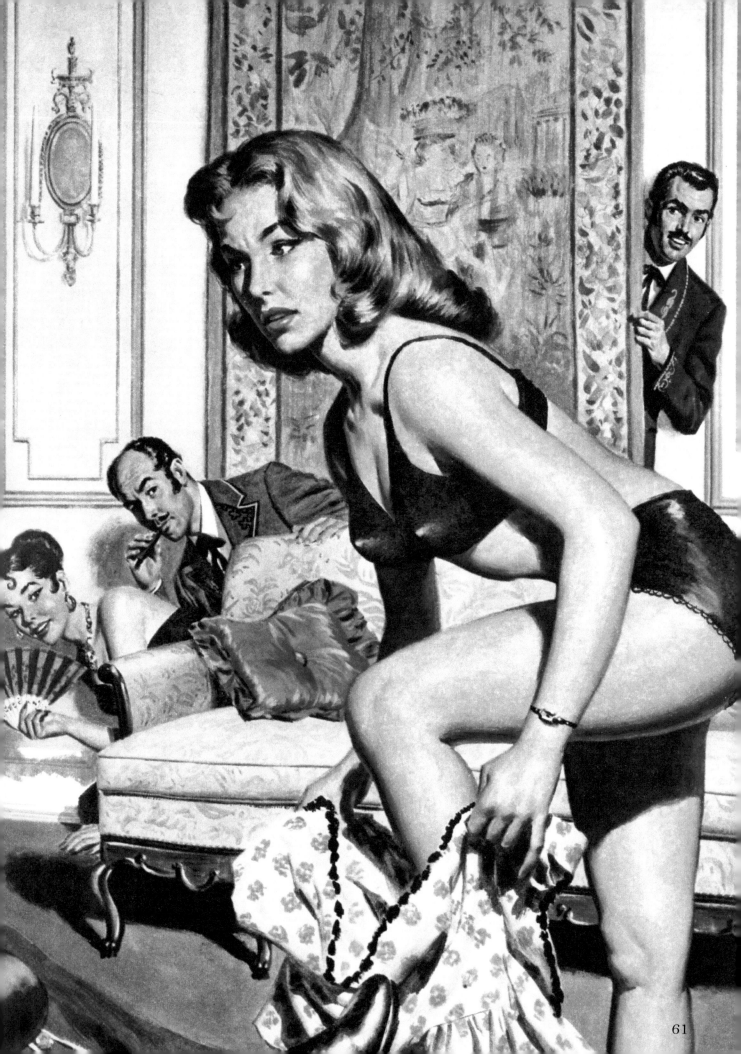

61

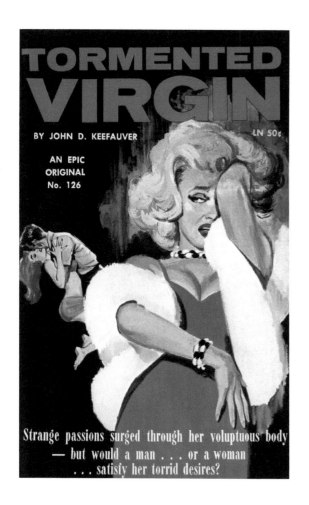

I love what Mike Ludlow did, but I didn't actually see it until my uncle found it and showed it to me. I never knew when or where something I did would be published. At the time, I never thought about it. If my Uncle Leo hadn't kept a scrapbook, I would not have anything at all of my print modeling days. He was very proud of me when I started modeling and landing TV shows, and he added to the scrapbook whenever he found something about me. (I didn't know about this until much later.) So for many of my appearances, I only have those pages, and not the entire magazine they were in.

The X-rated paperback *Tormented Virgin* (1962) *(left)* was sort of a fake/copy of the Mike Ludlow illustration I discovered recently. Not a very good copy, but I found it amusing.

Bring Back the Bride

By HANNIBAL COONS

The Problem:
To find a
honeymooning
actress who
didn't want
to be found.

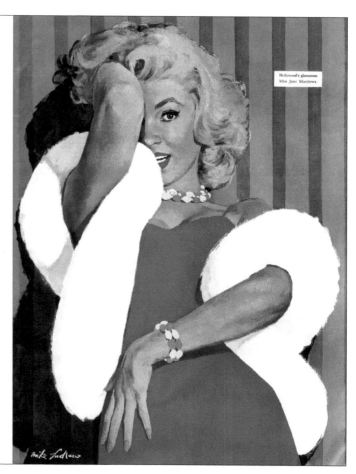

THE SATURDAY EVENING POST, September 1957; art by Mike Ludlow

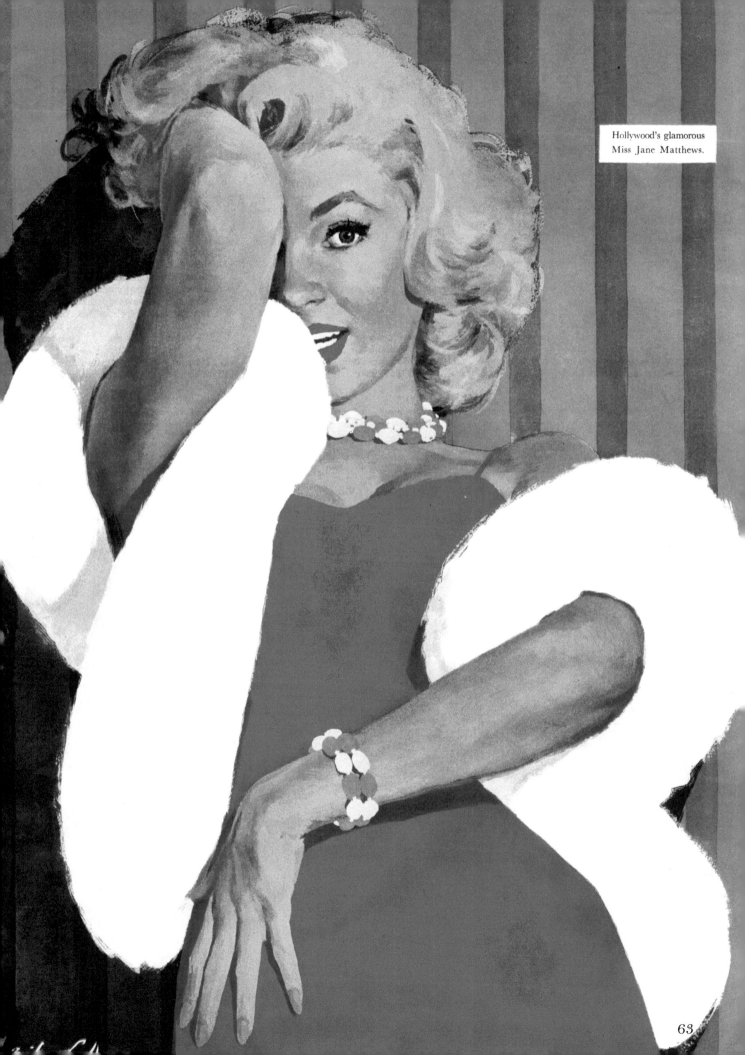

Hollywood's glamorous
Miss Jane Matthews.

63

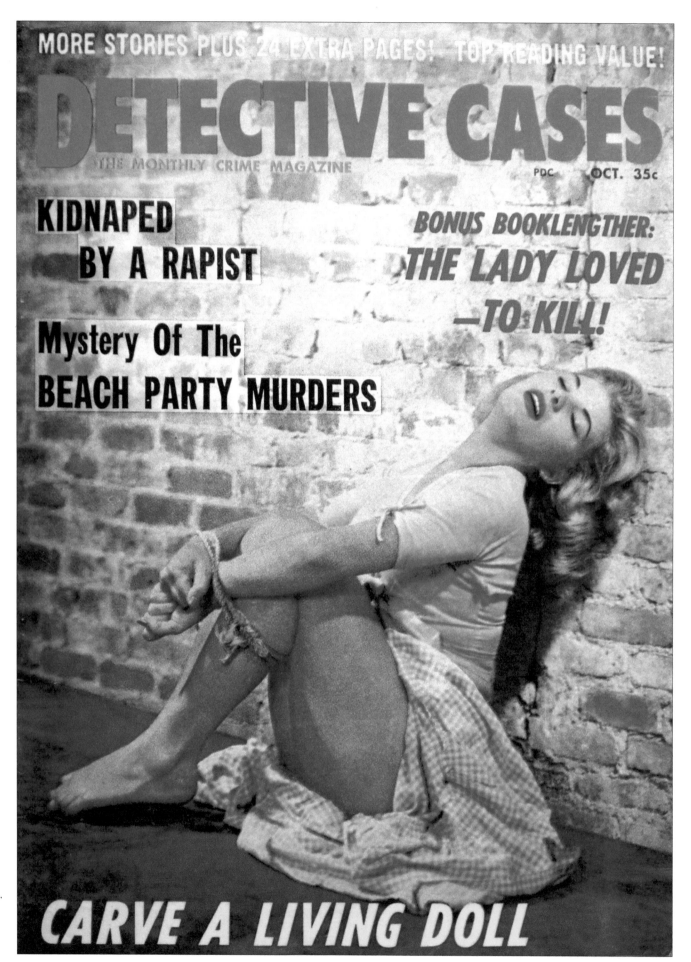

MORE STORIES PLUS 24 EXTRA PAGES! — TOP READING VALUE!

DETECTIVE CASES
THE MONTHLY CRIME MAGAZINE

PDC OCT. 35c

KIDNAPED BY A RAPIST

BONUS BOOKLENGTHER:
THE LADY LOVED
—TO KILL!

Mystery Of The BEACH PARTY MURDERS

CARVE A LIVING DOLL

DETECTIVE CASES, October 1957; photo by Charles Kell *Opposite:* POLICE GAZETTE, October 1957

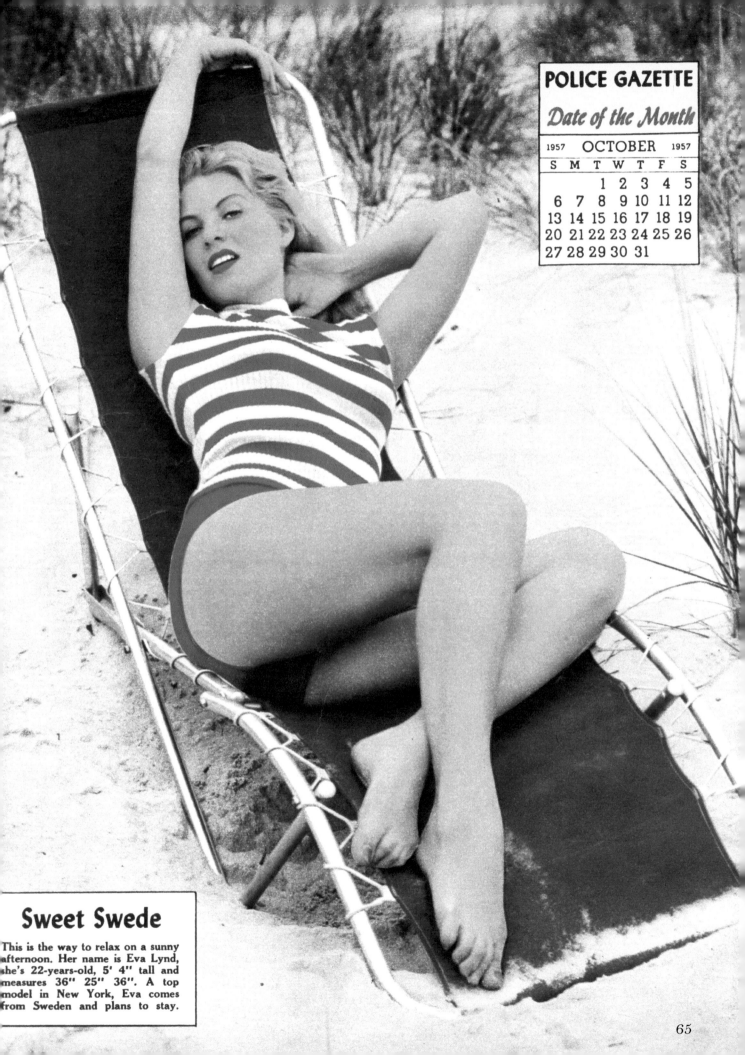

POLICE GAZETTE

Date of the Month

		OCTOBER				
1957						1957
S	M	T	W	T	F	S
		1	2	3	4	5
6	7	8	9	10	11	12
13	14	15	16	17	18	19
20	21	22	23	24	25	26
27	28	29	30	31		

Sweet Swede

This is the way to relax on a sunny afternoon. Her name is Eva Lynd, she's 22-years-old, 5' 4" tall and measures 36" 25" 36". A top model in New York, Eva comes from Sweden and plans to stay.

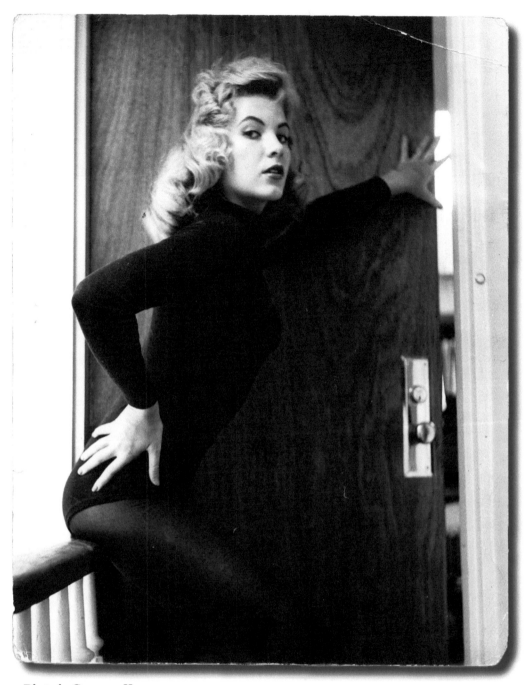

Photo by CHARLES KELL

When a photographer says "make love to the camera," you have to imagine that the camera is the love of your life, and that he is right there, waiting for you. Just as in acting, you are making up a scenario in your own head that will find its way into what you're doing—if you allow it to happen.

re was all the goodness,
tness, and warmth
ver looked for.
I lost her by turning
cheap, hard tramp

Periodicals in the related genres of *romance magazines* and *true confessions magazines* were very popular with women readers in the 1950s and 1960s. Like MAMs, many stories were portrayed as true, though the majority were fiction, by professional writers. Some of the pseudonymous authors also wrote stories for men's mags, including MAMs.

Unlike MAMs, romance and true confession mags tended to prefer photographs rather than artwork for their covers and interior illustrations. (Again, many MAM action and adventure stories could not easily be depicted with existing or staged photos.) Photos for those mags provided work for professional photographers able to shoot scenes that fit the stories, and work for models like Eva Lynd, who could act them out.

Forbidden Kisses

HIT AND RUN –
Was This My Lover's Crime?

I didn't want to believe it. My fiance couldn't have done this . . . the man I loved couldn't be the man the whole town hated!

"This story in the paper . . . it's not about you, is it?" I cried. But he didn't have to answer—I knew!

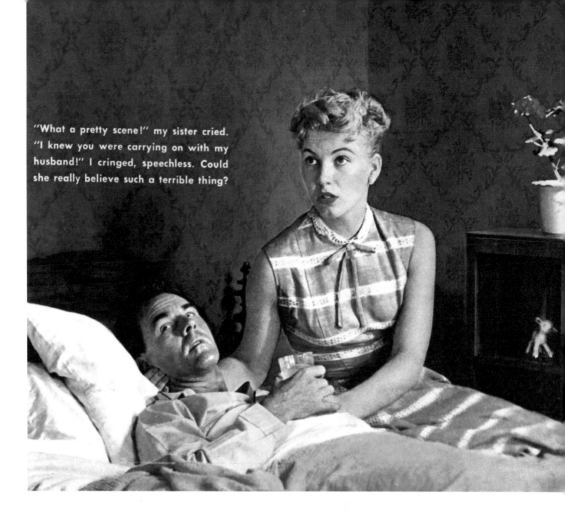

"What a pretty scene!" my sister cried. "I knew you were carrying on with my husband!" I cringed, speechless. Could she really believe such a terrible thing?

These magazines are impossible to find…I have tried. There are more with me out there; I did a lot of those in the '50s *and* '60s. These jobs may have come through an agent, but if someone liked me, they would use me again. It was a fun type of shoot to do, and as with the illustrators, easy to think myself into the situation. These were done with care, and they look good.

The image of me and another model in front of a fireplace while a man points a rifle at us, I remember vividly. The photographer was precise about how we were going to react and what the story was, so he must have had the commission to do this one. (Sometimes, photographers would shoot something *hoping* to sell it, and sometimes they already had the job.)

These were done in the photographer's studios. I would be introduced to the model, and we were told what the photographer wanted us to do. Frequently, lie down and have the other model kiss me on the cheek…with me looking like this was the best thing ever and I could hardly wait to see what would come next. We would hold the pose, and then change it a little. The photographer would shoot slightly different angles, and then we were done.

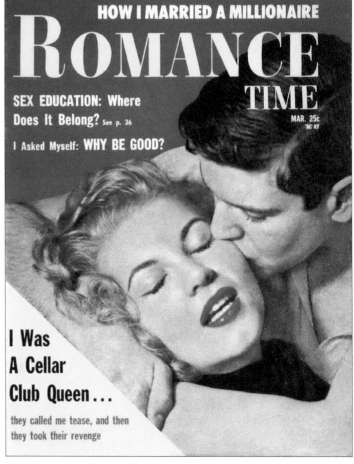

HOW I MARRIED A MILLIONAIRE

ROMANCE TIME

MAR. 25¢

SEX EDUCATION: Where Does It Belong? See p. 36

I Asked Myself: WHY BE GOOD?

I Was A Cellar Club Queen…

they called me tease, and then they took their revenge

ROMANCE TIME, March 1957

"Spend this weekend with me"

How else could I get him— he was married!

As the party got wilder and wilder, Leo had eyes only for me. I glanced triumphantly at his mousy little wife. He'd forgotten that she even existed!

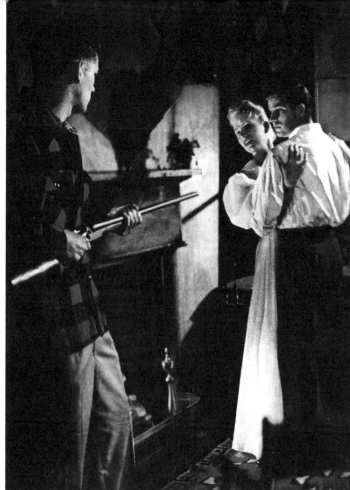

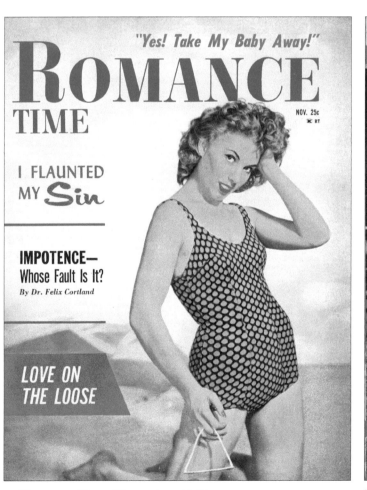

ROMANCE TIME, November 1957

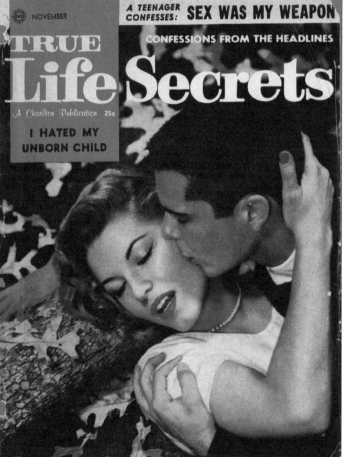

TRUE LIFE SECRETS, November 1957

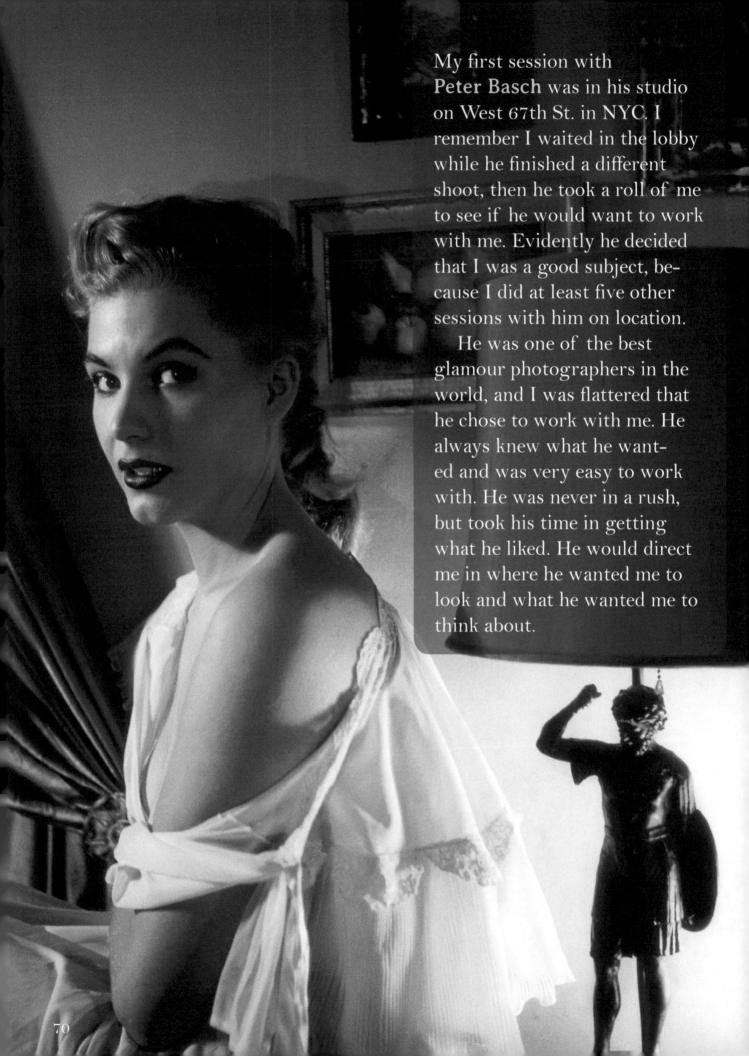

My first session with **Peter Basch** was in his studio on West 67th St. in NYC. I remember I waited in the lobby while he finished a different shoot, then he took a roll of me to see if he would want to work with me. Evidently he decided that I was a good subject, because I did at least five other sessions with him on location.

He was one of the best glamour photographers in the world, and I was flattered that he chose to work with me. He always knew what he wanted and was very easy to work with. He was never in a rush, but took his time in getting what he liked. He would direct me in where he wanted me to look and what he wanted me to think about.

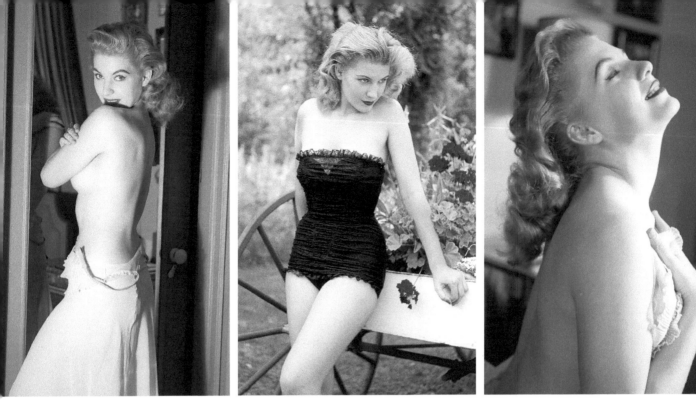

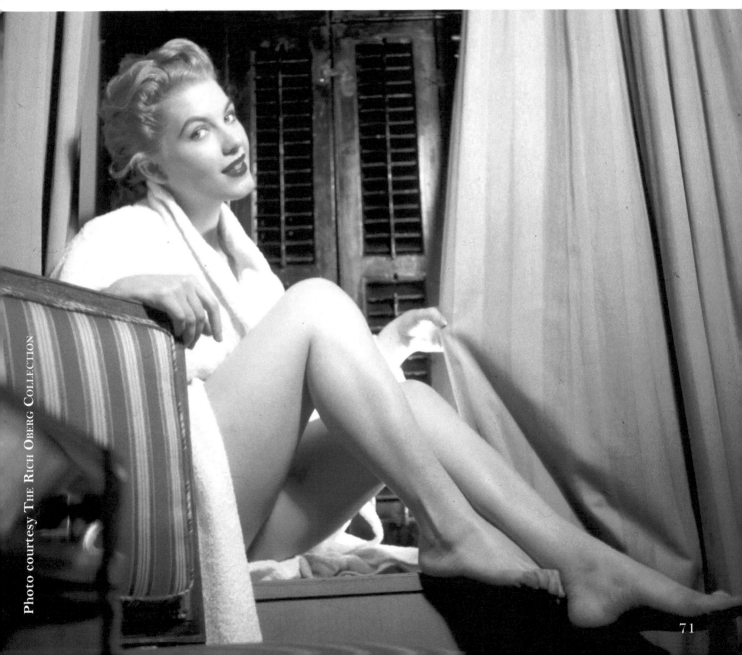

71

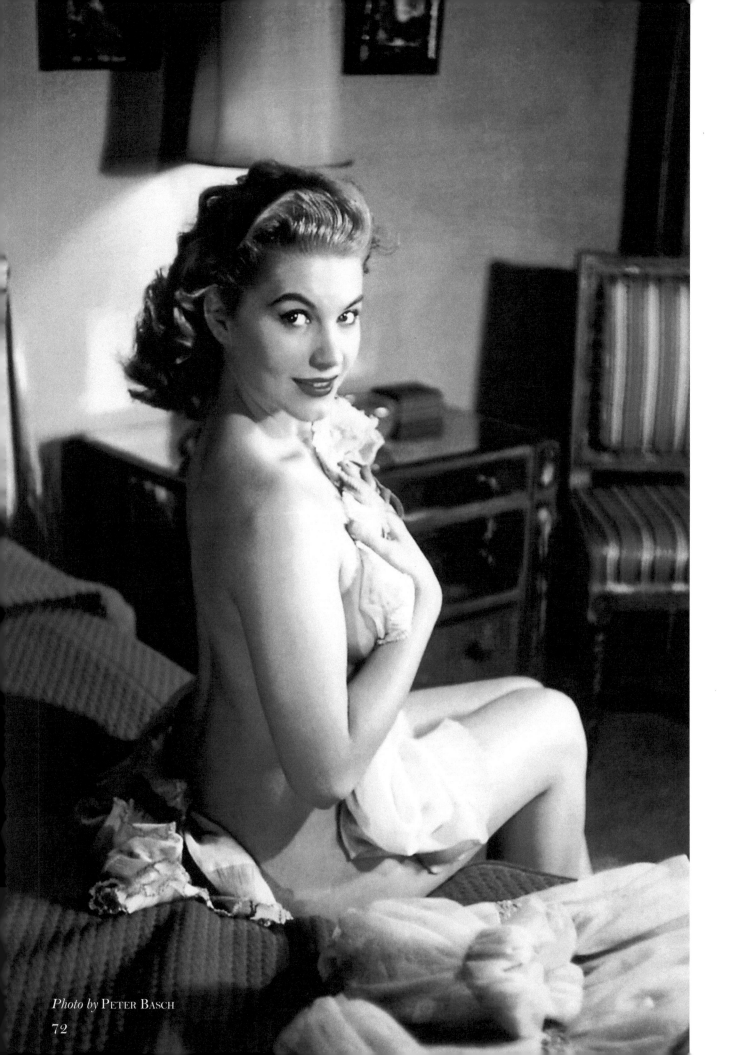

72

Artist Al Rossi was fun to work with; he shot us at a studio near where he lived. Working for Al was rather easy, since the stories he illustrated usually didn't need drastic expression—just a bit of fear, annoyance, flirtation, etc.

In Belle's satin-lined parlor no rough stuff was allowed, but upstairs anything went—for cash.

by Bob Duncan
ILLUSTRATED BY AL ROSSI

BELLE HEMLEY was not easily shocked, but on that summer night in 1926 when she stepped off the bus in Cromwell, Oklahoma, she felt as if she had suddenly arrived in hell. The gaudy wooden saloon fronts and the corrugated-iron dance halls shimmered in the light of flickering gas torches. The streets were swarming with men, fresh from the noon-to-eight shift in the oil fields.

The first of the nightly fights had begun in front of Ma and Pa Murphy's Dance Hall, (Continued on page 70)

Flames swept through the house so fast the girls had to run out just as they were—raw.

BOOM-TOWN MADAM

STAG, November 1957; art by Al Rossi *(Eva is the model for the two women on the left, possibly for all four women.)*

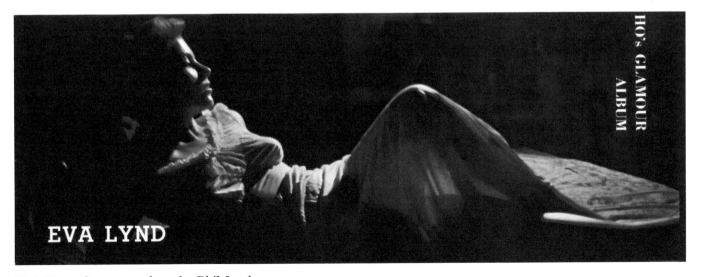

HO's GLAMOUR ALBUM

EVA LYND

Ho!, November 1957; photo by Phil Jacobson

WITH an untrained model, a photographer's shooting session can sometimes be a nightmare. But when you're working with someone like Eva Lynd, well, the camera practically takes the pictures by itself. Oh, there are other things to worry about—such as shooting script, lights, poses, angles and backdrops, but with Eva all these technicalities just seem to work out themselves.

Born 19 years ago in Sweden, Eva came to this country just about two years ago and promptly started on her way to becoming a top New York model. And no wonder. Eva stands a well-proportioned 5′6″, and this quiet, hazel-eyed beauty measures out to an eye-catching 36-25-36.

Although she enjoys modeling, Eva has other interests and presently she is taking dramatic lessons. Eventually she hopes to get into television and the movies As for getting away from the work routine, this Swedish lass enjoys the outdoors, particularly sports like skiing and ice skating.

There is no *one* man in Eva's life at the moment although, she admits, if the right guy comes along, she's going to set the trap for him. What's he got to be like? "Well," says Eva, "he's got to enjoy the same things I do—easy living. Do you know anyone?"

SHOOTING EVA

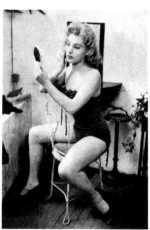

WITH an untrained model, a photographer's shooting session can sometimes be a nightmare. But when you're working with someone like Eva Lynd, well, the camera practically takes the pictures by itself. Oh, there are other things to worry about—such as shooting script, lights, poses, angles and backdrops, but with Eva all these technicalities just seem to work out themselves.

Born 19 years ago in Sweden, Eva came to this country just about two years ago and promptly started on her way to becoming a top New York model. And no wonder. Eva stands a well-proportioned 5′6″, and this quiet, hazel-eyed beauty measures out to an eye-catching 36-25-36.
MORE

Above, left: Eva talks over assignment with editor. Retiring to dressing room (above), she gets ready for shooting session.

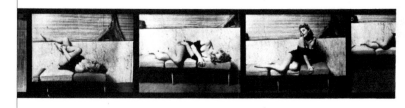

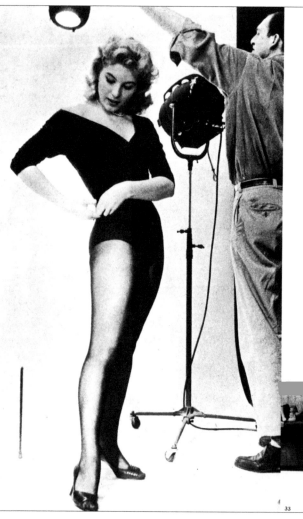

33

MAN'S CONQUEST, January 1958; photos by Herb Flatow

74

What can I say about modeling?

The main thing is that it is a lot of fun. I have worked at a lot of regular jobs that I had to remind myself were necessary at the time, but not exactly what I had in mind for my career. So when I started to get frequent work as a model, I simply enjoyed the experience—and the fact someone thought I was worth photographing.

Since I was paid $25 an hour, every illustrator tried to get as much into that hour as possible, so not to have to pay for another hour. When I worked for photographers who were not illustrators, the fee was the same, but if they wanted to go on location, they would usually try to make a deal for a lump sum, so not have to worry about the time it might take.

Another difference working with photographers for the pin-up pictures and others of that kind was that the pin-up guys would usually give me copies of the photos

they shot…which is why I have so many of those. Sometimes I would even pose for someone in exchange for 11"x14" photos, which is what we carried in our photo briefcases to show what we looked like in print.

It was great living in NYC at that time, and I walked everywhere…most things were within walking distance. I'd have a fistful of dimes with me every time I went into the city, so I would be able to check in with my phone service about any *go-sees* (modeling job interviews), because of course we didn't have cell phones.

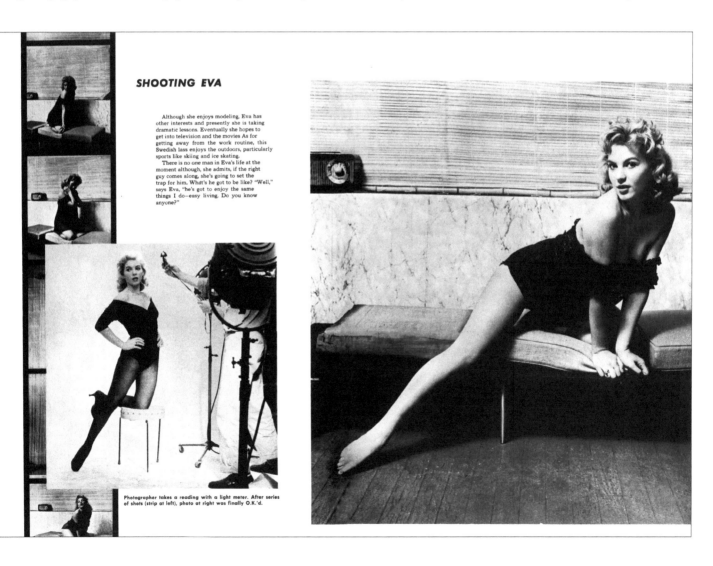

SHOOTING EVA

Although she enjoys modeling, Eva has other interests and presently she is taking dramatic lessons. Eventually she hopes to get into television and the movies As for getting away from the work routine, this Swedish lass enjoys the outdoors, particularly sports like skiing and ice skating.

There is no *one* man in Eva's life at the moment although, she admits, if the right guy comes along, she's going to set the trap for him. What's he got to be like? "Well," says Eva, "he's got to enjoy the same things I do—easy living. Do you know anyone?"

Photographer takes a reading with a light meter. After series of shots (strip at left), photo at right was finally O.K.'d.

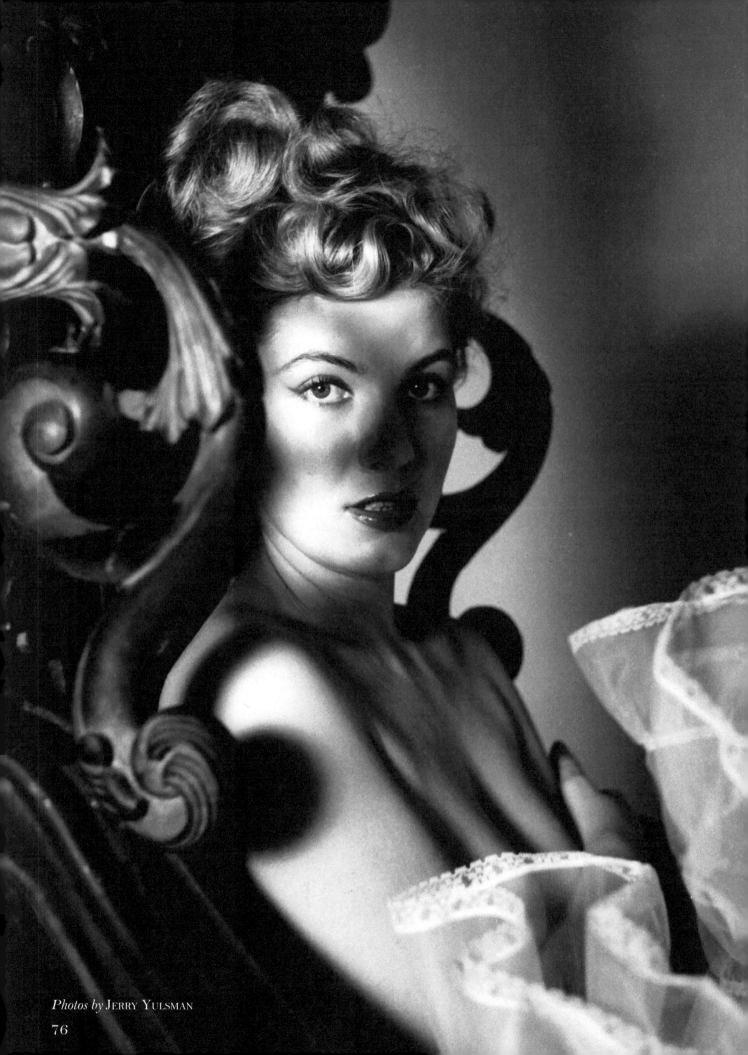

76

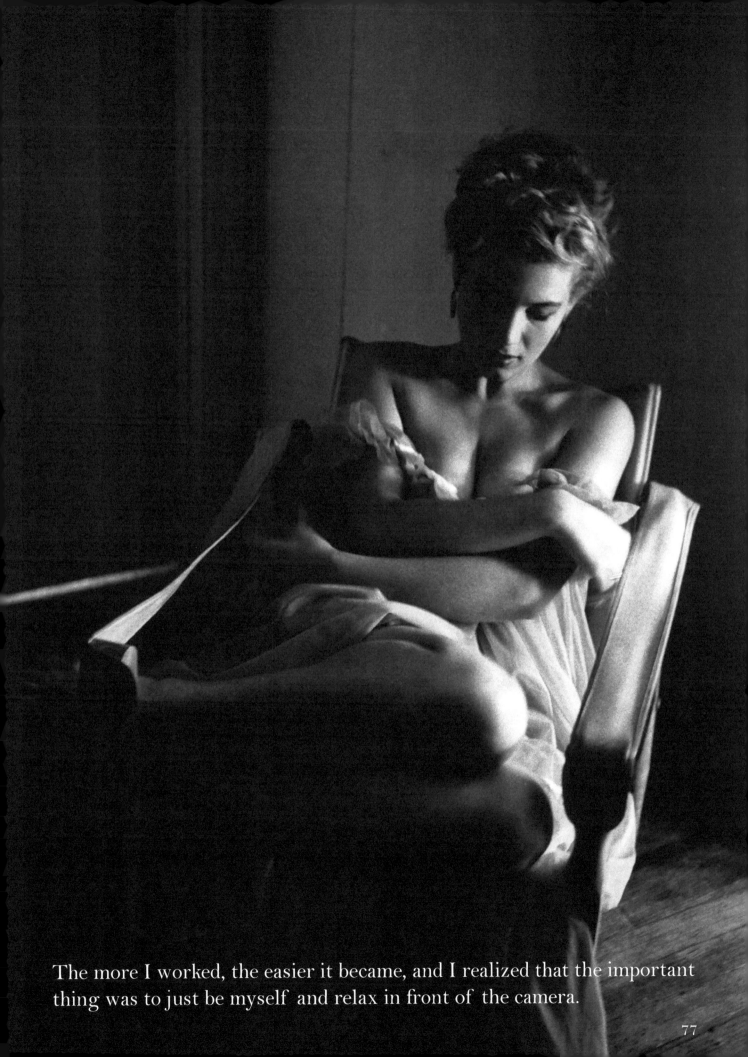

The more I worked, the easier it became, and I realized that the important thing was to just be myself and relax in front of the camera.

I especially liked shooting outdoors, where I might have a chance to climb a tree or two. Whenever I was asked to do a shoot in any area with trees, I was thrilled to be able to get into one. The photographers didn't seem to mind at all. So there are a lot of photos of me in trees!

Most men's magazines published in the 1950s and 1960s were either *standard size* (8" to 8.5" wide by 11" high), *digest size* (5 3/8" or 5.5" by 7.5" to 8 3/8") or *pocket size* (4" to 4.25" by 5.75").

In 1957, publisher Aaron A. Wyn launched two odd-sized magazines, *High* and *Ho!* Both were 4.25" by 11"—an unusual dimension apparently designed to make them stand out and get more attention on newsstands.

In addition to publishing magazines and comics, Wyn founded Ace paperbacks. One of his most creative ideas was the iconic Ace Doubles format.

His long, tall men's magazines turned out to be a less successful idea. *High* lasted for six issues in the odd format, then changed to standard format and lasted for another eight. *Ho!* only lasted for three issues. But two feature photos of Eva Lynd—another reason why they are highly collectible.

Ho!, January 1958; photos by Ed Lettau

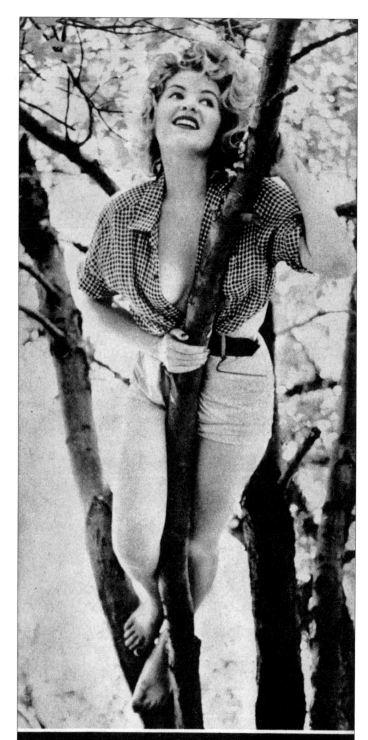

EVA LYND

WHEN P. T. Barnum brought the talented Scandinavian beauty, Jenny Lind to this country, all America hailed her. Now we bring you another Scandinavian lovely with a similar sounding name, although it is spelled differently. We give you Eva Lynd—and we know that all America will hail her, too.

37

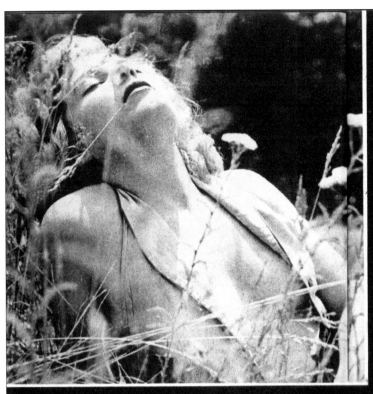

LIKE her predecessor, Jenny Lind, Eva is also talented as well as beautiful. She spends a great deal of time studying art—and she's really good at it. As a matter of fact, when she gives up modeling, she plans to make art her career. Lessons are expensive, and a good part of the fees she receives for posing go toward payment for this instruction—but Eva thinks it's worth it.

ONE item she saves on, however, is model fees. Eva never uses them. She doesn't have to—she just sits in front of a mirror and paints her own image. If she ever decides to sell these pictures of herself, she'll make a fortune. We know—because we've seen them.

AT the moment, Eva is only interested in modeling, but if reports we've been getting from Hollywood are right, all of us will soon be seeing her on the screen—and that's a sight not to be missed.

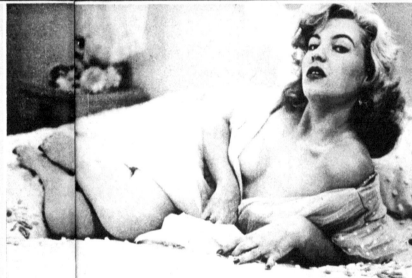

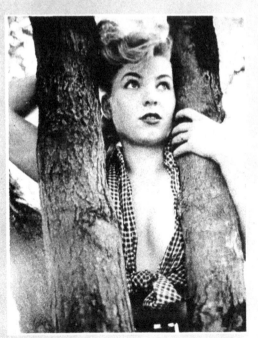

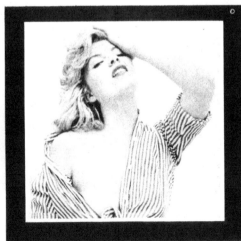

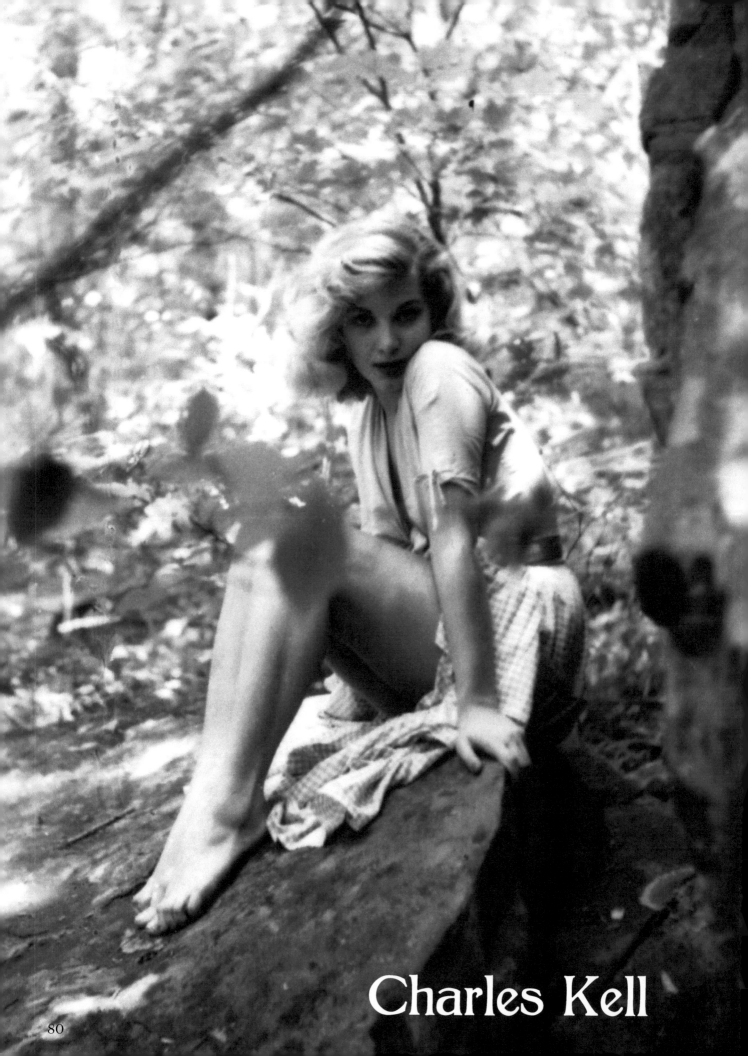

Charles Kell

When I lived with my maternal grandparents in Sweden, there were a lot of trees in our garden, and all around the property. Lots of fruit trees and other trees. I had a favorite linden tree which was situated on one side of the gate. I used to climb up there and sit whenever I was sad about something. I talked to the tree, and that always seemed to help.

I also had the idea that I was the spirit of one of the wisteria bushes in the garden. When it bloomed, showing its long strands of yellow flowers, it was spectacular; like gold rain.

In the summertime, when it stayed light outside for a very long time, I would sometimes sneak out into the garden at night and dance around the trees and bushes....

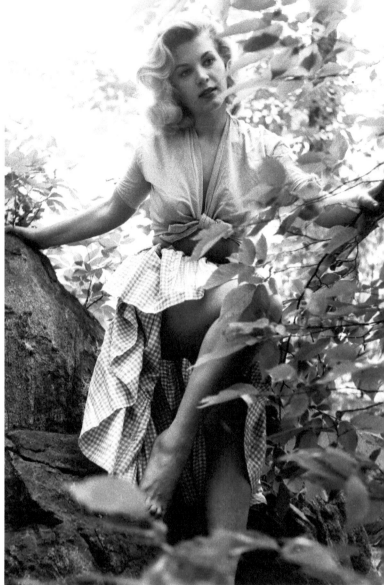

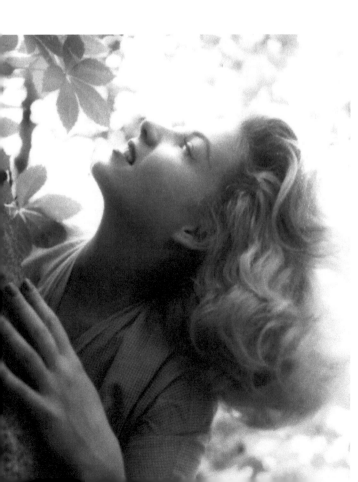

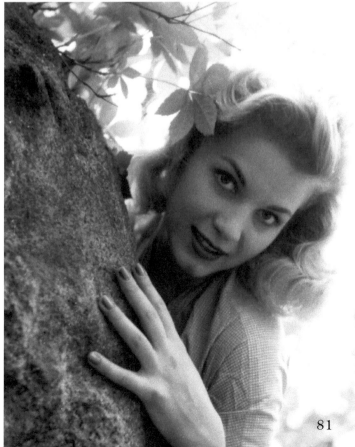

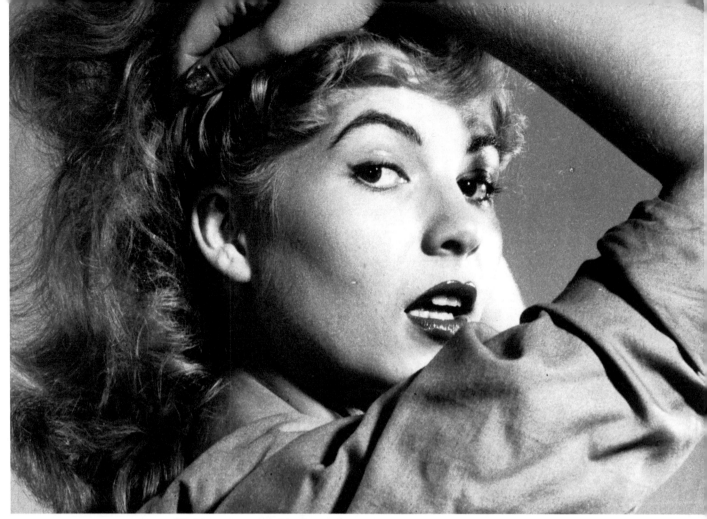

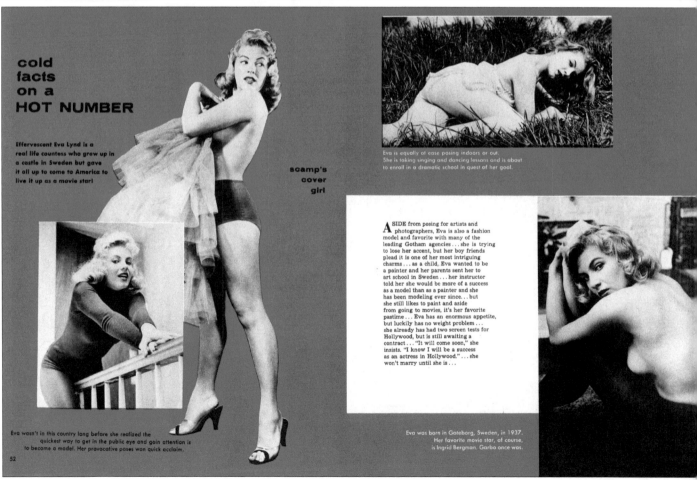

cold facts on a HOT NUMBER

Effervescent Eva Lynd is a real life countess who grew up in a castle in Sweden but gave it all up to come to America to live it up as a movie star!

scamp's cover girl

Eva is equally at ease posing indoors or out. She is taking singing and dancing lessons and is about to enroll in a dramatic school in quest of her goal.

ASIDE from posing for artists and photographers, Eva is also a fashion model and favorite with many of the leading Gotham agencies . . . she is trying to lose her accent, but her boy friends plead it is one of her most intriguing charms . . . as a child, Eva wanted to be a painter and her parents sent her to art school in Sweden . . . her instructor told her she would be more of a success as a model than as a painter and she has been modeling ever since . . . but she still likes to paint and aside from going to movies, it's her favorite pastime . . . Eva has an enormous appetite, but luckily has no weight problem . . . she already has had two screen tests for Hollywood, but is still awaiting a contract . . . "It will come soon," she insists. "I know I will be a success as an actress in Hollywood." . . . she won't marry until she is . . .

Eva wasn't in this country long before she realized the quickest way to get in the public eye and gain attention is to become a model. Her provocative poses won quick acclaim.

52

Eva was born in Goteborg, Sweden, in 1937. Her favorite movie star, of course, is Ingrid Bergman. Garbo once was.

SCAMP, March 1958; photos by Charles Kell

Top and opposite: CHARLES KELL proofsheet

82

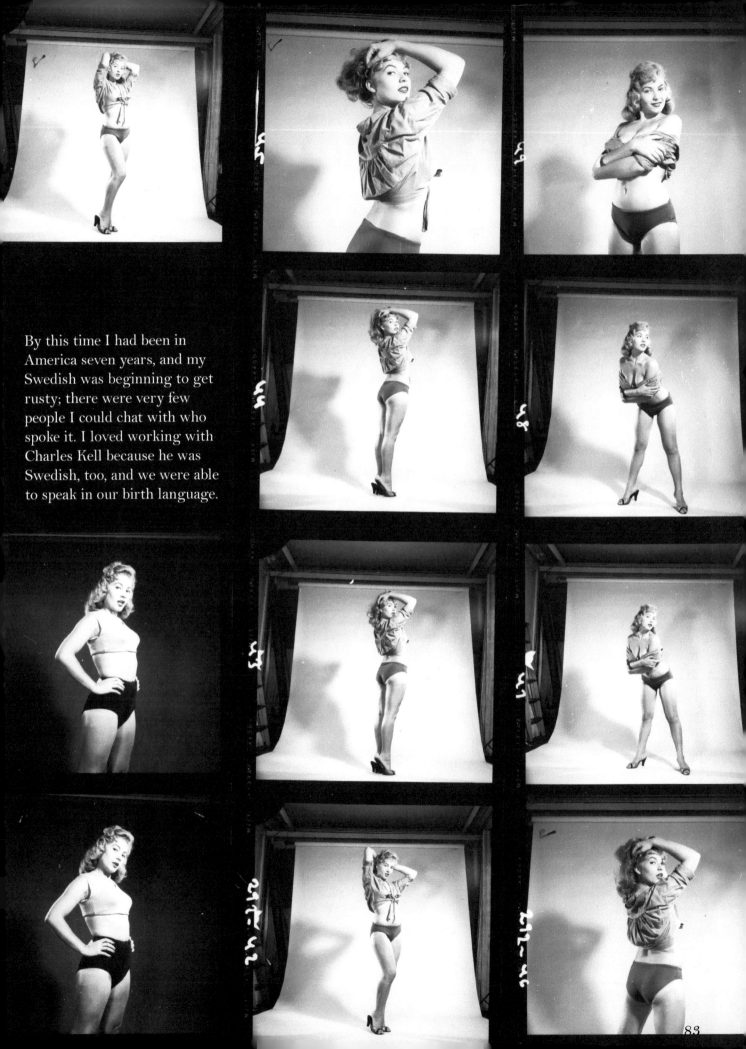

By this time I had been in America seven years, and my Swedish was beginning to get rusty; there were very few people I could chat with who spoke it. I loved working with Charles Kell because he was Swedish, too, and we were able to speak in our birth language.

New York's FIVE DAYS of TERROR

Like a crazed monster suddenly let loose, the mob stormed through the streets in the wildest orgy of looting, drinking, killing and raping that any city has ever seen.

by IRVING WERSTEIN

"THERE she is, the dirty slut!"
The screaming crowd rushed at the woman who was trying to slip unnoticed from the house with her small brown-skinned son. They knocked her down and trampled her until she was unconscious. Her son cowered on the stoop screaming in terror.
A snaggle-toothed harridan, who had been beating the mother with a

PLEASE TURN PAGE

STAG *True Book* BONUS

STAG, March 1958; art by Al Rossi *(Eva is the model for both women.)*

It is amazing how people lie about what they put in print. Despite the claims in the text of this pictorial, the driftwood was something Herb had in his apartment. (I have never been to the Florida Keys; I wish I had!) One should never believe everything that is written, because some of it may be just a whim of the writer.

About the only thing most people have to show for a summer in the sun is a sun burn or a handful of sea shells. Not our girl Eva Lynd, though. She spent the summer in the Florida Keys and came home with a souvenir handsome enough to use in her apartment. Her prize from a season on the beach: a huge piece of unusual driftwood. Eva set to work polishing it and cutting, with the result that her summer souvenir now decorates a living room table. Besides bringing back many delightful memories of her summer sea-side vacation, the driftwood also serves another purpose: it's a great conversation piece. But with Eva around, no excuse is needed to get the conversational ball rolling. This beautiful strawberry blonde does alright all by herself. She need only smile to make any helpless guy relax.

CAPER, January 1959; photos by Herb Flatow

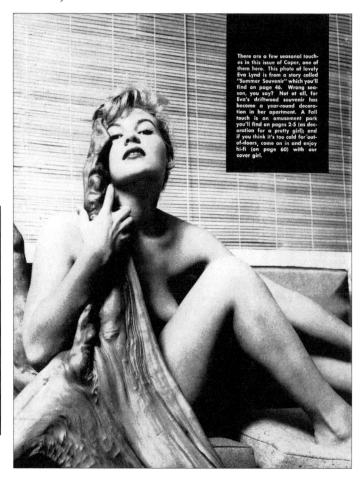

There are a few seasonal touches in this issue of Caper, one of them here. This photo of lovely Eva Lynd is from a story called "Summer Souvenir" which you'll find on page 46. Wrong season, you say? Not at all, for Eva's driftwood souvenir has become a year-round decoration in her apartment. A Fall touch is an amusement park you'll find on pages 2-5 (as decoration for a pretty girl); and if you think it's too cold for out-of-doors, come on in and enjoy hi-fi (on page 60) with our cover girl.

84

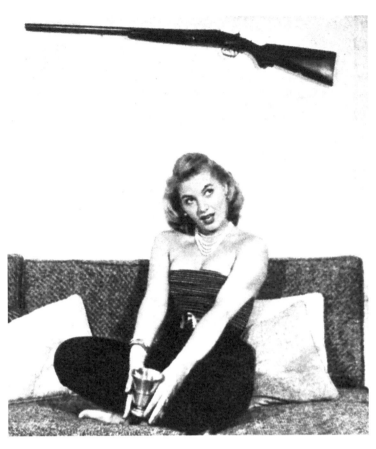

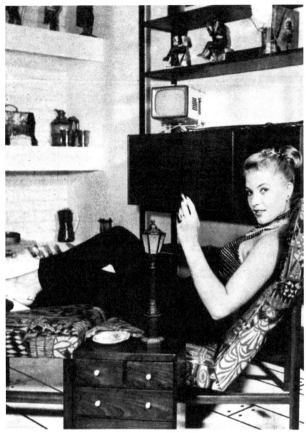

*A Hi-Fi set and port-
able television
help to set up moods.*

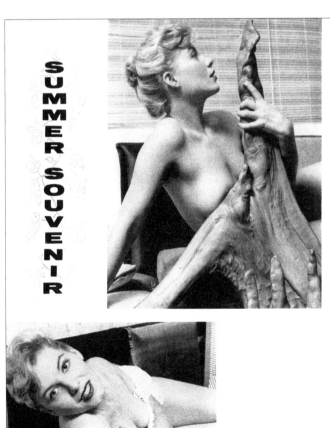

SUMMER SOUVENIR

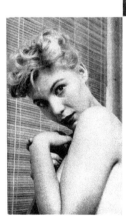

About the only thing most people have to show for a summer in the sun is a sun burn or a handful of sea shells. Not our girl Eva Lynd, though. She spent the summer in the Florida Keys and came home with a souvenir handsome enough to use in her apartment. Her prize from a season on the beach: a huge piece of unusual driftwood. Eva set to work polishing it and cutting, with the result that her summer souvenir now decorates a living room table. Besides bringing back many delightful memories of her summer sea-side vacation, the driftwood also serves another purpose: it's a great conversation piece. But with Eva around, no excuse is needed to get the conversational ball rolling. This beautiful strawberry blonde does alright all by herself. She need only smile to make any helpless guy relax.

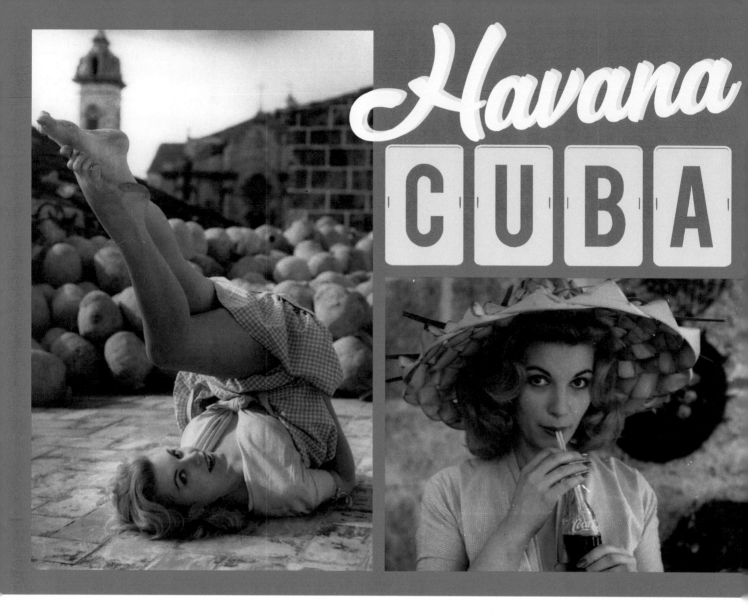

Havana CUBA

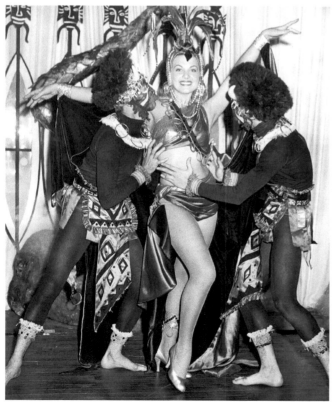

There were six of us from the US who went to Havana as showgirls. My roommate landed the job first, and I thought, *"That would be fun."* So I went in, and I was hired, too.

We were in the newest hotel, the Riviera, right on the Malecón (Havana's harbor front and promenade). Very fancy. We did at least two shows a night for two months. And we had fun.

I didn't speak Spanish; we didn't need to. The person who put the shows together spoke English, so we knew what to do. It was basically showgirl semi-dancing; dance *moves*, but not dancing. We were more or less walking through and swaying and moving… that sort of thing. Nothing really difficult. I only had two costumes. Judging by today's standards, they were rather modest, I think. Just a bit of glamour, I guess.

We were there in March and April, only months before Castro came in. It was marvelous, absolutely marvelous. It was fun. It was warm. Everybody was happy, having a good time. It was people and music and performing and being happy. It was a playground, really. People playing music in the streets….

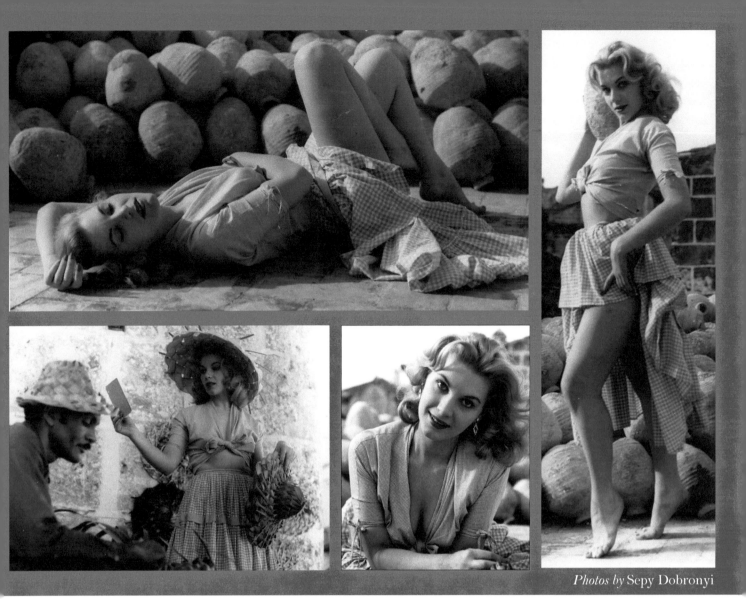

Photos by Sepy Dobronyi

There was one group who happened to be working in the hotel and they played "La Barca" for me every time I came into the casino, because they knew I loved that song. (I think the lead singer had a crush on me.)

Photographer Sepy Dobronyi was a Baron something-something, and very famous. I only realized *how* famous after the fact—after Cuba—when I looked him up. He famously created a gold statue of a nude Anita Ekberg—which was semi-scandalous at the time. And he wanted to do one of me, too; but I said no, I don't think so! In a way, I'm sorry, because that would be fun to have now. In Havana, he took me on rooftops and places and photographed me.

The Riviera's owners asked us to spend some time in the casino. I think because they wanted to show us off, so people would come and see the shows. We'd be gambling a bit here and there…only blackjack, because I loved playing blackjack. I would sit and play for a few hours after one of the shows. But I never lost any money, which was nice. So I made $30–$40 a night at the table! I was a pretty girl playing, so men would come and sit and play.

I was told that they wanted me to pose for a magazine photo, maybe because I was the only blonde of the showgirls. I wasn't sure it was *Life* magazine; I found that out later. I don't think I saw it at the time. Magazines I appeared in never sent me copies of anything. My Uncle Leo, who made the scrapbook for me, *he's* the one who found my picture in *Life* magazine—and a lot of the other stuff,which I never would have had if not for him. The first time I saw myself in *Life*, I saw it in the scrapbook, later.

The thing is, I never saw *any* of the magazines I was in, or the covers, or anything like that. It was just a job that I was doing. Of course, now I think, *"I was in* Life *magazine!"* But at the time, I didn't realize the importance of that.

There was a lot in the magazine about the life and times of Havana. I never knew the underbelly of the city at that time…only the fun.

I had a contract for two months and I knew I'd be in New York after that. But while I was there, it was absolutely fabulous. One of the times in my life that I

87

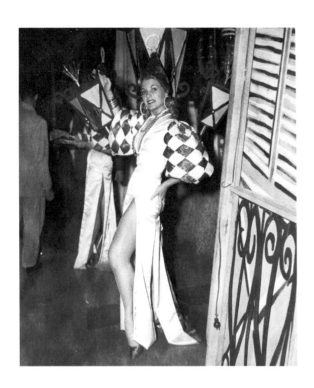

remember with great fondness.

I was not political, I didn't really know what was going on, except what I heard. And then there was an undertone of uncertainty; everybody was getting frightened that something was going to happen. I dated a guy when I was there who was part of the Batista regime. I remember we were in a limousine, and as I looked around, I realized there were guns on the floor, rifles. There was a security detail following us, surrounding us wherever we went. It was a strange feeling.

They did ask all Americans to leave the country because they knew Castro was coming; which, of course, he did. He arrived in January of 1959 and everything changed…. When I saw in the news there were chickens in the hotel where I had performed, it was a bit of a horrifying thought. *What has he done? What is he going to do?* Chickens, running around in the hotels! It was very sad.

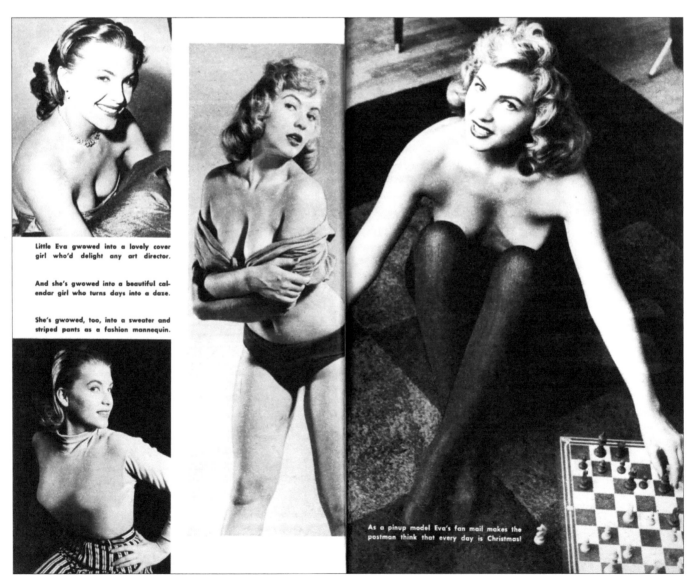

Little Eva gwowed into a lovely cover girl who'd delight any art director.

And she's gwowed into a beautiful calendar girl who turns days into a daze.

She's gwowed, too, into a sweater and striped pants as a fashion mannequin.

As a pinup model Eva's fan mail makes the postman think that every day is Christmas!

Vue, July 1958; photos by Charles Kell

88

Somebody recently asked me, "Now that you can go to Cuba, do you want to go back to Havana and see what it's like now?"

I said, "Absolutely not!" That's one memory I'd like to keep intact. You go there now, and…well, I don't know what's happening now. Nor do I want to know, really. But my time there in 1958 is one of my happiest memories.

Following my showgirl stint in Cuba, I was back in NYC, where I met the personal manager of several stars. He invited me to various happenings from time to time.

Peter Lawford was throwing a party to which I was invited. It was the usual crowded, smoky party that was common at that time, taking place in the hotel suite where Peter was staying—a tall, beautiful building with a balcony overlooking Central Park.

When I had been there for a while, I noticed that

Peter was sitting on a chair, trying to throw bottle caps into a wastebasket across the room. He consistently missed. I sat down in a chair next to him and asked if I could try it.

"Sure," he said. "Have a go."

I picked up a bottle cap and threw it into the waste-basket.

Amazed, Peter said, "I bet you a hundred dollars that you can't do that again."

Without thinking, I picked up another bottle cap, and again threw it neatly into the wastebasket.

Shaking his head, Peter gave me the hundred dollars. That was a surprise, because in my mind that is just something you say as a challenge, without actually meaning it. (Later on, it also occurred to me that he could have asked *me* for the hundred, had I missed…! Luckily, that didn't happen.)

I was doing some extra work on a new Cary Grant movie that was filming in NYC, *North by Northwest.*

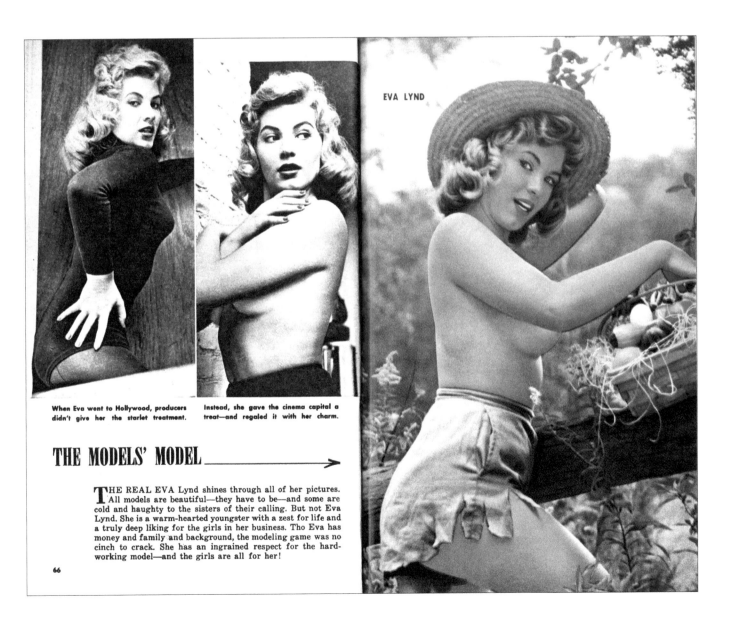

EVA LYND

When Eva went to Hollywood, producers didn't give her the starlet treatment.

Instead, she gave the cinema capital a treat—and regaled it with her charm.

THE MODELS' MODEL ⟶

THE REAL EVA Lynd shines through all of her pictures. All models are beautiful—they have to be—and some are cold and haughty to the sisters of their calling. But not Eva Lynd. She is a warm-hearted youngster with a zest for life and a truly deep liking for the girls in her business. Tho Eva has money and family and background, the modeling game was no cinch to crack. She has an ingrained respect for the hard-working model—and the girls are all for her!

66

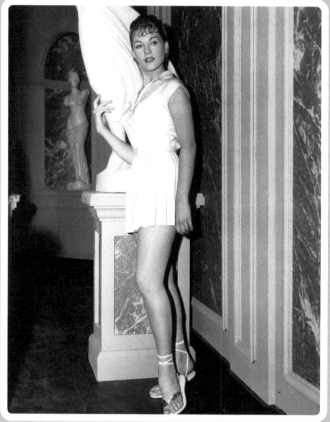

"Beauty and the Bath," *original airdate:* January 2, 1959

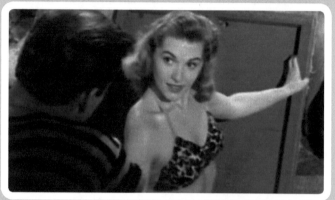

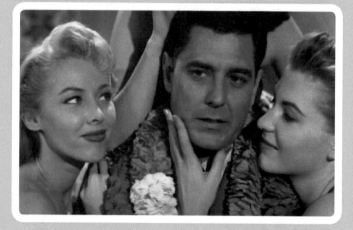

"SCUBA," *original airdate:* February 16, 1959

When Peter heard that I was going to be on the set with Cary Grant the following day, he said, "Please ask him to phone me."

The request was not exactly an easy one, since an extra on any set does not usually have immediate access to the star of that film. However, that day's scene was filmed on the street. I waited until I heard *"Cut!"* and saw Cary Grant return to his chair. I watched and waited until nobody was around him, and then I walked up to his chair and stood there until he looked up. I said nervously, "I have a message for you."

He looked at me and smiled. "How very nice

for me."

I melted! It was a lovely thing to say to someone who was not very important on that set. I have no idea what I said after that, but I hope I gave him the message.

When I went to L.A. the following year, I got a pretty good role on *The Thin Man*, which was Peter's TV series. I worked in an episode called "Beauty and the Bath." Unfortunately, this series is now very hard to see. I worked on various series like *Desilu Playhouse, Bourbon Street Beat,* and others.

On *Peter Gunn*, I made my first apperance emerg-

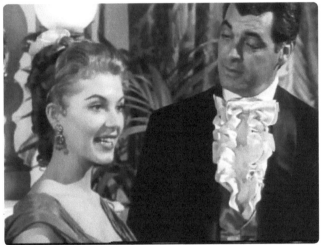

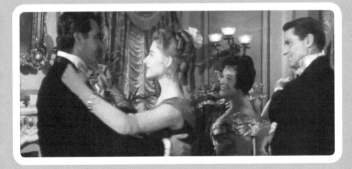

"The Governor's Lady," *original airdate:* March 14, 1960

ing from a hidden trap door in the floor. I was wearing a two-piece bathing suit which looked pretty good on me…although I didn't think so at the time. It was fun working with star Craig Stevens, but I loved working, and I don't remember any time when I *didn't* have fun.

"The Governor's Lady" episode of *The Texan* is a favorite. It was a period piece, so a lot of time was spent finding me the perfect ballgown, and long, above-the-elbow opera gloves. The hairdresser took her time putting my hair up, styling me with curls dripping down the back of my head. I also got to dance with one of the most handsome men on television, Rory Calhoun,

and I don't think I had ever felt more beautiful as he waltzed me around the room. I remember thinking that I could do this for the rest of my life…. It was a moment of total happiness.

I also appeared on *A Day in Court* and *Night Court* (the 1957 version), which were supposed to be based on real court cases. On *A Day in Court*, I was on the stand, and I had to deliver a rather long speech—which was modified just before filming. I got the script the night before, and I think that I was chosen because I had a very good memory and could memorize almost anything overnight; but it isn't easy to instantly cut out a word here and there from a script that you have spent time learning.

On *Night Court*, I was hauled into court wearing just a towel—I don't remember exactly why. But there I was, standing in front of the judge, trying to explain what I had been doing….

I always loved working on TV or in films—or onstage, for that matter. I never considered it work, but a place to enjoy life. After finishing a show, there was always the feeling of loss, and the thought that I would probably never work again…but I think that is a thought a lot of actors have. I didn't always get to see the episodes I was in until later—sometimes decades later!

Every actor at that time was signed up to do extra work, including me; I did a lot of it. It was not taboo for an actor in New York to do extra work, like it seemed to be in L.A. at the time. But we all still tried *not* to have our faces show up onscreen. Too bad, because it would be fun to be able to spot me in the various films I did. It was a lot of fun—and a way to earn extra money, since it paid a lot more than modeling.

I also did stand-in work for several films, and that meant I had a job throughout the film. Stand-in jobs were great, because you would work the whole film, have a steady job, and be on the set throughout the shoot. I learned a lot from just being there and watching what was going on.

Another perk of stand-in work was that the director would usually use me in a scene somewhere, so you can actually see me! One where you can is with Sidney Poitier in *For Love of Ivy* (1968), where I am very noticeable at a gambling table. (In fact, I recently discovered I'm pictured on the back cover of the MGM/UA DVD release of the film.)

Another was *A Face in the Crowd* (1957), starring Andy Griffith, Patricia Neal, and Walter Matthau, now considered something of a classic. I was the stand-in for Lee Remick, in her first big film. Later, director Elia Kazan picked me out to appear in a protest scene where I set fire to a garbage can.

United Press International Photo.

SAILOR'S KNOT: Starlet Eva Lynd ties her blouse as she stands on windswept deck of Staten Island ferry yesterday during filming of "That Kind of Woman."

I worked as a stand-in for Barbara Nichols in Sidney Lumet's film, *That Kind of Woman*, starring Sophia Loren (I think in her first American film). It was released in 1959, which means that I was on the set in 1958.

Mr. Lumet also gave me a bit part in it: I'm coming out of the ladies' room as the two ladies go in. Barbara turns to look at me with the kind of look that women have when evaluating another woman. It is a very quick moment. With luck, you may see me.

Tab Hunter played Sophia's love interest, but he kept pretty much to himself. I now wish that I had gone over to talk to him, but I didn't want to disturb him. However, since I worked the whole film, I got used to hanging out with the whole group. When not shooting, we would sometimes sit in the

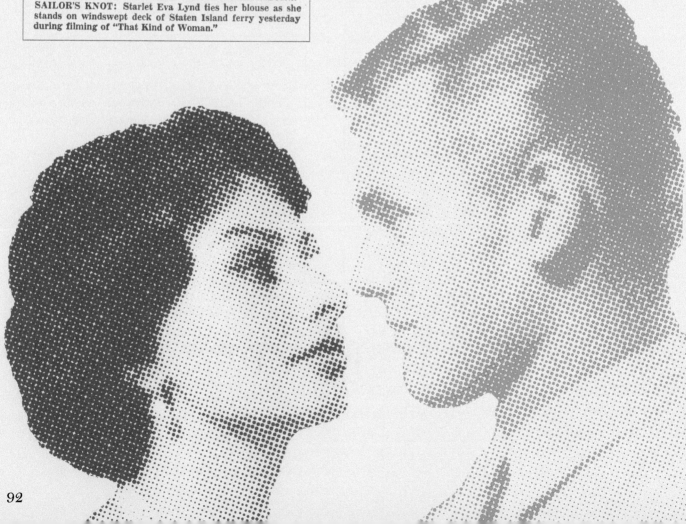

For years the French ladies-of-the-night made fools of the Gestapo by beating them at a game as old as their profession—espionage.

When the Nazis raided a house, the girls stalled them long enough for escapees to get away.

PARIS' BAWDY HOUSE SPY RING

by Roxane Pitt

Editor's Note: Roxane Pitt, one of the most resourceful British Secret Service agents in World War Two, had no espionage training. In fact, she was a scared fugitive in Paris after the blitz, hunted by the Gestapo. Her following adventures as a spy began the day she was at the end of her rope and literally rescued from the streets by a British undercover man . . .

RECOVERING my wits I was about to say something when he made a warn-
PLEASE TURN PAGE

12

Art by Al Rossi

MEN, April 1958; art by Al Rossi (*Eva is the model for all four women, Steve Holland for the officers.*)

various director's chairs provided for the actors and chat.

One day I had overslept slightly, and I was in a rush not to be late. I managed to catch a ride to the location on one of the city's garbage trucks (!) which was heading that way. (There is a newspaper clipping somewhere showing me catching that ride!)

I raced onto the set, feeling sweaty and trying to catch my breath. I apologized for being (almost) late, plopped into a chair (which happened to be next to Sophia Loren), and said, "I caught a ride on a garbage truck and I am sweating, so I must stink." After everyone stopped laughing, Sophia leaned over, sniffed my underarm, and assured me: "No, you don't." That is just the way she was throughout the whole filming: totally relaxed, never behaving like the star she was. I always admired her for that.

Swedish actress Eva Lynd, who has a small part in "That Kind of Woman," the Sophia Loren-Tab Hunter starrer now reeling in New York, displayed some Scandinavian resourcefulness the other day . . . When a taxi took her only so far in the direction of that day's location, the Sanitation Disposal Pier under Brooklyn Bridge, Eva thumbed a ride the rest of the way aboard one of our city trucks that was headed there on obvious business.

It becomes very intimate, because the camera knows just what you are thinking about; you can express a multitude of feelings by just thinking them. That also applies if you have no thoughts whatsoever in your head, because the camera will see that, too.

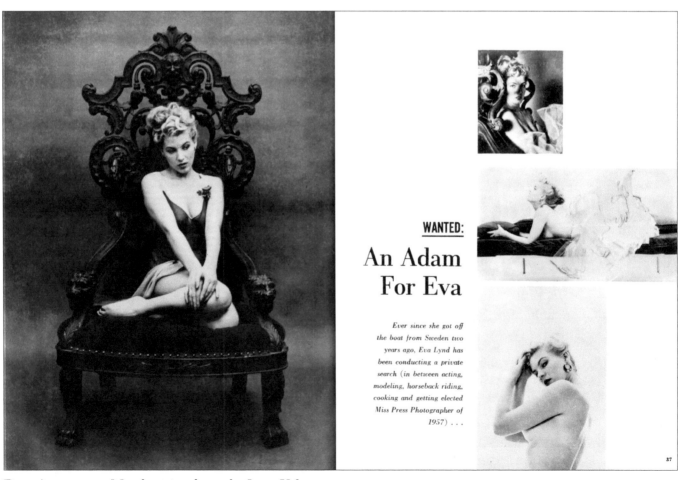

REAL ADVENTURE, March 1958; photos by Jerry Yulsman

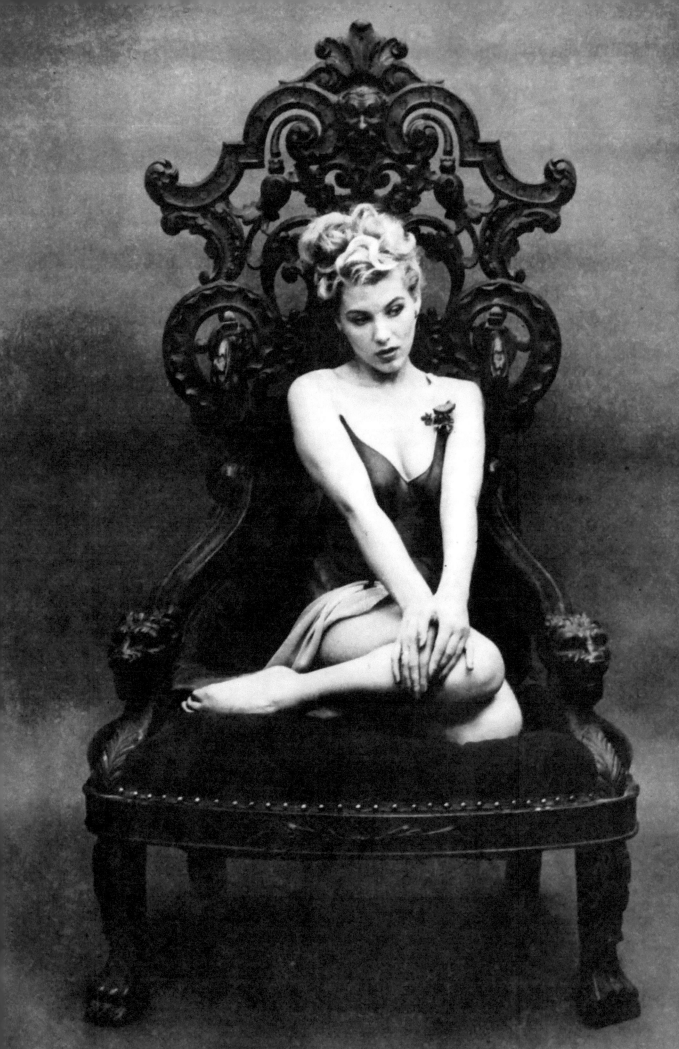

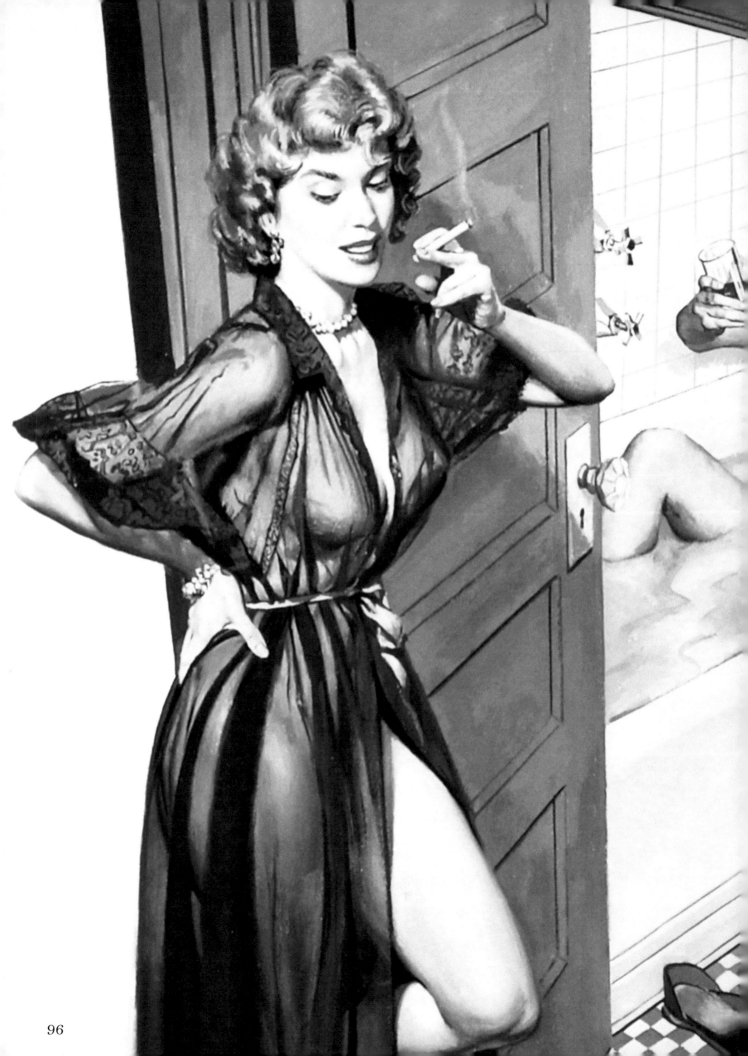

It is fun to be part of someone else's concept, imagining what the final layout will be when it goes to print... I have always thought of it as the first step of acting, because it is, after all, taking on an imaginary character that may not be exactly you, but more of a whimsical image of who you are.

Opposite and below: "Bathtub" Al Rossi serves as his own model for the character of "Lover Boy" Leo Koretz. *Original artwork courtesy William Rossi*

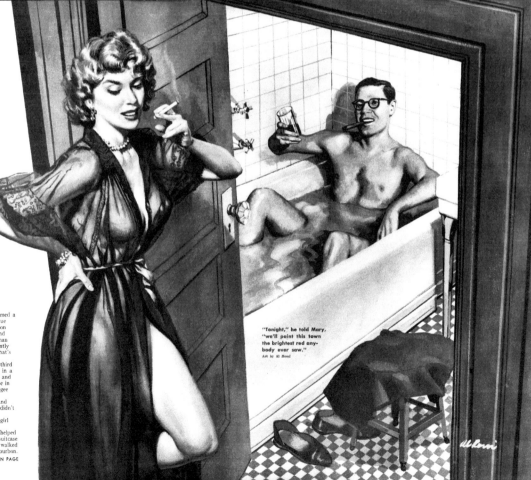

THE PHONY EMPIRE OF LOVER BOY LEO KORETZ

It took a lot of cash to keep up his outside interests. To get it, he sold the biggest bill of goods since the snake made his pitch in the Garden of Eden.

by Sumner Plunkett

The man who called himself Frank Watson hummed a merry tune as he crossed New York's Lexington Avenue and walked the two blocks from Grand Central Station to the south side of 44th Street, just west of Second Avenue. He looked for all the world like a salesman returning to his loving wife after a long and eminently successful trip out of town. And, in a sense, that's exactly what he was.

He entered a new brownstone, walked up to the third floor and opened the door of apartment C. A girl in a thin black negligee was lying on the rug, reading and eating bonbons. She wriggled with delight as he came in and leaped to her feet, ignoring the way her negligee spilled open in front.

"Frank, darling, it's been so *long!*" she cooed and snuggled tight against him for a loving hug. "Why didn't you tell me you were coming?"

Frank Watson grinned. "Got to make sure my girl isn't cheating on me, don't I?"

She pouted deliciously and gave him a kiss, then helped him off with his coat and hung it up. She took his suitcase into the bedroom and started unpacking it. Frank walked into the kitchen and poured himself a good slug of bourbon.

PLEASE TURN PAGE

26

"Tonight," he told Mary, "we'll paint this town the brightest red anybody ever saw." Art by Al Rossi

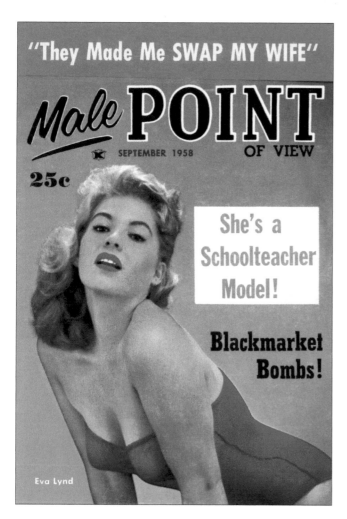

"They Made Me SWAP MY WIFE"

Male **POINT** OF VIEW

SEPTEMBER 1958

25c

She's a Schoolteacher Model!

Blackmarket Bombs!

Eva Lynd

Catalog modeling simply means that you are wearing whatever they are selling in the catalog. If it is clothing, it is more important to see the garment that you are wearing—so you are just a prop, in a way.

As a spokesmodel, I might be doing an *industrial*, where I'd have to explain to people what the product was all about. There were also a couple of automobile shows where I just had to stand next to a car that was on a slowly rotating platform.

In that case, as in the various flower shows I did, I just had to be there, looking like it was the happiest place on earth—which the flower shows actually were!

MALE POINT OF VIEW, September 1958; photos by Herb Flatow *(cover, left)*, Wil Blanche *(interior, below)*

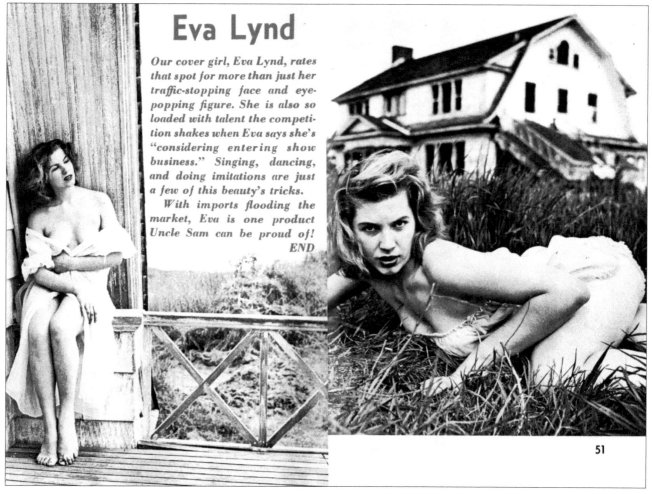

Eva Lynd

Our cover girl, Eva Lynd, rates that spot for more than just her traffic-stopping face and eye-popping figure. She is also so loaded with talent the competition shakes when Eva says she's "considering entering show business." Singing, dancing, and doing imitations are just a few of this beauty's tricks.

With imports flooding the market, Eva is one product Uncle Sam can be proud of!
END

51

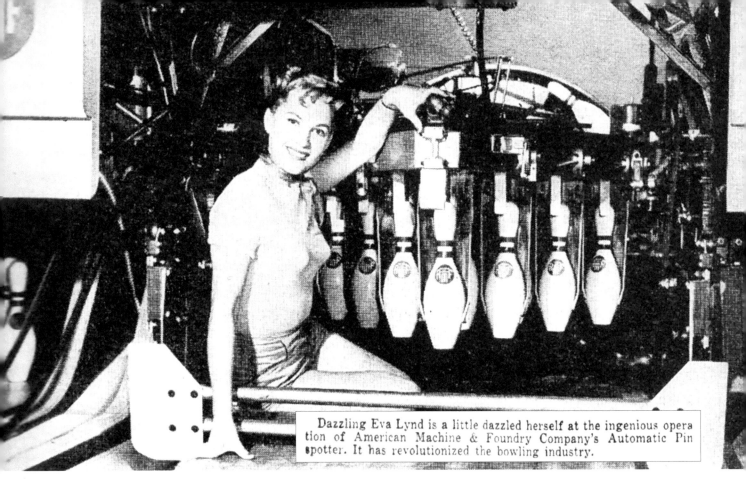

Dazzling Eva Lynd is a little dazzled herself at the ingenious opera tion of American Machine & Foundry Company's Automatic Pin spotter. It has revolutionized the bowling industry.

BOWLER'S HANDBOOK, 1958

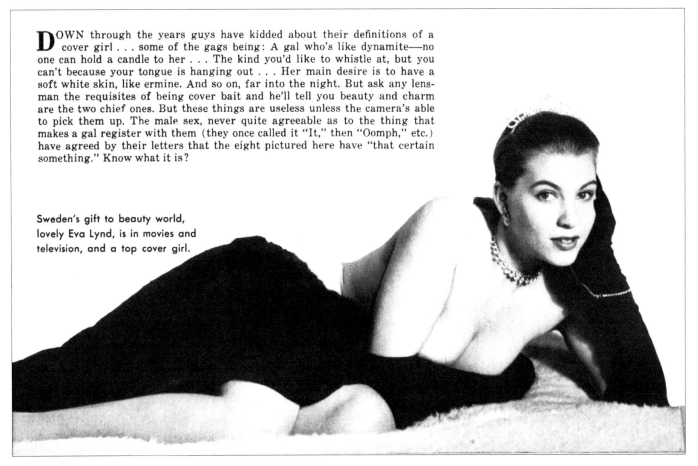

DOWN through the years guys have kidded about their definitions of a cover girl . . . some of the gags being: A gal who's like dynamite—no one can hold a candle to her . . . The kind you'd like to whistle at, but you can't because your tongue is hanging out . . . Her main desire is to have a soft white skin, like ermine. And so on, far into the night. But ask any lens-man the requisites of being cover bait and he'll tell you beauty and charm are the two chief ones. But these things are useless unless the camera's able to pick them up. The male sex, never quite agreeable as to the thing that makes a gal register with them (they once called it "It," then "Oomph," etc.) have agreed by their letters that the eight pictured here have "that certain something." Know what it is?

Sweden's gift to beauty world, lovely Eva Lynd, is in movies and television, and a top cover girl.

FOLLIES, September 1958; photo by Earl Leaf

Up in the showroom, Judd rubbed some ointment on Ruth's sunburned shoulders and wound up giving her a corset to model—on the spot.

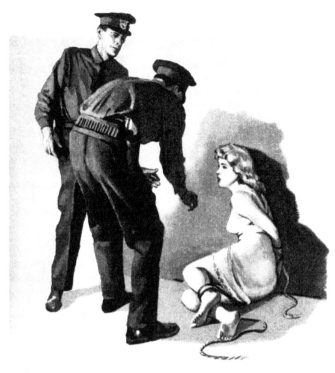

From the beginning, nobody believed her story of a robber. Certainly not the police, who found her tied up—very loosely—in the hallway.

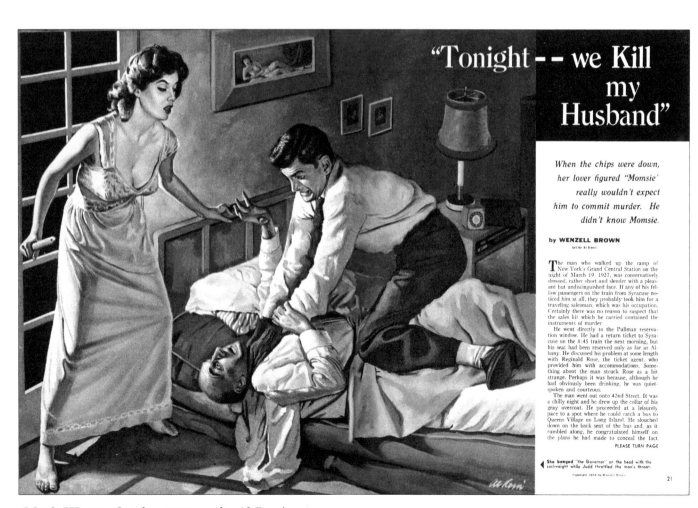

"Tonight -- we Kill my Husband"

When the chips were down, her lover figured 'Momsie' really wouldn't expect him to commit murder. He didn't know Momsie.

by WENZELL BROWN

Art by Al Rossi

The man who walked up the ramp of New York's Grand Central Station on the night of March 19, 1927, was conservatively dressed, rather short and slender with a pleasant but undistinguished face. If any of his fellow passengers on the train from Syracuse noticed him at all, they probably took him for a traveling salesman, which was his occupation. Certainly there was no reason to suspect that the sales kit which he carried contained the instruments of murder.

He went directly to the Pullman reservation window. He had a return ticket to Syracuse on the 8:45 train the next morning, but his seat had been reserved only as far as Albany. He discussed his problem at some length with Reginald Rose, the ticket agent, who provided him with accommodations. Something about the man struck Rose as a bit strange. Perhaps it was because, although he had obviously been drinking, he was quiet-spoken and courteous.

The man went out onto 42nd Street. It was a chilly night and he drew up the collar of his gray overcoat. He proceeded at a leisurely pace to a spot where he could catch a bus to Queens Village on Long Island. He slouched down on the back seat of the bus and, as it rumbled along, he congratulated himself on the plans he had made to conceal the fact

PLEASE TURN PAGE

◄ She banged "the Governor" on the head with the sashweight while Judd throttled the man's throat.

Copyright 1958 by Wenzell Brown

21

MAN'S WORLD, October 1958; art by Al Rossi

It is a beautiful fall day in 1958.

I look at my watch and there is time for me to take a little walk before I go to my first assignment with Al Rossi.

It is just one day when everything is perfect. The weather…New York City at its best. And me: looking good, feeling great!

I am going to take a little walk through the flower district and watch the merchants open their shops. I live just a few blocks from there on West 35th street, so off I go.

I can feel myself strutting, and smiling at nothing in particular. Then one of the sellers of flowers rushes out and puts a bouquet into my arms! Surprised, I thank him and walk on. As I continue my walk, other sellers come out and, one by one, put bouquets of flowers into my arms…! At this point I am laughing at the sheer joy of it all. What have I done to deserve all this attention? I have no idea, but it is clear that I now must return to my apartment to put all these treasures into water….

Once again, I am on my way, but now I am going directly to Al Rossi's studio. Luckily it is in Midtown Manhattan, and not that far away. I walk everywhere whenever possible. Traffic is usually heavy, it takes longer by taxi to get anywhere, and the subway may not go where I want to go…. I look at my watch and see that I have time to make it. I am a fanatic when it comes to time.

Time…to be on time, wherever I have to be…. It is rude to have someone waiting for you, especially if it is for a job. Even if it is just meeting someone for coffee, it isn't nice to have anyone waiting.

I make it on time to the studio, and Al opens the door for me. I see that Steve Holland is already there. He also has a thing about being on time, and he is a very busy model; so it is very important for him not to keep anyone waiting. Steve and I have been working together now for some time, and we get along very well, which is why we end up working together a lot. We have a natural understanding between us how a scene is going to work out.

Al gives me a negligee and asks me to put it on. I have been modeling for Al since about 1956, and I am very aware of the kind of illustrations he does. Usually it is something that requires me to be in a bra and panties or half-dressed, but never nude. I had dressed in a white bra and panties this morning for this sitting, and he told me that he would supply the negligee; he has several for the various scenarios that he illustrates.

I am ready, and Al explains that we are going to illustrate a true story about what happened in Norway during the Second World War. Steve has gone underground to help his country fight the Nazis, and I am not sure if I will ever see him again. I think about how I will feel about this while Al sets up the shot.

Photo by CHARLES KELL

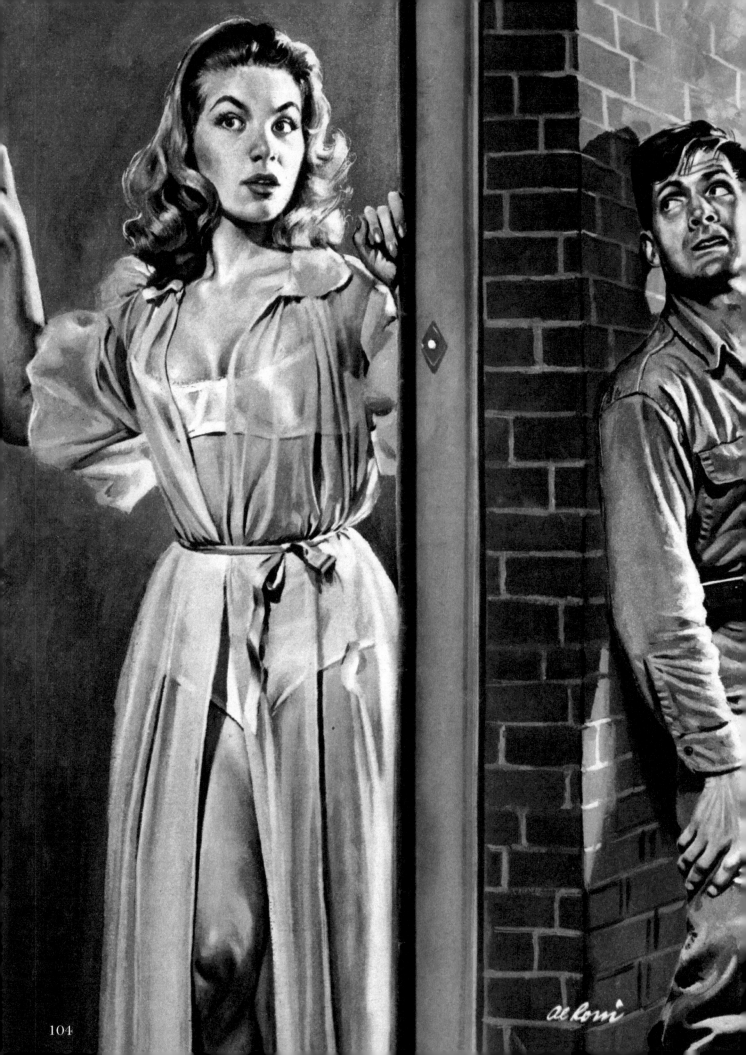

I hear a knock on the door, and I open it. I stand in the doorway and look out. It is nighttime, and I don't see anyone…. I hold onto the doorframe…I have the strange feeling that someone is nearby…. Could it be my husband? I feel both hopeful and scared, but I know that it is impossible for him to be here, because if he is caught, they will put him to death…. I stand very still in the doorway, almost afraid to breathe…. I can feel it in the air…somehow, I know he is there…. Steve is leaning on the brick wall, looking scared, ready to run into the house. But I haven't seen him as yet….

That is the moment that Al shoots.

"Great!" Al says. *"That is just what I wanted."*

The session is over, and Steve rushes out to his next appointment. I take my time, because today I don't have another job, neither with an illustrator nor a photographer. Al thanks me, pays me the hourly fee of $25, and tells me that he will see me soon. He is one of my favorite illustrators, and very easy to work with.

I walk home. I know that my apartment will smell like a spring garden, so I get a cup of coffee to go, in a nearby deli. I have learned to love it black, because it doesn't put any weight on without sugar and cream, and added weight is something I don't need. So I walk slowly, just enjoying the city. The city is wonderful today. It is just one of those perfect days….

The scene that we shot that day later appears in *Stag* magazine, December 1958 ("You Will Never Come Back"), as an illustration by Al Rossi…and is one of my favorites.

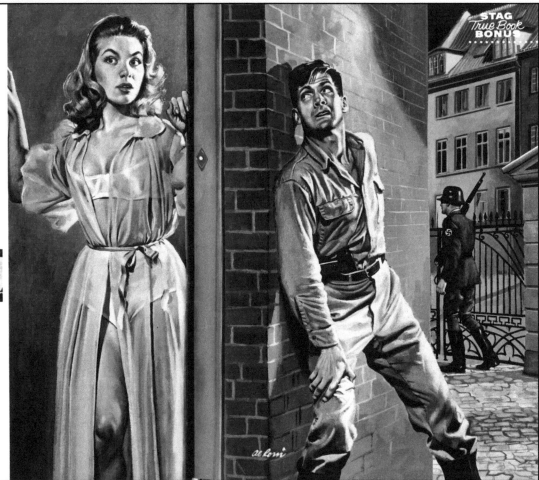

STAG, December 1958; art by Al Rossi

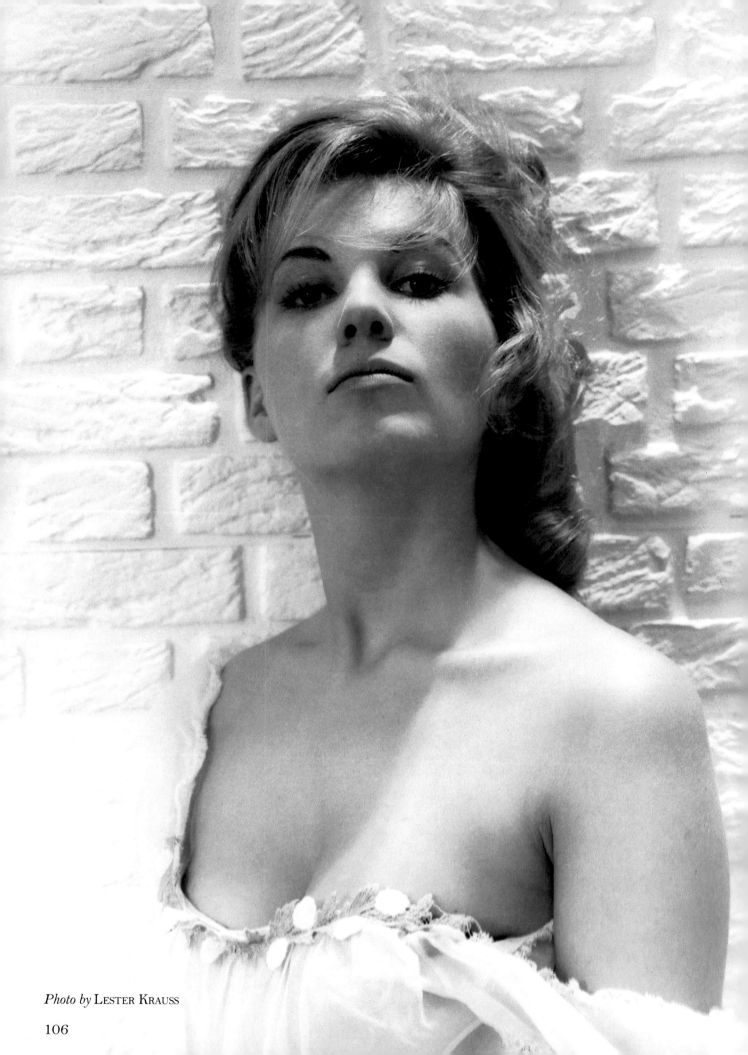

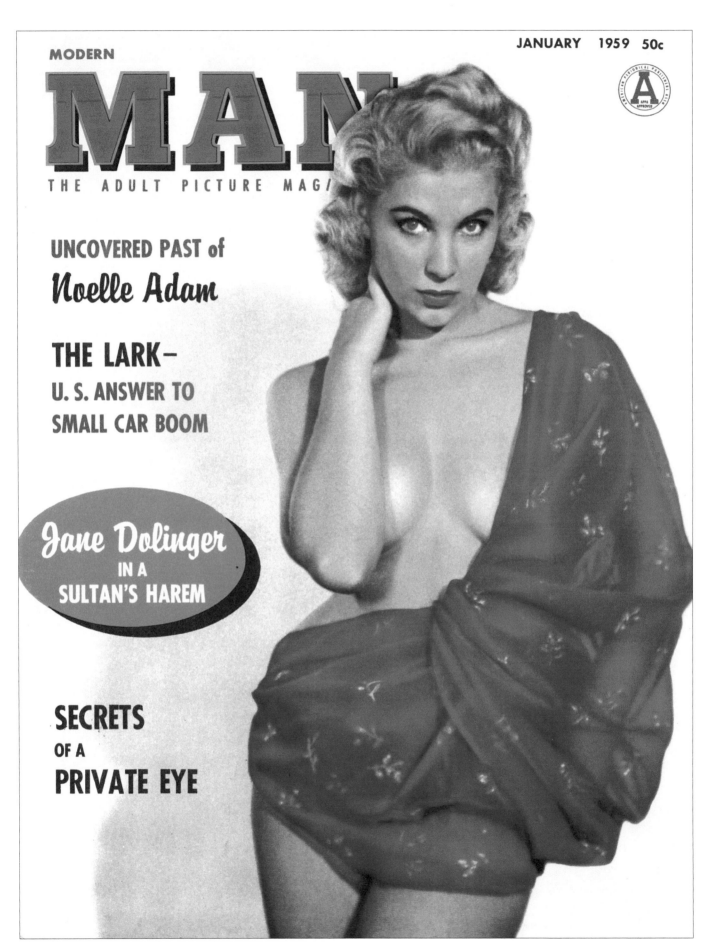

MODERN MAN, January 1959; photo by Leo Fuchs

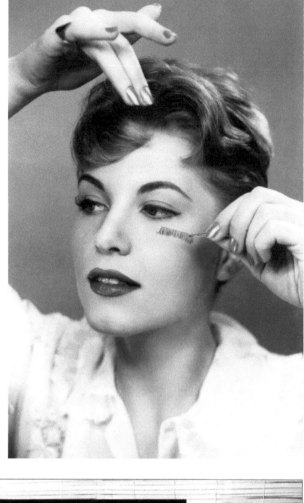

When it comes to ads, you are showing off the product. So you're looking interested in what's being advertised. You're holding up the product, or pointing to it. Your face should be saying, *"I really love this, and I know you will, too."*

Max Factor campaign, 1959

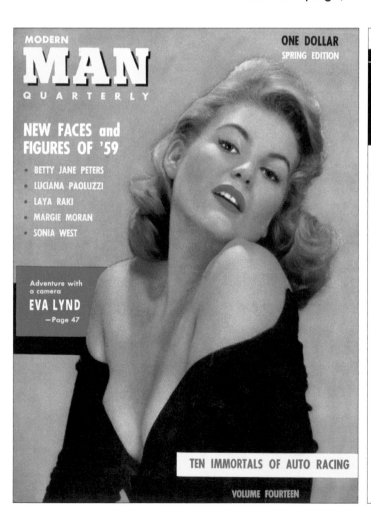

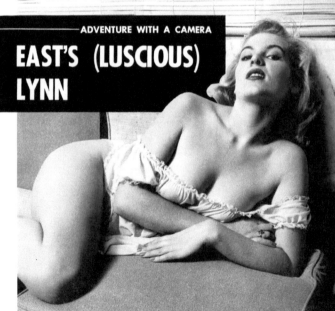

Luxuriantly reclining, *visual impact of ebullient Eva fully explains Flatow's difficulty in obtaining ethereal effect.*

Emanating lusty charm, New York-born
Li'l Eva just "growed and growed"—in all the right places.

THE BALMY BREEZES of early Spring often stir a man to dreaming. He may dream of mountain climbing or trout fishing or some more voluptuous pursuit like driving through the countryside with a lovely young woman, then picnicing in warm sunlight amidst the intoxicating smell of Spring grass. As a matter of fact, these were the thoughts of glamour photog Herb Flatow as he strode briskly along a Manhattan thoroughfare while Hugh Philips, his short-legged assistant, struggled to keep pace.

Herb was saying: "No blouse busters this time, Hugh. No 44-23-37 eye popper who looks like a hip-swinging example of Had-a-col gone berserk. I have a terrific idea for an innocent young lady dreaming away a Spring day."

"It sounds dull, boss," Hugh mumbled.

Entering the lobby in the New York building that housed Flatow's studio, they passed a newly hired blonde cigar stand clerk. Herb waited until they were beyond earshot, then asked: "Hugh, does that girl make you think of anything?"

47

MODERN MAN QUARTERLY, Spring 1959; photos by Herb Flatow

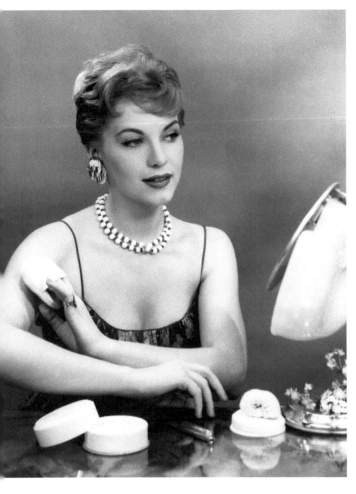

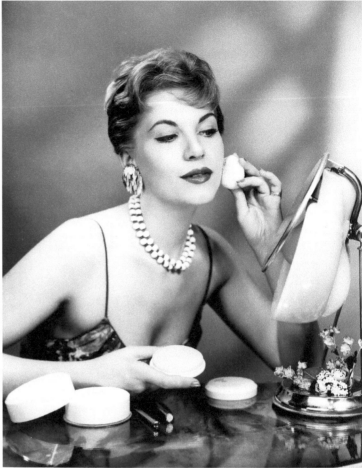

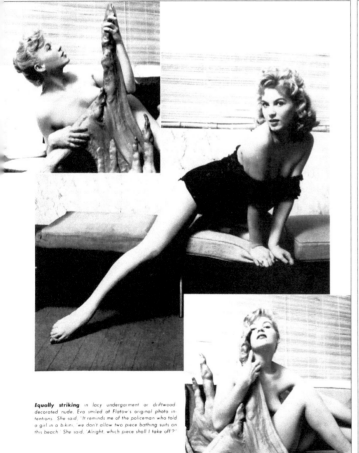

49

"Yeah, my cousin's wife Frieda. She's a beautiful blonde too and they've got eight kids. Man, what a breeder! Why Mert says — my cousin's name is Mert — Mert says . . ."

"Nonsense, Hugh, that young woman has ethereal charm. Ask her to please come up to our studio."

Thus lissome Eva Lynn was introduced to Herb Flatow and at the mention of scale wages she gladly agreed to model. Flatow set out at once directing ebullient Eva's poses and telling Hugh how to place the floods.

"We're trying something really different, Miss Lynn," he explained. "Uh, try not to appear so sexy, Miss Lynn."

"Sorry. How's this?" said the Manhattan-born lovely.

"Well, that's even sexier. Turn your head to the left."

"Like this?"

"Yes," he said, snapping the shutter without fully realizing that she looked more voluptuous than ever.

"You can't do it, boss," Hugh whispered. "This girl is just too much."

"I told you, runt, I want an ethereal portrait of a young woman stirred to dreaming."

"Aw, boss, this Eva is about as ethereal as Ekberg."

"Uh, Miss Lynn," Flatow said, "perhaps if you lowered your chin you wouldn't look so devastatingly sensual."

And so the session continued with Flatow still determined. In fact, it was not until he developed the pulsating prints that he had to admit that these were not ethereal fantasies but exciting photo glimpses of a mature and intoxicating woman. MODERN MAN editors quickly recognized this and decided to use a color shot of Eva on the cover as well. They told Flatow that the pix might not be what he had in mind, but they formed a swinging good job. After all, no lensman can disguise the sensual warmth of Eros, and Spring breezes do not stir all men to dreaming of picnics! O

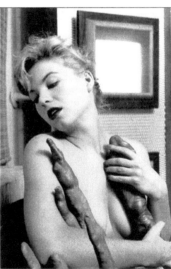

Hugging driftwood, Eva expresses Spring's exultancy.

Lolling voluptuously on Herb Flatow's studio divan, lissome Eva Lynn could be symbol of Eros' conquering powers.

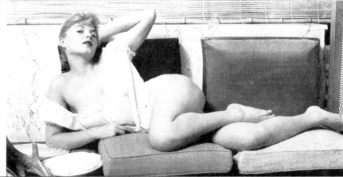

Equally striking in lacy undergarment or driftwood decorated nude, Eva smiled at Flatow's original photo intentions. She said, "It reminds me of the policeman who told a girl in a bikini, 'we don't allow two piece bathing suits on this beach.' She said, 'Alright, which piece shall I take off?'"

48

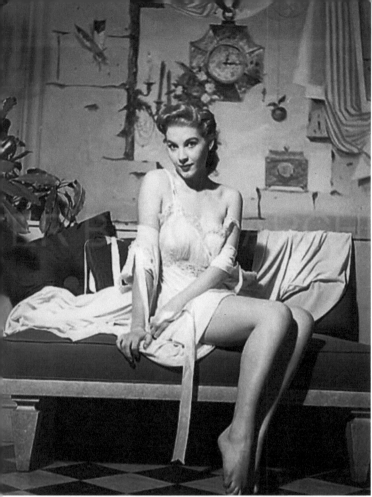

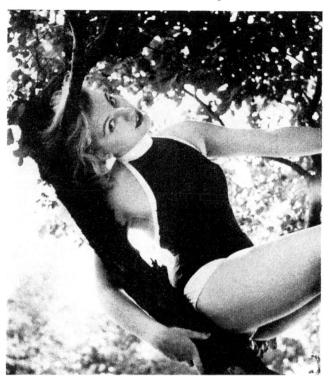

Out on another limb sits Eva Lind,
a Swedish miss who will not break bough or lens.

From Peter Basch's **BEAUTIES OF THE WORLD**, 1958

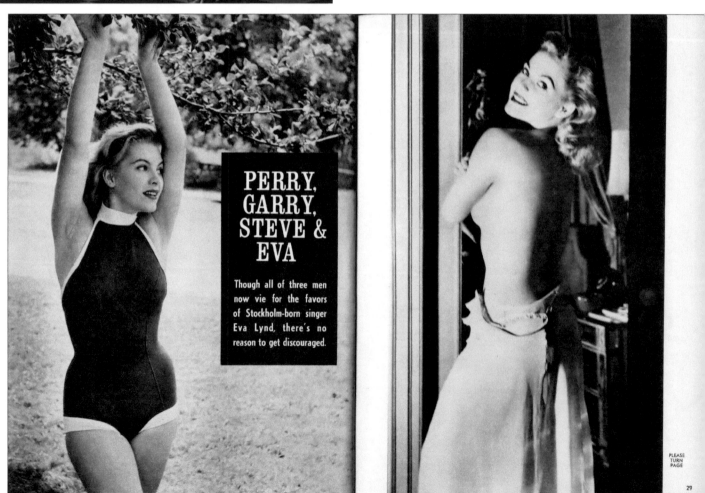

PERRY, GARRY, STEVE & EVA

Though all of three men now vie for the favors of Stockholm-born singer Eva Lynd, there's no reason to get discouraged.

PLEASE
TURN
PAGE

29

MAN'S WORLD, December 1959; photos by Peter Basch

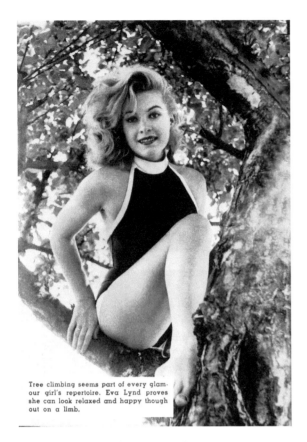

Tree climbing seems part of every glamour girl's repertoire. Eva Lynd proves she can look relaxed and happy though out on a limb.

From Peter Basch's **PHOTO STUDIES**, 1957

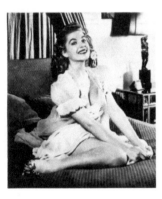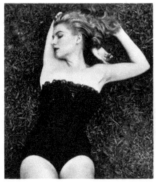

PERRY, GARRY, STEVE & EVA

The competition is merely Como, Moore and Allen—old, married guys who just want to win Eva for their own TV shows.

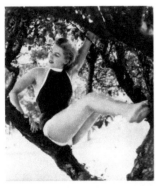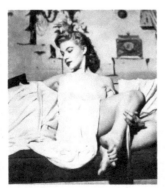

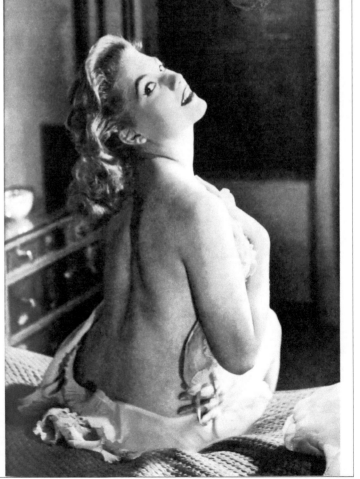

The Hypnotic Eye was one of the first films where I actually had a part—one line. Nevertheless, it was fun to be on the set. I was cast as an audience member called to the stage by magician Jacques Bergerac to help him with a trick. He hypnotized Merry Anders, she fell backwards, and I caught her by the shoulders. Another girl was at her feet, and together we lifted her up and placed her on a board that Jacques Bergerac made float in the air. By sheer luck, I ended up on one of the color lobby cards. (Lobby cards were promotional stills—collector's items, now—made for display in theatre lobbies.) The film itself has since become a sort of cult favorite.

I had previously appeared on Festival of Magic, the 1957 TV special emceed by legendary comic Ernie Kovacs. I had done a lot of pre-publicity with magician

Milbourne Christopher for this special, but on the show I ended up assisting Robert Harbin with one of his illusions. Coincidentally, the same one that I'd later help Jacques Bergerac with in The Hypnotic Eye—but in this case, I was the one floating in the air. A portrait of me with Milbourne Christopher became the cover of his biography, and we appear in the book How Sweet It Was.

Luckily, I was never asked to do any illusions that had to do with being shut up in a trunk, because I am claustrophobic, and that would not have ended well.

I have always been fascinated with magic and the people who can make such illusions look so real. But I am glad that they don't explain how it is done, because that would destroy the mystery of it all…and I would rather believe that it is indeed magic. Who is to say that it isn't?

THE MOST PERFECT FIGURE IN THE WORLD

Jem
THE MAGAZINE FOR MASTERFUL MEN

AUGUST/50c

HEDY LAMARR
DISCUSSES L'AMOUR

CUT IT OUT PARIS
(are the French really sexy?)

LOVE RAIDS

ЕМ, August 1959

BREEZY

DEC. 35¢

A RACY PAGEANT OF LUSTY ENTERTAINMENT!

A FULL DIET
OF VITAMIN 'SEE'!

A HUMORAMA MAGAZINE

CAROL HILL!

EVA LYND!

TEMPEST STORM!

BREEZY, December 1959

I didn't spend a lot of time with my mother throughout my life, and when she died in November, 1959 at only 55, there were a whole lot of questions left unanswered. I felt lost for a while, so I got married in 1960. Unfortunately, he insisted that I take an ordinary job to help with expenses. Too bad, since my career had a good start at that time, and that put a stop to it.

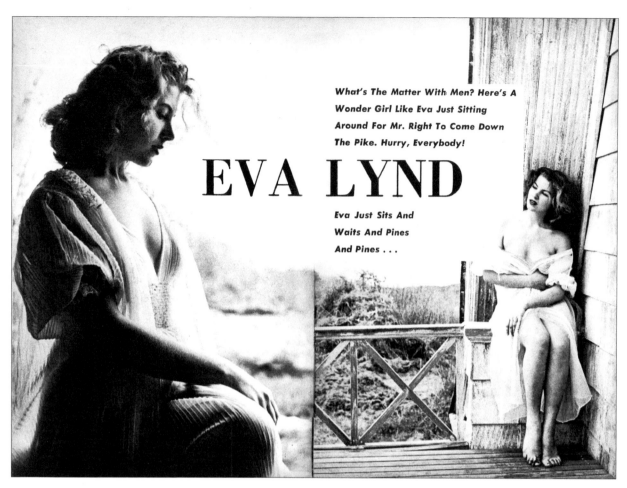

What's The Matter With Men? Here's A Wonder Girl Like Eva Just Sitting Around For Mr. Right To Come Down The Pike. Hurry, Everybody!

EVA LYND

Eva Just Sits And Waits And Pines And Pines . . .

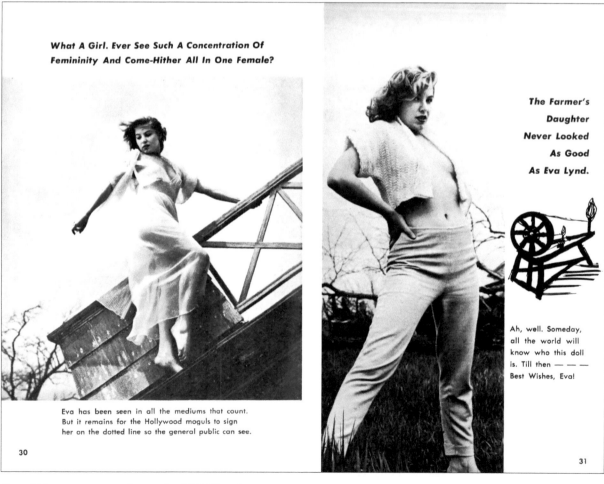

What A Girl. Ever See Such A Concentration Of Femininity And Come-Hither All In One Female?

The Farmer's Daughter Never Looked As Good As Eva Lynd.

Ah, well. Someday, all the world will know who this doll is. Till then — — — Best Wishes, Eva!

Eva has been seen in all the mediums that count. But it remains for the Hollywood moguls to sign her on the dotted line so the general public can see.

30

31

SHE, February 1960; photos by Wil Blanche

114

This was when I was a redhead, which only happened one time in my life. It was taken by the same photographer who took nude photos of me when I considered posing for *Playboy.* (They wanted to see more, but I chickened out.) I don't remember the photographer's name.

Following my first marriage, which ended in 1963, I went back to New York City. I had been gone for three years, but I quickly regained my footing, because I was not forgotten by the people I had worked for in the '50s. There hadn't been a great deal of change since I had been gone, and I felt very comfortable being back in the city.

I also met and started working with Norm Eastman, who to my mind is the best illustrator ever. The two illustrators with whom I worked most often were Norm Eastman for men's magazine covers, and Al Rossi for interior stories. They were more similar in the way they worked than different. They both knew what they wanted, and they both shot reference photos to use in their renderings later. I loved working for both of them, and both usually paired me with Steve Holland, who I already knew and had worked with for Al Rossi in the '50s.

It was always fun.

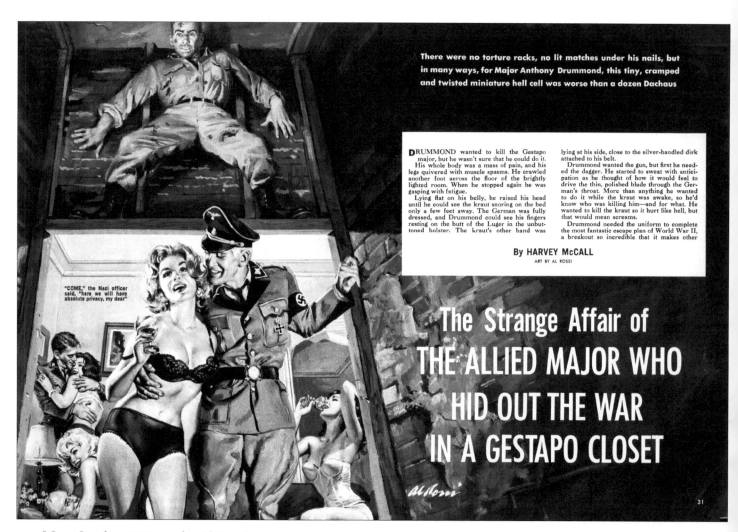

MEN, October 1963; art by Al Rossi

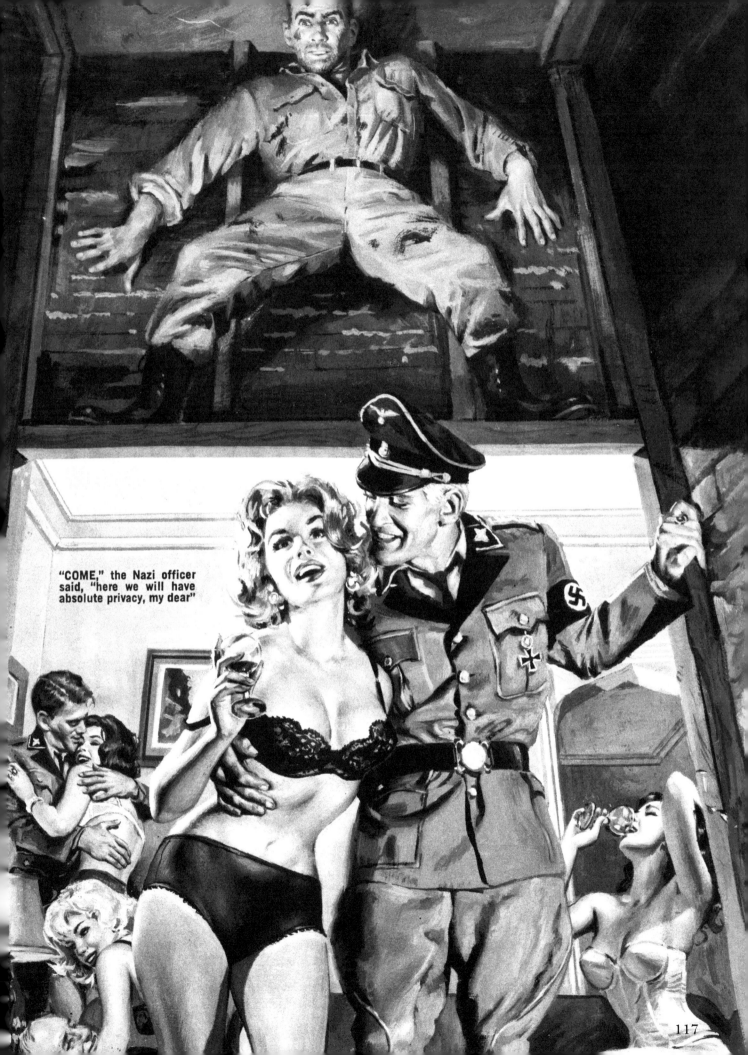

"COME," the Nazi officer said, "here we will have absolute privacy, my dear"

All Eva's men's adventure magazine covers—from 1964 through 1974—are the work of a single artist: Norm Eastman.

The three of us—Norm, Steve Holland, and me—worked together a lot, but I also worked with Norm alone. I never met the other two favorites of his, Shere Hite [later a bestselling author], and Lisa Karan, but we pop up here and there in some of the same images as if we had worked together. I loved working with Norm.

He always took a lot of reference photos of me in various positions; he had furniture or blocks that would allow me to keep the various positions without any problem. I can remember him saying, *"This is where you are hanging from a helicopter," "This is where you are coming out of a window," "This is where you are throwing something out of a window," "This is where you are holding a rifle,"* etc. Then he would have me lying on something upside down, sitting with my hands and/or feet bound, or standing with my arms bound above my head, or otherwise not being able to move. (In one case, as if I

was tied to a cross.) He would not actually bind me, just asked me to hold my hands/feet as if I was unable to escape. Always with an expression of fear, but not making ugly grimaces.

The thing that illustrators want, as a rule, is for the model to look terrified without distorting the face. This has to be accomplished with the look in the eyes. *Think* terror, but only *show* it in your eyes and mouth, and don't screw up your face to make it ugly.

There were never any torture instruments present during the modeling sessions, nor was I ever tied up; that was all paint. Norm just explained what was happening in the scene, and what position he wanted me in.

Norm would tell me the scenario and I would act it out, very often with Steve. It amused me later to see that, as often than not, Norm would paint himself as the bad guy.

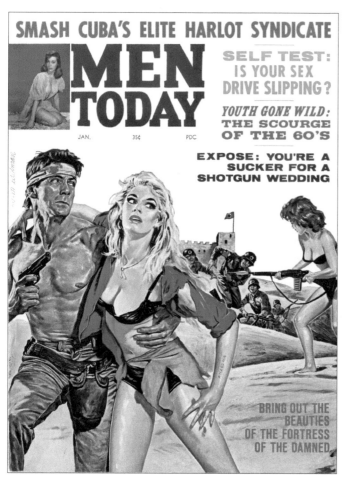

MEN TODAY, January 1964; art by Norm Eastman

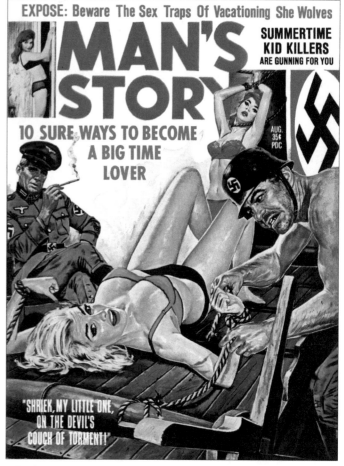

MAN'S STORY, August 1964; art by Norm Eastman

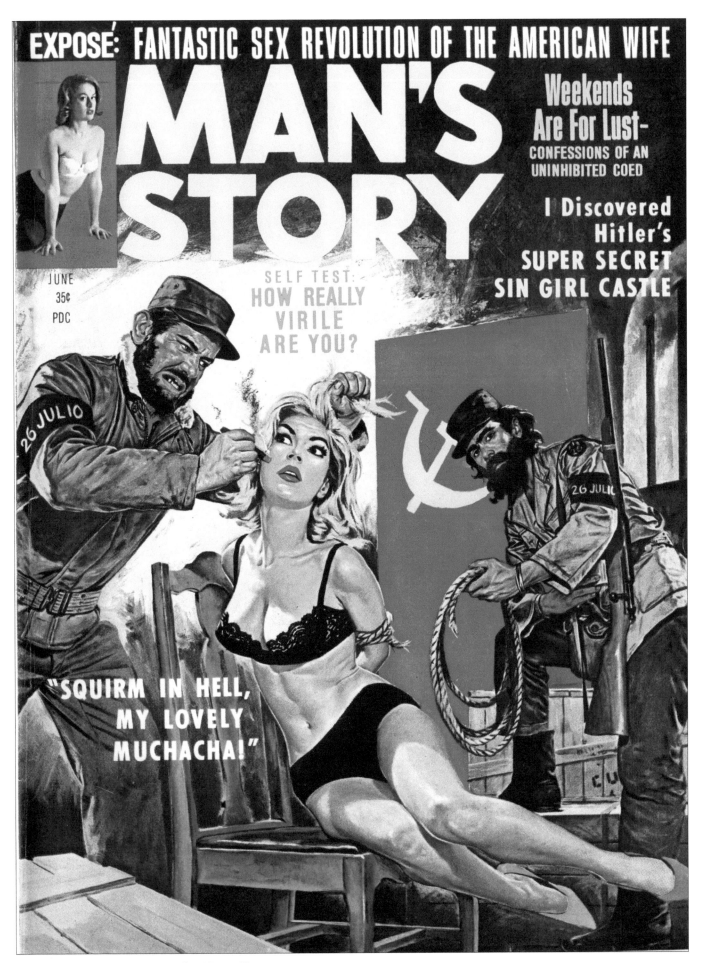

MAN'S STORY, June 1964; art by Norm Eastman

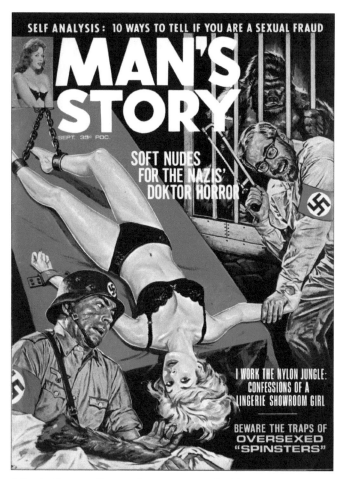

MAN'S STORY, September 1964; art by Norm Eastman

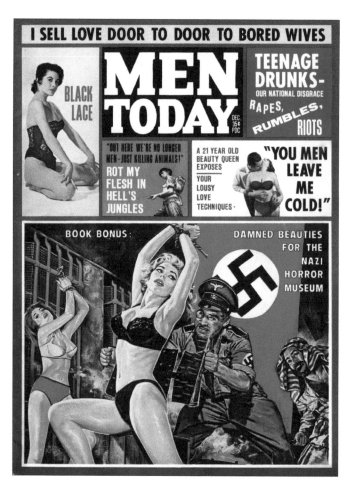

MEN TODAY, December 1964; art by Norm Eastman

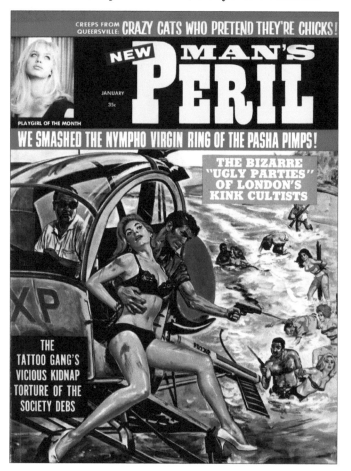

MAN'S PERIL, January 1965; art by Norm Eastman

Occasionally, American publishers of men's adventure magazines tried publishing editions in other English-speaking countries—though there are few examples, and MAMs remained a mostly American phenomenon. One rare example that features a Norm Eastman cover painting Eva modeled for is the February 1965 issue of *Clash*. It's essentially a duplicate copy of *Man's Story*, January 1965, published for distribution in Canada with a different title, a phony Quebec office address and a phony list of editors. The owners of the Reese & Emtee line of MAMs, which included *Man's Story*, apparently published *Clash* as an experiment. Years before, in 1957, a different American publisher created a MAM titled *Clash* that only lasted one issue. The 1965 version was equally unsuccessful, and February 1965 is the only known issue of that second incarnation of *Clash*.

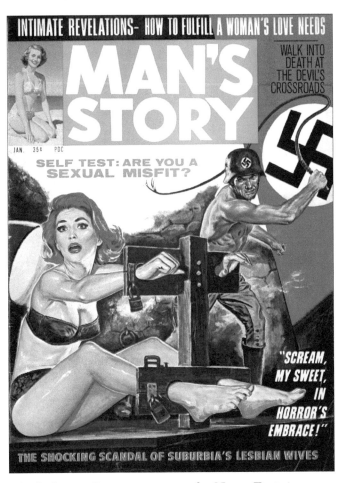

MAN'S STORY, January 1965; art by Norm Eastman

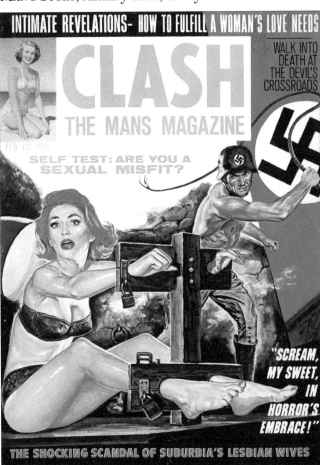

CLASH, February 1965; art by Norm Eastman

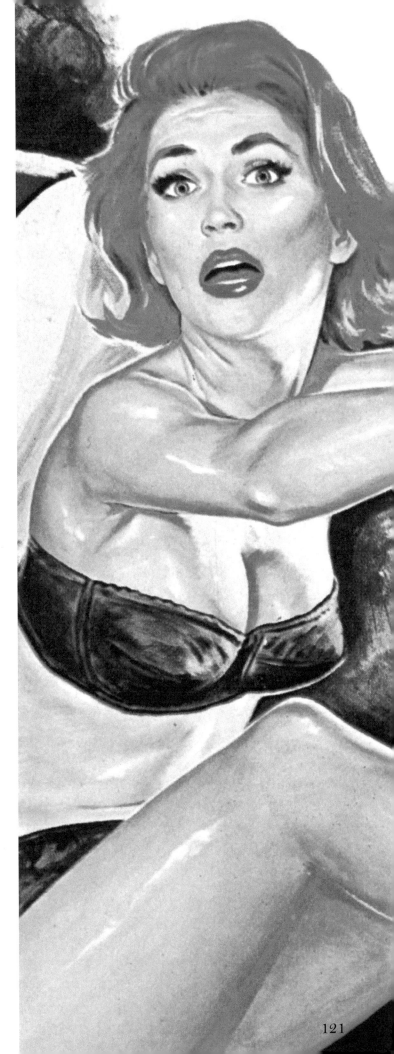

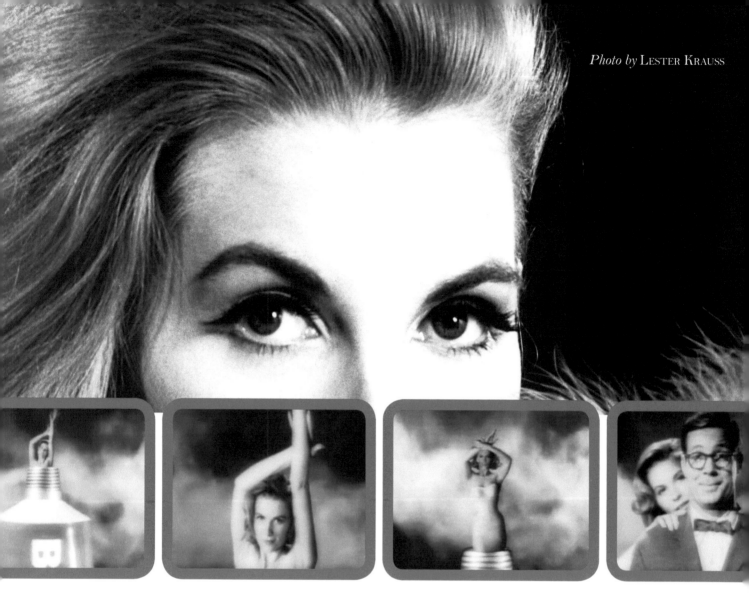

Normally, a TV commercial is something you have to audition for, with a multitude of other actors who are reading for the same part. I made several commercials in New York in the 1960s; Cool Whip, Doral cigarettes, Dawn dishwashing liquid… But this is one I remember very well: I was "the Girl in the Tube" for Brylcreem. It aired in 1964 and ran for two years, and then a clip from it was reused in two other commercials. And yes, I got residuals from *all* of those—paid directly to me, because I didn't have an agent on this one. I made a lot of money, especially for that time; over $25K, which kept me from having to live on the streets of New York. This is how it happened:

I was wearing a bustier, sitting on a high stool in one of the artist's rooms of Kenyon & Eckhardt ad agency in NYC. I don't remember what I

Channel Chuckles

was there for, but someone was taking pictures of me.

The door to the hall was open, and I saw a man walk by and glance in at me as he passed. Then I saw him back up and stop at the door, watching me.

When I finished with the photographer, the man came in and asked me if I would like to do a commercial for them. I said that I would love to, and that is how I got the Brylcreem commercial—through an accidental audition. I wish it was that easy every time!

It won at least one advertising award, and was fodder for a lot of jokes and speculation about how it was done. (I was on an automatic lift, and had to do it several times until they got what they wanted.)

There was also my little treasure *(left),* a cartoon for *Channel Chuckles* by Bil (*The Family Circus*) Keane.

122 *Used by permission of Jeff Keane and Bil Keane, Inc. All rights reserved.*

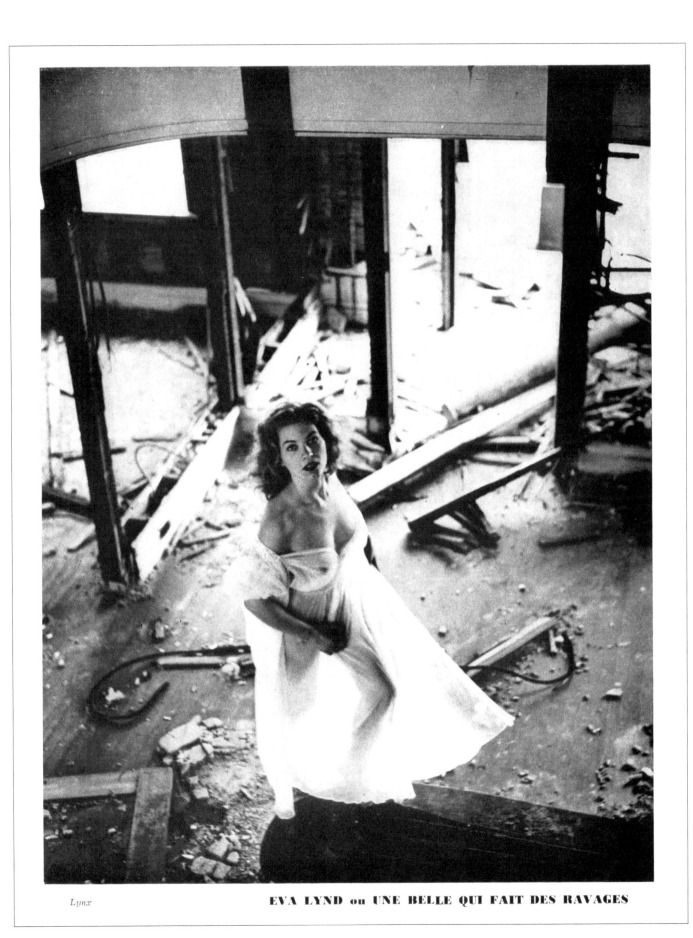

Lynx EVA LYND ou UNE BELLE QUI FAIT DES RAVAGES

LA VIE PARISIENNE, November 1965; photo by Wil Blanche

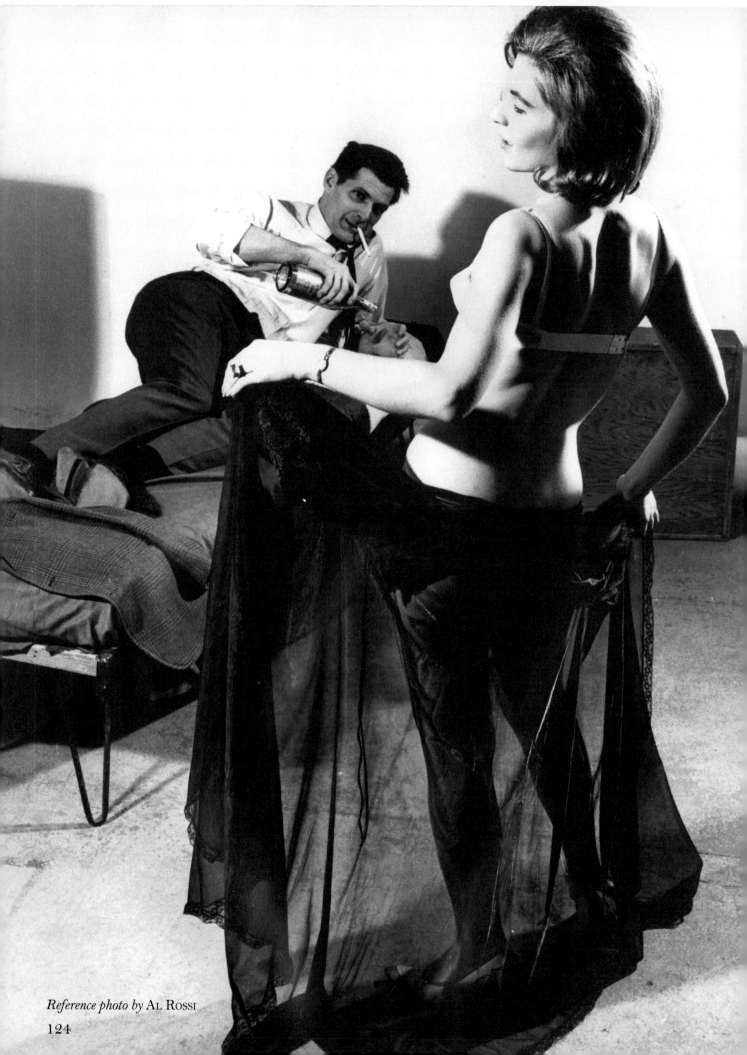

124

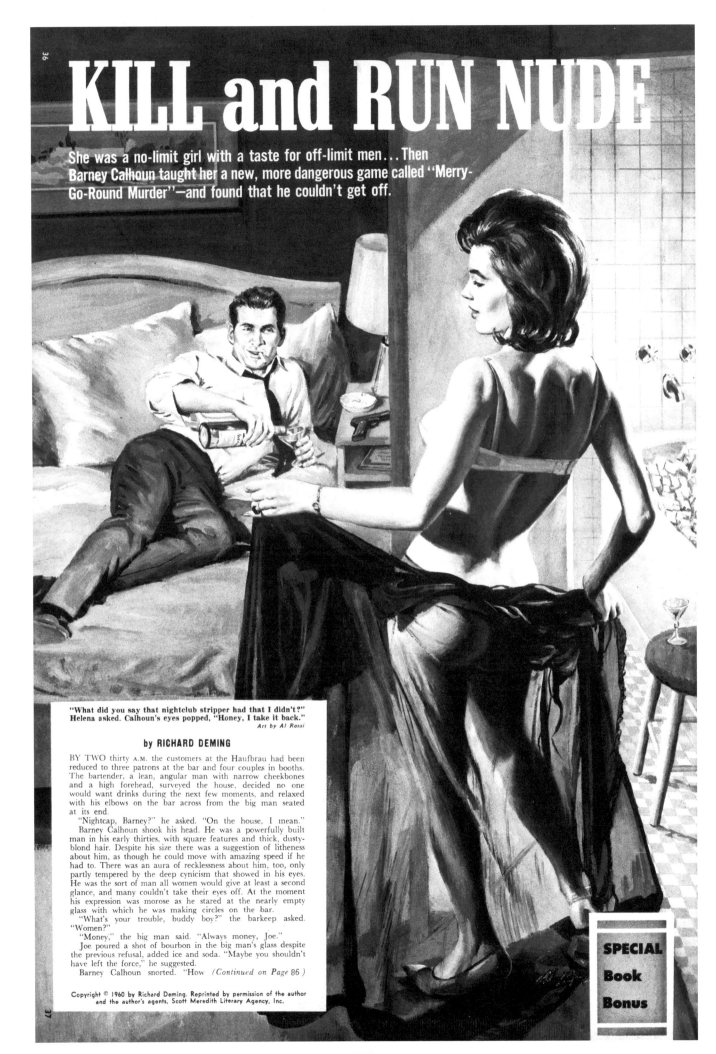

KILL and RUN NUDE

She was a no-limit girl with a taste for off-limit men... Then Barney Calhoun taught her a new, more dangerous game called "Merry-Go-Round Murder"—and found that he couldn't get off.

"What did you say that nightclub stripper had that I didn't?" Helena asked. Calhoun's eyes popped, "Honey, I take it back."

Art by Al Rossi

by RICHARD DEMING

BY TWO thirty A.M. the customers at the Haufbrau had been reduced to three patrons at the bar and four couples in booths. The bartender, a lean, angular man with narrow cheekbones and a high forehead, surveyed the house, decided no one would want drinks during the next few moments, and relaxed with his elbows on the bar across from the big man seated at its end.

"Nightcap, Barney?" he asked. "On the house, I mean."

Barney Calhoun shook his head. He was a powerfully built man in his early thirties, with square features and thick, dusty-blond hair. Despite his size there was a suggestion of litheness about him, as though he could move with amazing speed if he had to. There was an aura of recklessness about him, too, only partly tempered by the deep cynicism that showed in his eyes. He was the sort of man all women would give at least a second glance, and many couldn't take their eyes off. At the moment his expression was morose as he stared at the nearly empty glass with which he was making circles on the bar.

"What's your trouble, buddy boy?" the barkeep asked. "Women?"

"Money," the big man said. "Always money, Joe."

Joe poured a shot of bourbon in the big man's glass despite the previous refusal, added ice and soda. "Maybe you shouldn't have left the force," he suggested.

Barney Calhoun snorted. "How *(Continued on Page 86)*

SPECIAL
Book
Bonus

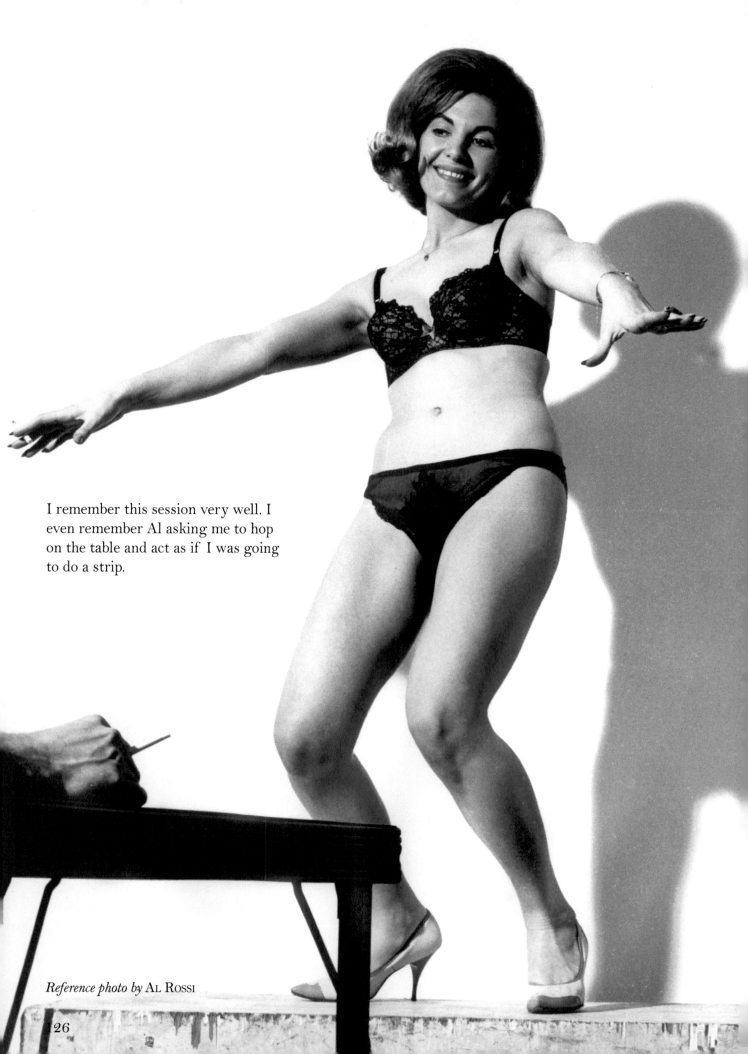

I remember this session very well. I
even remember Al asking me to hop
on the table and act as if I was going
to do a strip.

Reference photo by Al Rossi

126

You have to remember that artists took rolls of photos of us that they could use—in whole or in part—at any time after we were gone. So likenesses of me—or parts of me—appear in renderings I never specifically modeled for.

"Kill and Run Nude" (spot illustration), **FOR MEN ONLY**, July 1964; art by Al Rossi

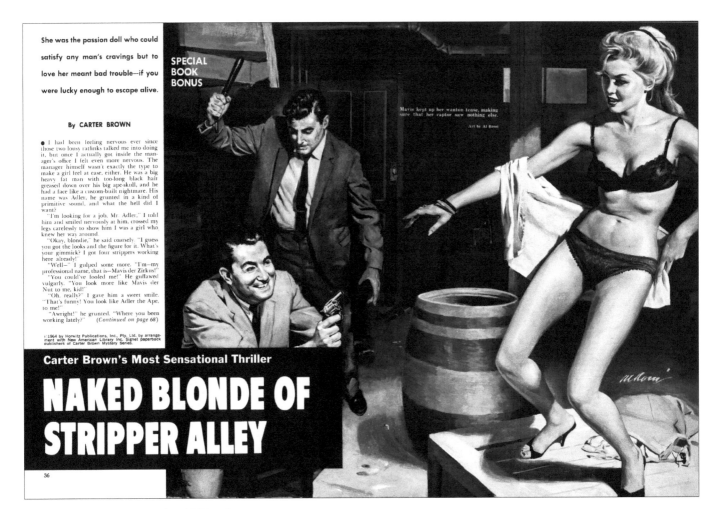

She was the passion doll who could satisfy any man's cravings but to love her meant bad trouble—if you were lucky enough to escape alive.

SPECIAL
BOOK
BONUS

By CARTER BROWN

● I had been feeling nervous ever since those two lousy ratfinks talked me into doing it, but once I actually got inside the manager's office I felt even more nervous. The manager himself wasn't exactly the type to make a girl feel at ease, either. He was a big heavy fat man with too-long black hair greased down over his big ape-skull, and he had a face like a custom-built nightmare. His name was Adler, he grunted in a kind of primitive sound, and what the hell did I want?

"I'm looking for a job, Mr. Adler," I told him and smiled nervously at him, crossed my legs carelessly to show him I was a girl who knew her way around.

"Okay, blondie," he said coarsely. "I guess you got the looks and the figure for it. What's your gimmick? I got four strippers working here already!"

"Well—" I gulped some more. "I'm—my professional name, that is—Mavis der Zirkus!"

"You could've fooled me!" He guffawed vulgarly. "You look more like Mavis der Nut to me, kid!"

"Oh, really?" I gave him a sweet smile. "That's funny! You look like Adler the Ape, to me!"

"Awright!" he grunted. "Where you been working lately?" *(Continued on page 68)*

©1964 by Horwitz Publications, Inc., Pty. Ltd. by arrangement with New American Library Inc. Signet paperback publishers of Carter Brown Mystery Series.

Mavis kept up her wanton tease, making sure that her captor saw nothing else.
Art by Al Rossi

Carter Brown's Most Sensational Thriller

NAKED BLONDE OF STRIPPER ALLEY

36

MEN, January 1966; art by Al Rossi

Calhoun looked up from his drink and caught Helena's frank, admiring stare.

"Blackmail's a word I don't like," Calhoun growled, grabbing Cushman's coat

The moment Helena's husband saw the dented fender—she decided to kill him.

Lawrence Powers, aided by a 12 lb. anchor, slid into the waters of Lake Erie.

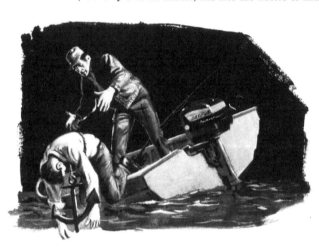

"Don't," Cushman screamed, "I won't talk—" But Helena was not convinced.

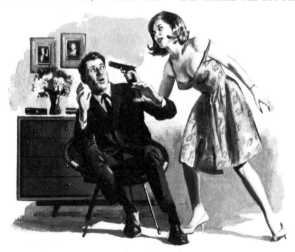

I am "Helena"in the small spot illustrations, too; some look more like me than others. A fun series. The one in the sundress where I am holding a gun on the guy? I have that dress. In fact, I also have a Lester Krauss photo where I'm wearing it *(right)*.

"Kill and Run Nude," FOR MEN ONLY, July 1964; art by Al Rossi

Photo by LESTER KRAUSS

I can't remember exactly how it was that I came to work as a model for Al Rossi. It may have been through an agent that I got my first gig with him, but after that he would always call me direct. And since I had already worked for him in the '50s, I told him that I was back in New York City again in 1963.

With Al, things were easy. He always knew what he wanted, and Steve Holland and I would simply imagine ourselves into the situation. I was usually mostly undressed in bra and panties or with negligees covering transparently, but there was never a thought of either Steve or Al being unprofessional in any way.

I was very good at assuming the persona Al wanted in each drawing, as was Steve—which is why we worked well together, and why Rossi and Eastman used us together so often. I can only assume that our acting ability helped a lot in doing the still photos.

Steve worked a lot, and I think he liked working with me as much as I liked working with him because he could depend on me doing it right from the get go—thus allowing him to get to his next assignment on time. Al was equally professional, because time is money, and since he paid me $25 an hour (not bad pay at that time), there was no time to fool around. I don't think he would have in any case, because it was not the kind of guy he was.

Al was a very easy guy to work with. Often he would tell us to relax while he set up the next scenario…and that is how he took this photo of me.

Photo by AL ROSSI

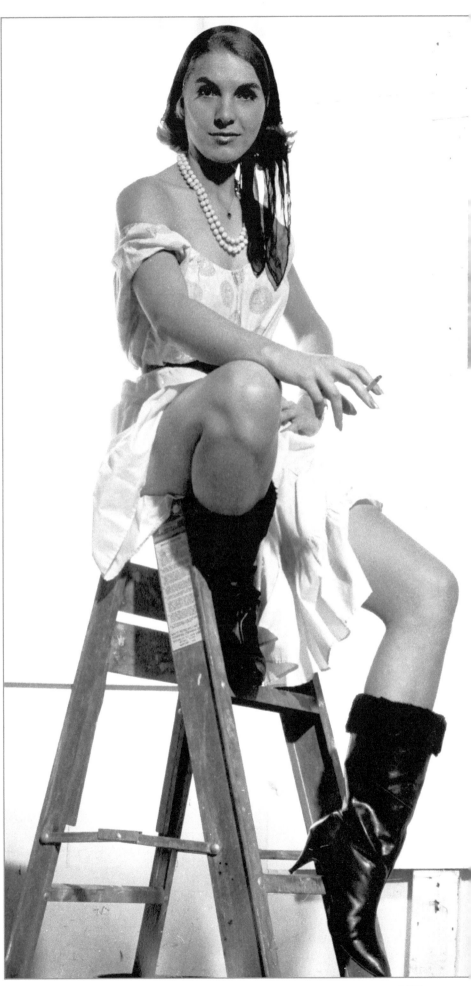

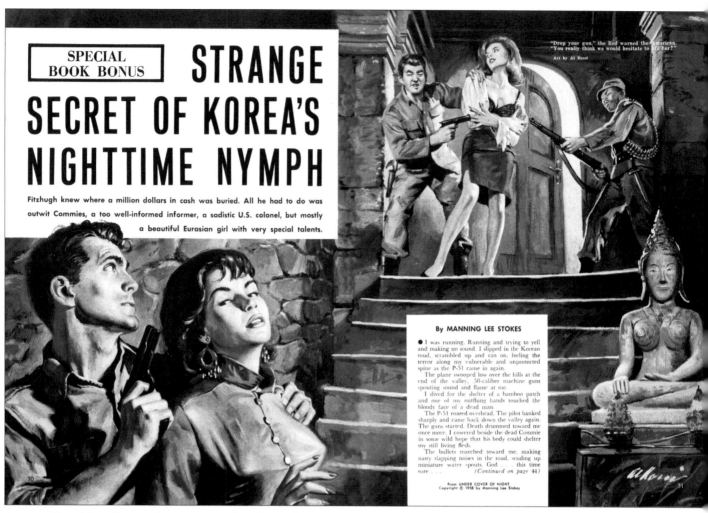

SPECIAL BOOK BONUS

STRANGE SECRET OF KOREA'S NIGHTTIME NYMPH

Fitzhugh knew where a million dollars in cash was buried. All he had to do was outwit Commies, a too well-informed informer, a sadistic U.S. colonel, but mostly a beautiful Eurasian girl with very special talents.

"Drop your gun." the Red warned the American. "You really think we would hesitate to kill her?"

Art by Al Rossi

By MANNING LEE STOKES

● I was running. Running and trying to yell and making no sound. I slipped in the Korean mud, scrambled up and ran on, feeling the terror along my vulnerable and unprotected spine as the P-51 came in again.

The plane swooped low over the hills at the end of the valley, .50-caliber machine guns spouting sound and flame at me.

I dived for the shelter of a bamboo patch and one of my outflung hands touched the bloody face of a dead man.

The P-51 roared overhead. The pilot banked sharply and came back down the valley again. The guns started. Death drummed toward me once more. I cowered beside the dead Commie in some wild hope that his body could shelter my still living flesh.

The bullets marched toward me, making nasty slapping noises in the mud, sending up miniature water spouts. God . . . this time sure . . . (Continued on page 44)

ACTION FOR MEN, September 1964; art by Al Rossi

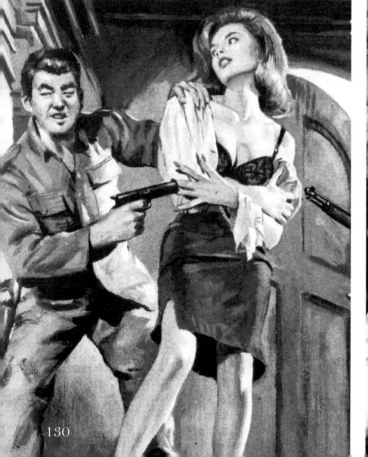

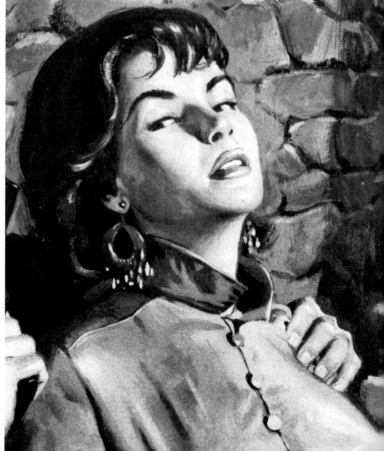

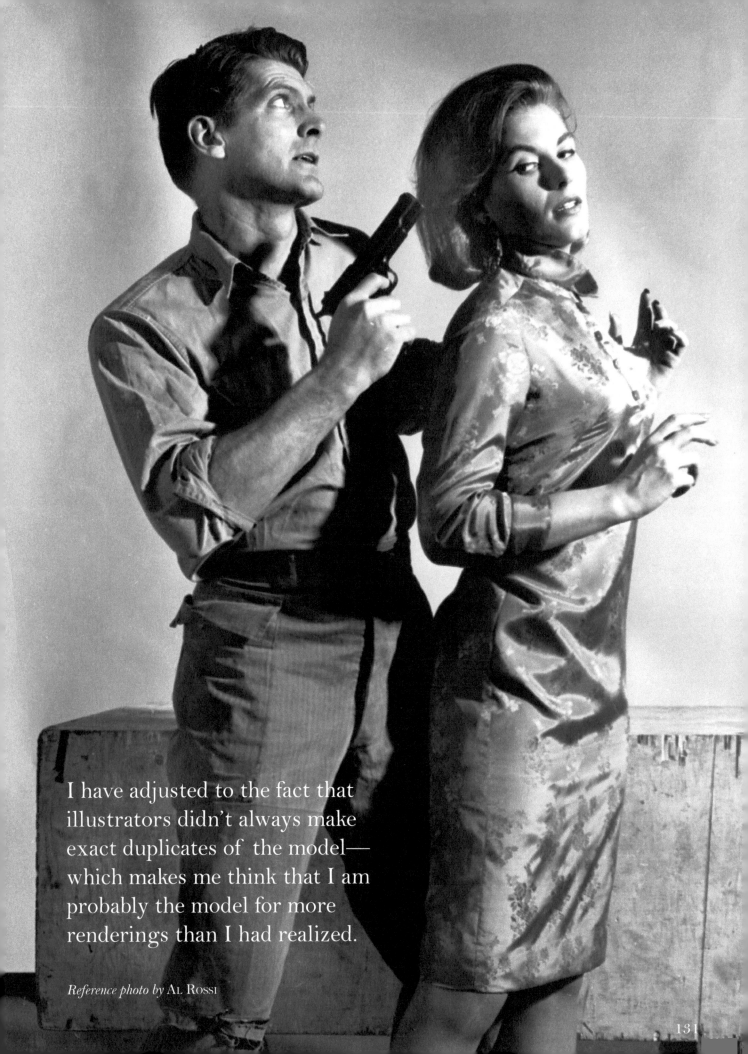

I have adjusted to the fact that illustrators didn't always make exact duplicates of the model— which makes me think that I am probably the model for more renderings than I had realized.

Reference photo by Al Rossi

A MARRIED WOMAN...A SECRET LOVER...
A REMOTE BAYOU RENDEZVOUS.

THE FRANKLY TOLD STORY OF
AN EROTIC PASSION THAT EXPLODES
INTO LUST AND VIOLENCE!

B 253
35¢
K

NUDE IN THE SAND

John Burton Thompson

HER VOLUPTUOUS CURVES SET OFF A
BOMBSHELL OF THROBBING DESIRE!

When hubby was away, this wife liked to play...

SUMMER WIDOW

Florence Stonebraker

WHAT DID THE BEACH-
BOYS HAVE THAT HER
HUSBAND DIDN'T?
MAGGIE MEANT TO
FIND OUT — AND DID!

B394
35¢
K

A Fascinating Study
Of Marital Infidelity

STRANGE LOVERS

Dan Bartell

S75151
MAC
75¢

Tender girls,
older men, wives
craving hot young
lust—swinging together!

1959 1961 1964

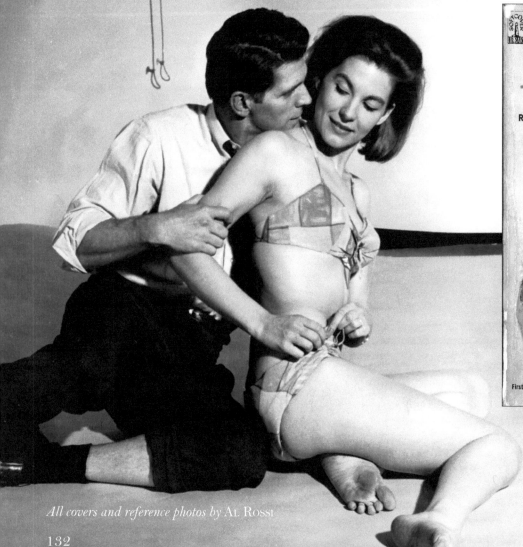

B890X
60¢
K

Suburbia After Dark

A NOVEL WITH A DARING THEME:

Restless women who make themselves more available
than younger girls—to any boy with nerve!

CARLTON GIBBS

First time in print

1965

All covers and reference photos by AL ROSSI

NYMPHOMANIA—AND WORSE—RAGED
AMONG THE FEMALE INMATES

B914X
60¢
K

COVER LIBRARY

WOMEN'S WARD

The savage sex and humiliation
heaped on a girl supposedly
confined for protection from
her own compulsions!

FIRST TIME IN PRINT

ORRIE HITT

1966

SHEILA WAS A YOUNG WIDOW—
BEAUTIFUL, PASSIONATE, LONELY!

the empty bed

Louis Lorraine

THE WILD
SUBURBAN
SEX PARTIES
REPELLED
BUT EXCITED HER.
A TORRID AFFAIR
WITH A MARRIED MAN
LEFT HER
TWISTED WITH GUILT.
BUT NOTHING
COULD STILL HER
HUNGER FOR LOVE!

BEACON
SIGNAL
B567F
50¢
K

1966

These covers are by Al Rossi, but I modeled for other artists for paperbacks as well; I wish I had
kept better records. The only ones I owned were copies I chanced to find. But all the paperback
books with me on the cover that I had collected were ruined in a rainstorm a few years ago, when
there was a leak in the garage.

133

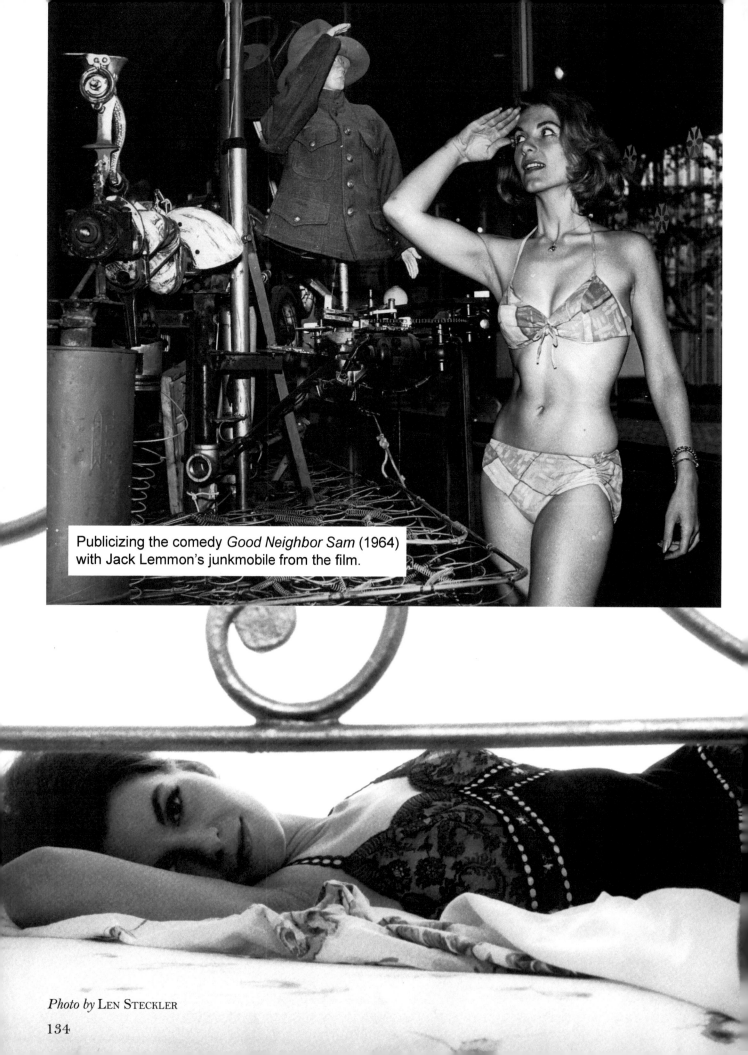

Publicizing the comedy *Good Neighbor Sam* (1964) with Jack Lemmon's junkmobile from the film.

Photo by LEN STECKLER

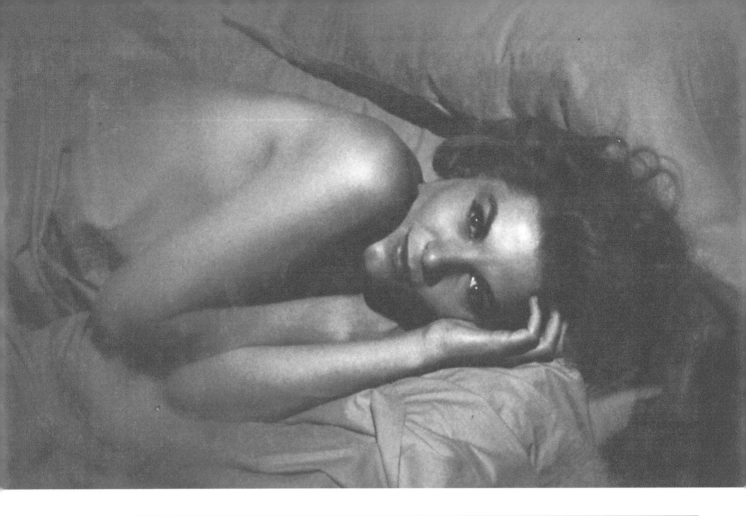

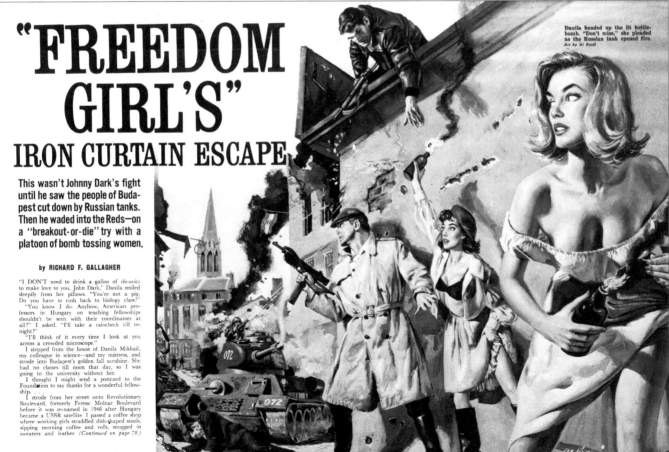

"FREEDOM GIRL'S"
IRON CURTAIN ESCAPE

This wasn't Johnny Dark's fight until he saw the people of Budapest cut down by Russian tanks. Then he waded into the Reds—on a "breakout-or-die" try with a platoon of bomb tossing women.

by RICHARD F. GALLAGHER

"I DON'T need to drink a gallon of *slivovitz* to make love to you, John Dark," Danila smiled sleepily from her pillows. "You're not a pig. Do you have to rush back to biology class?"

"You know I do. Anyhow, American professors in Hungary on teaching fellowships shouldn't be seen with their coordinators at all?" I asked. "I'll take a raincheck till tonight?"

"I'll think of it every time I look at you across a crowded microscope."

I stepped from the house of Danila Mikhail, my colleague in science—and my mistress—and strode into Budapest's golden fall sunshine. She had no classes till noon that day, so I was going to the university without her.

I thought I might send a postcard to the Foundation to say thanks for a wonderful fellowship. . . .

I strode from her street onto Revolutionary Boulevard, formerly Ferenc Molnar Boulevard before it was re-named in 1946 after Hungary became a USSR satellite I passed a coffee shop where working girls straddled dish-shaped stools, sipping morning coffee and rolls, snugged in sweaters and leather *(Continued on page 78)*

Danila handed up the lit bottle-bomb. "Don't miss," she pleaded as the Russian tank opened fire.
Art by Al Rossi

32

33

FOR MEN ONLY, June 1964; art by Al Rossi

MAN'S BOOK, February 1965; art by Norm Eastman

WORLD OF MEN, April 1965; art by Norm Eastman

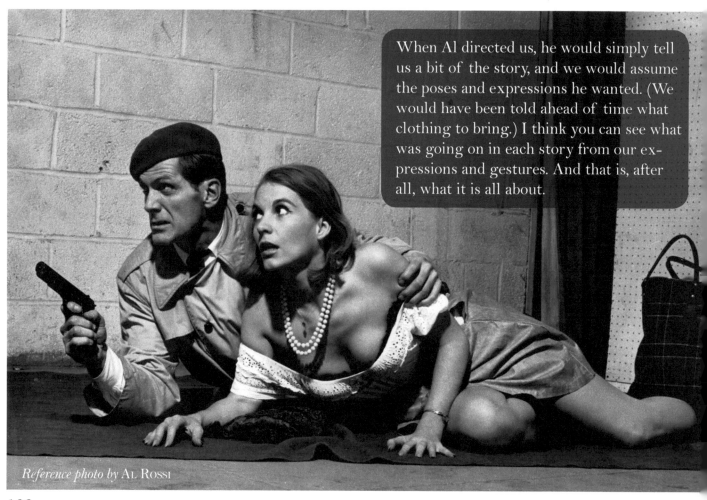

When Al directed us, he would simply tell us a bit of the story, and we would assume the poses and expressions he wanted. (We would have been told ahead of time what clothing to bring.) I think you can see what was going on in each story from our expressions and gestures. And that is, after all, what it is all about.

Reference photo by AL ROSSI

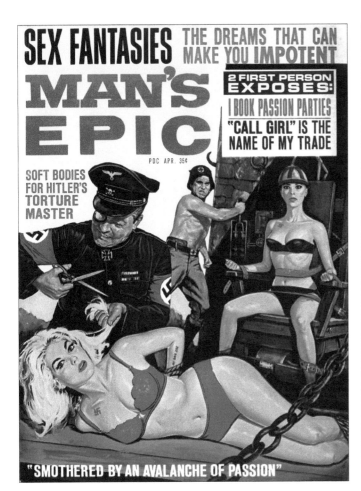

MAN'S EPIC, April 1965; art by Norm Eastman

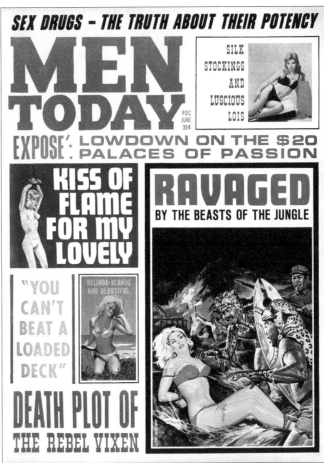

MEN TODAY, June 1965; art by Norm Eastman

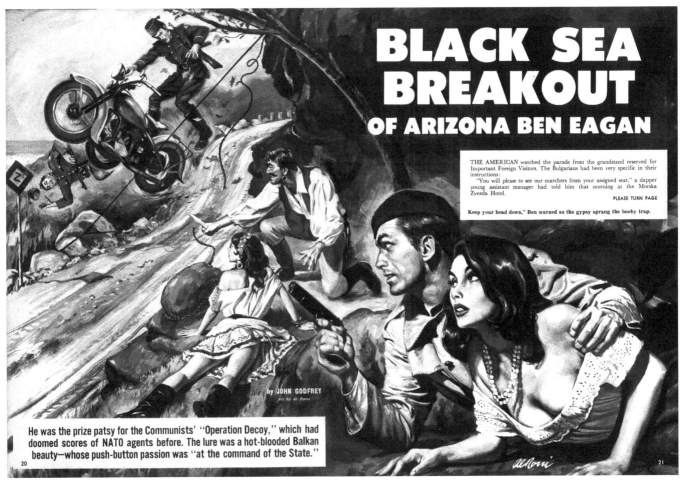

FOR MEN ONLY, March 1965; art by Al Rossi

MAN'S STORY, May 1965; art by Norm Eastman

I showed my scrapbook of Eastman covers to some old friends, and I noticed that they were uncomfortable with the covers showing the swastika. I look at his renderings as depicting how awful the Nazis were. Who can argue with that? I personally think that Norm Eastman is the best illustrator of his era, and I am totally happy to have been able to work with him as much as I did.

He was a very gentle man, who you would not think could be capable of devising so much torture—and often including himself as a villain! He was very easy to work with, and never made a pass at me. He treated me with total respect.

Unfortunately I never saw any of his paintings or works in progress, and I never saw any of the magazines that he did the covers for. I have since collected some of the magazines, but I am sure that I don't have them all. (I never saw many of the covers included in this book until we started work on it.)

I so deeply regret not getting back to Norm years ago. I had lived in Germany for three years, 1972 'til 1975, with my second husband, a lieutenant in the US Army. While there, I worked for the Army as a music and theatre director, organizing USO shows and directing and acting in various plays. Upon returning to Los Angeles in 1976, we realized that our marriage was over and started divorce proceedings.

In the middle of all that, I got a call from Norm, who had just landed in California. I have no idea how he got my number, since I had just returned from Germany and moved into a new apartment, and I had a different last name!

We chatted a while about his move to California. He said that he wanted to live here, and asked my advice about what to charge for photos for actors who would need them. He wondered if $50 would be too much. I told him that he was worth a whole lot more than that! I also told him that my life was in total flux at the time, and that we should get in touch later. But when later came,

I had no idea how to reach him.

Time went by, a lot of time. Then one day I came across something online about him, posted by a gallery here in L.A. I then started searching to get more information, only to find out that he was no longer alive. It felt like a knife went through my heart. When I was young, I had the idea that all the people I cared for would always be there. Now, most of the people I have cared for and/or loved in my life are gone. In Norm's case, I wish I had searched for him sooner, so we could have made a plan to get together. I would have loved to have known how and what he was doing, what had happened to him. When I finally tried to find him, it was too late.

When I worked for him in New York (which was often), he was always a lot of fun, and always respectful. I know he liked me and that he liked to work with me, but he was always a gentleman, and never made a pass at me. I have the book *Men's Adventure Magazines* (Taschen, 2004), and I was very pleased and very proud to read in his interview there that I was one of his favorite models.

He was always unassuming, and a bit shy. I had the feeling that he had no idea how good he was. I still think he's the best of all the illustrators whose work I have seen; I only wish that I could have been able to tell him so. He was one of the people in my life who I appreciate so very much, for everything that he was.

He was my favorite person to work with, but I never spent any time with him except when we were working together. I couldn't even remember where his apartment was, until I found an old address book and it occurred to me that Norm's address could be in it; it was. *Norm Eastman … 135 East 34th Street, NYC…*and an obsolete phone number, *MU92483*—that stands for Murray Hill. (That was before they changed it to all numbers.)

It gave me a little pull on the heartstring to find it. But sadly, it is just another thing from the past that I can't get back.

Opposite: Model for both women: Eva Lynd. As the shirtless tormentor: fellow illustration artist Mark Schneider. The Nazi officer is Norm Eastman.

MAN'S STORY, July 1965; art by Norm Eastman

MAN'S BOOK, October 1965; art by Norm Eastman

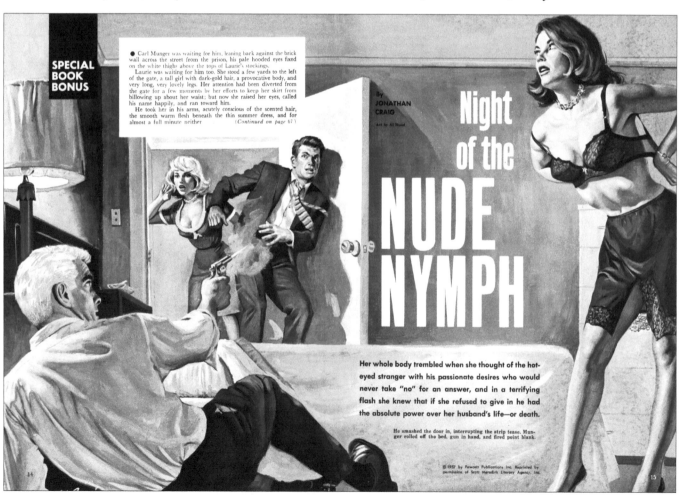

ACTION FOR MEN, June 1965; art by Al Rossi

By
JONATHAN
CRAIG

Art by Al Rossi

Night of the NUDE NYMPH

Her whole body trembled when she thought of the hot-eyed stranger with his passionate desires who would never take "no" for an answer, and in a terrifying flash she knew that if she refused to give in he had the absolute power over her husband's life—or death.

He smashed the door in, interrupting the strip tease. Munger rolled off the bed, gun in hand, and fired point blank.

141

MEN TODAY, November 1965; art by Norm Eastman

MAN'S BOOK, December 1965; art by Norm Eastman

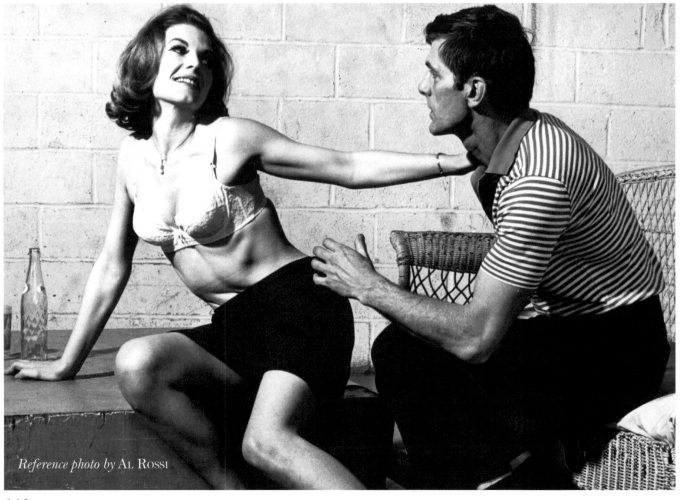

Reference photo by AL ROSSI

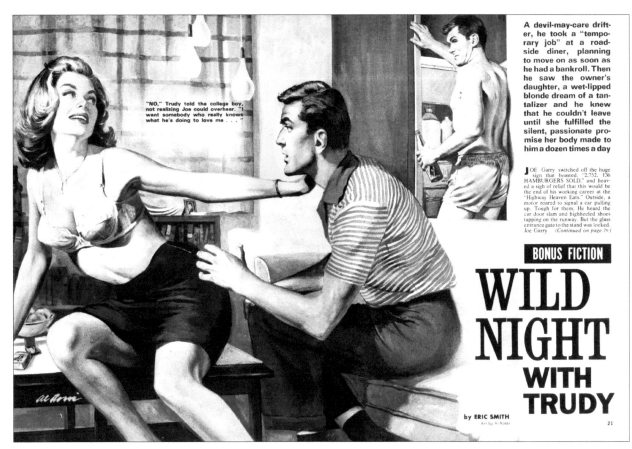

A devil-may-care drifter, he took a "temporary job" at a roadside diner, planning to move on as soon as he had a bankroll. Then he saw the owner's daughter, a wet-lipped blonde dream of a tantalizer and he knew that he couldn't leave until she fulfilled the silent, passionate promise her body made to him a dozen times a day

JOE Garry switched off the huge sign that boasted, "2,752, 136 HAMBURGERS SOLD." and heaved a sigh of relief that this would be the end of his working career at the "Highway Heaven Eats." Outside, a motor roared to signal a car pulling up. Tough for them. He heard the car door slam and highheeled shoes tapping on the runway. But the glass entrance gate to the stand was locked. Joe Garry *(Continued on page 79)*

BONUS FICTION

WILD NIGHT WITH TRUDY

by ERIC SMITH
Art by Al Rossi

21

"NO," Trudy told the college boy, not realizing Joe could overhear, "I want somebody who really knows what he's doing to love me . . ."

TRUE ADVENTURES, January 1967; art by Al Rossi

A devil-may-care drifter, he took a "temporary job" at a roadside diner, planning to move on as soon as he had a bankroll. Then he saw the owner's daughter, a wet-lipped blonde dream of a tantalizer and he knew that he couldn't leave until she fulfilled the silent, passionate promise her body made to him a dozen times a day

JOE Garry switched off the huge sign that boasted. "2,752,136 HAMBURGERS SOLD". and heaved a sigh of relief that this would be the end of his working career at the "Highway Heaven Eats." Outside, a motor roared to signal a car pulling up. Tough for them. He heard the car door slam and highheeled shoes tapping on the runway. But the glass entrance gate to the stand was locked. Joe Garry *(Continued on page 64)*

Fiction Bonus SPECIAL

Hot AFTER TRUDY

By Erik Broske
Art By Al Rossi

41

"NO," Trudy told the college boy, not realizing Joe could overhear, "I want somebody who really knows what he's doing to love me . . ."

MAN'S WORLD, August 1965; art by Al Rossi

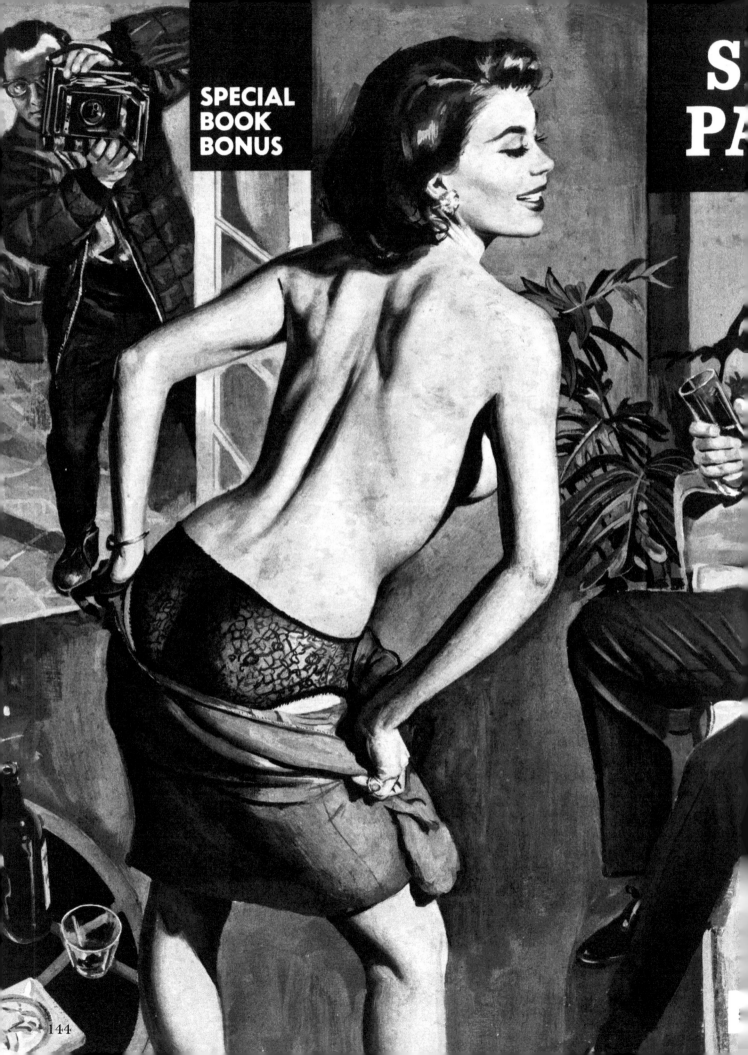

144

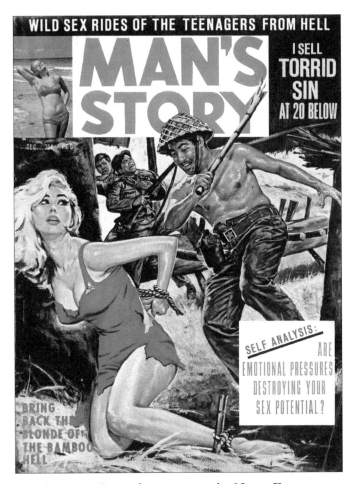

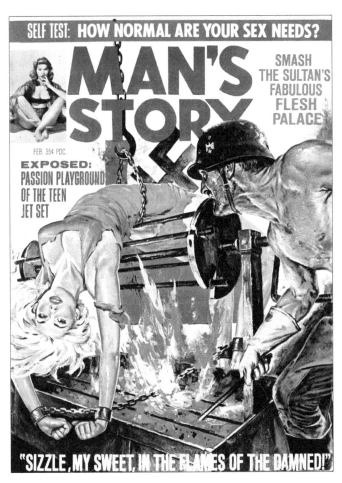

MAN'S STORY, December 1965; art by Norm Eastman MAN'S STORY, February 1966; art by Norm Eastman

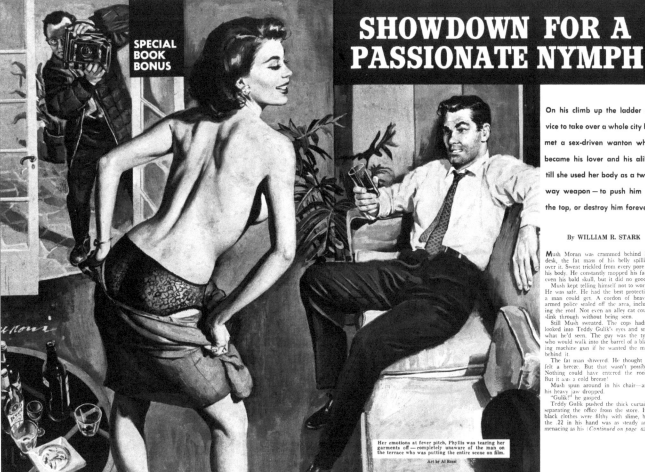

COMPLETE MAN, September 1965; art by Al Rossi

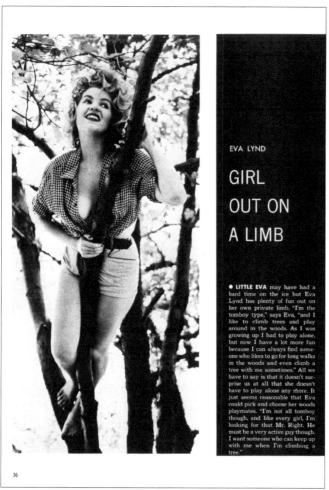

EVA LYND

GIRL OUT ON A LIMB

● **LITTLE EVA** may have had a hard time on the ice but Eva Lynd has plenty of fun out on her own private limb. "I'm the tomboy type," says Eva, "and I like to climb trees and play around in the woods. As I was growing up I had to play alone, but now I have a lot more fun because I can always find someone who likes to go for long walks in the woods and even climb a tree with me sometimes." All we have to say is that it doesn't surprise us at all that she doesn't have to play alone any more. It just seems reasonable that Eva could pick and choose her woods playmates. "I'm not all tomboy though, and like every girl, I'm looking for that Mr. Right. He must be a very active guy though. I want someone who can keep up with me when I'm climbing a tree."

36

I played guitar and sang with a friend of mine from time to time, and suddenly we decided that we should have a singing act. We called ourselves *The Models*, and even got a brilliant composer friend of mine, Coleridge-Taylor Perkinson, to write arrangements for us. We should have stayed with the guitar playing and singing, because the more complex act never quite made it.

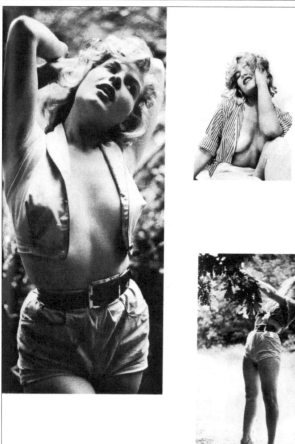

37

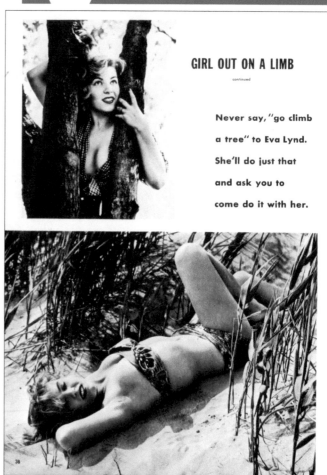

GIRL OUT ON A LIMB

continued

Never say, "go climb a tree" to Eva Lynd. She'll do just that and ask you to come do it with her.

38

MAN'S TRUE DANGER, December 1965 (originally in **MAN'S ACTION**, July 1959); photos by Ed Lettau

146

The Models

Exclusive Management: ROD SMITH
GKS ASSOCIATES, INC.
7 Park Avenue, New York, N.Y.
YU 9-7903, 899-4772

Secret, shameless, violent nights —
as moral values crumble before the onslaught of:

THE SEX REBELS

BEACON
SIGNAL
SIXTY
B754X
60¢
K

A BOLD
NEW NOVEL
— mercilessly
unveiling the
scandals that
rock suburbia
today!

by Christopher Storm

1964

ACE
LIBRARY

First Time in Print

B848X
60¢
K

What happens when a pretty tramp
marries into suburban society?

SEX FEVER

Her husband did not know about
Laura's lurid past. She did not
know about his lurid present. It
took a lot of hectic cheating to
even the score!

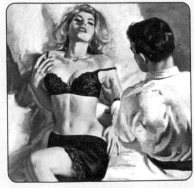

VAL MUNROE

1965

Art by Al Rossi

I don't recall if any of the
illustrators ever told me what
book covers I was posing for,
but I don't believe so. I wasn't
paid any differently for them,
either. I got paid by the hour
for all of it, and usually I only
worked an hour at a time.

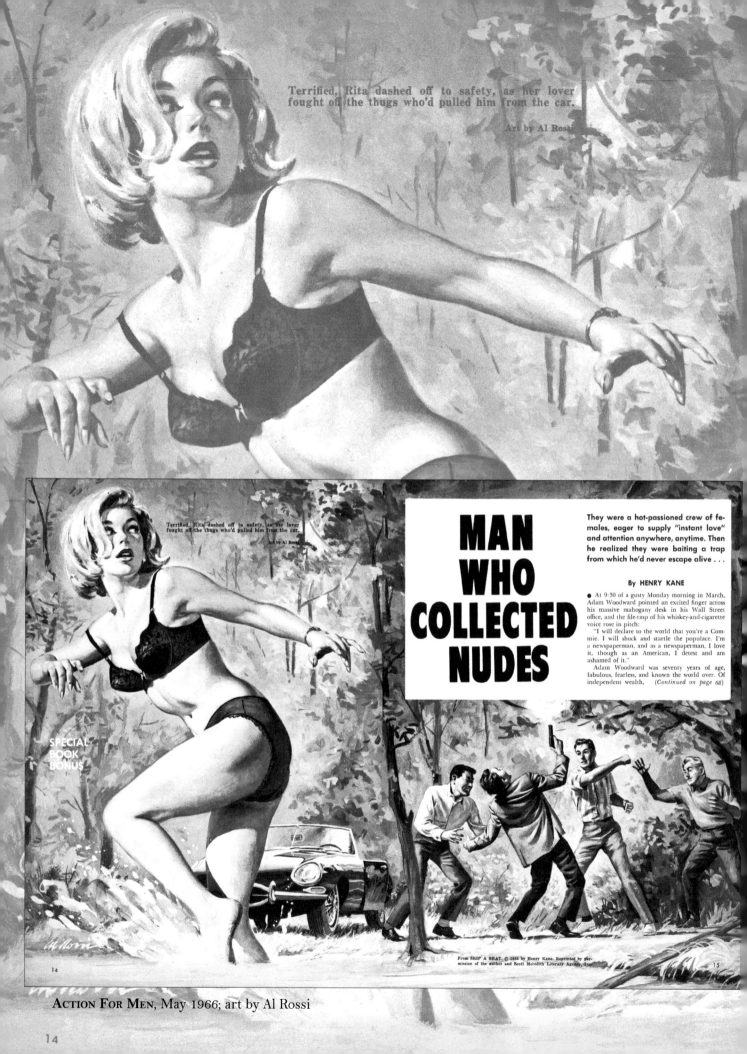

Terrified, Rita dashed off to safety, as her lover fought off the thugs who'd pulled him from the car.

Art by Al Rossi

SPECIAL BOOK BONUS

MAN WHO COLLECTED NUDES

By HENRY KANE

They were a hot-passioned crew of females, eager to supply "instant love" and attention anywhere, anytime. Then he realized they were baiting a trap from which he'd never escape alive . . .

● At 9:30 of a gusty Monday morning in March, Adam Woodward pointed an excited finger across his massive mahogany desk in his Wall Street office, and the file-rasp of his whiskey-and-cigarette voice rose in pitch:

"I will declare to the world that you're a Commie. I will shock and startle the populace. I'm a newspaperman, and as a newspaperman, I love it, though as an American, I detest and am ashamed of it."

Adam Woodward was seventy years of age, fabulous, fearless, and known the world over. Of independent wealth, *(Continued on page 68)*

14

15

ACTION FOR MEN, May 1966; art by Al Rossi

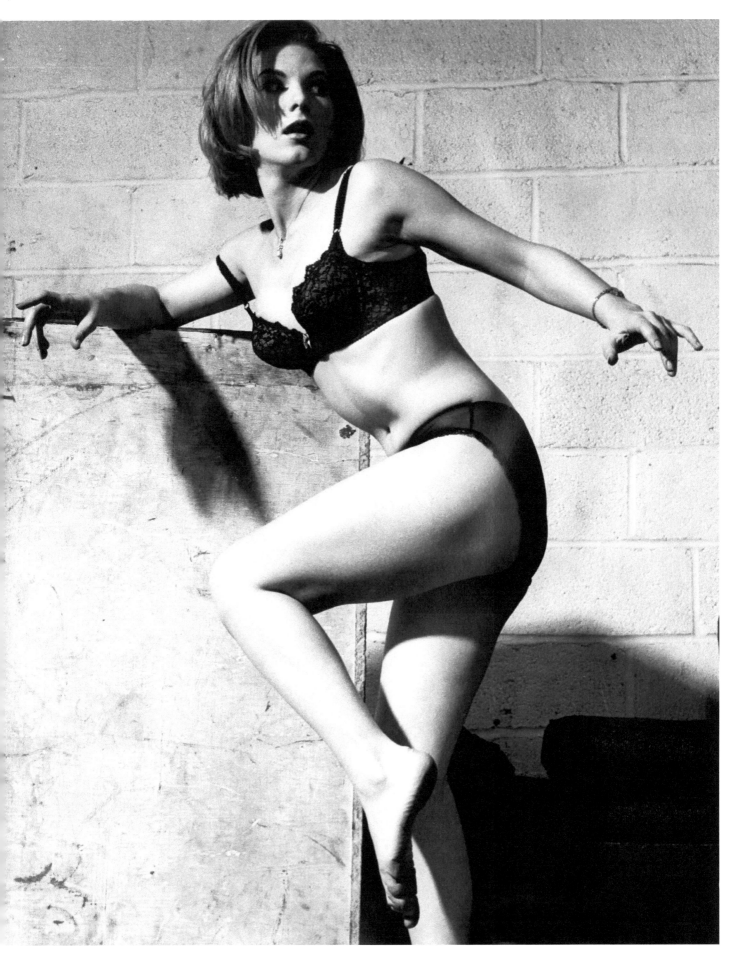

Reference photo by AL ROSSI

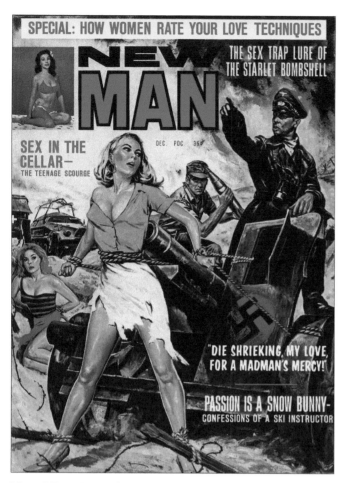

NEW MAN, December 1965; art by Norm Eastman

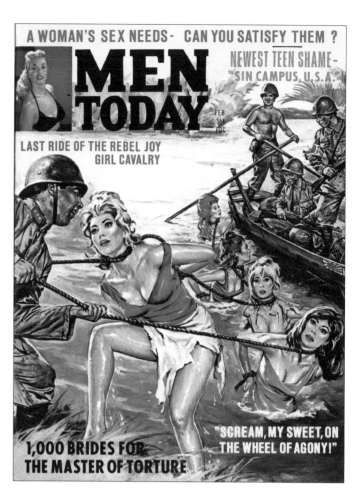

MEN TODAY, February 1966; art by Norm Eastman

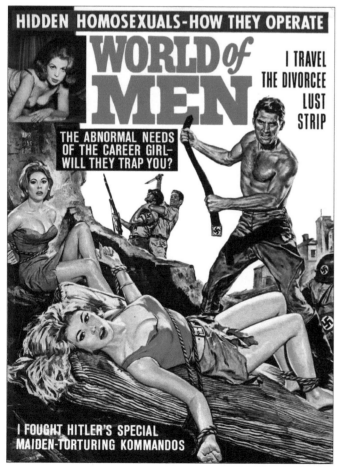

WORLD OF MEN, April 1966; art by Norm Eastman

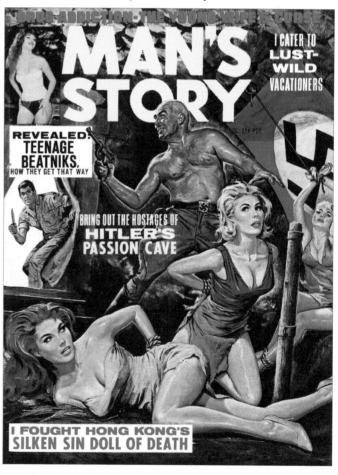

MAN'S STORY, August 1966; art by Norm Eastman

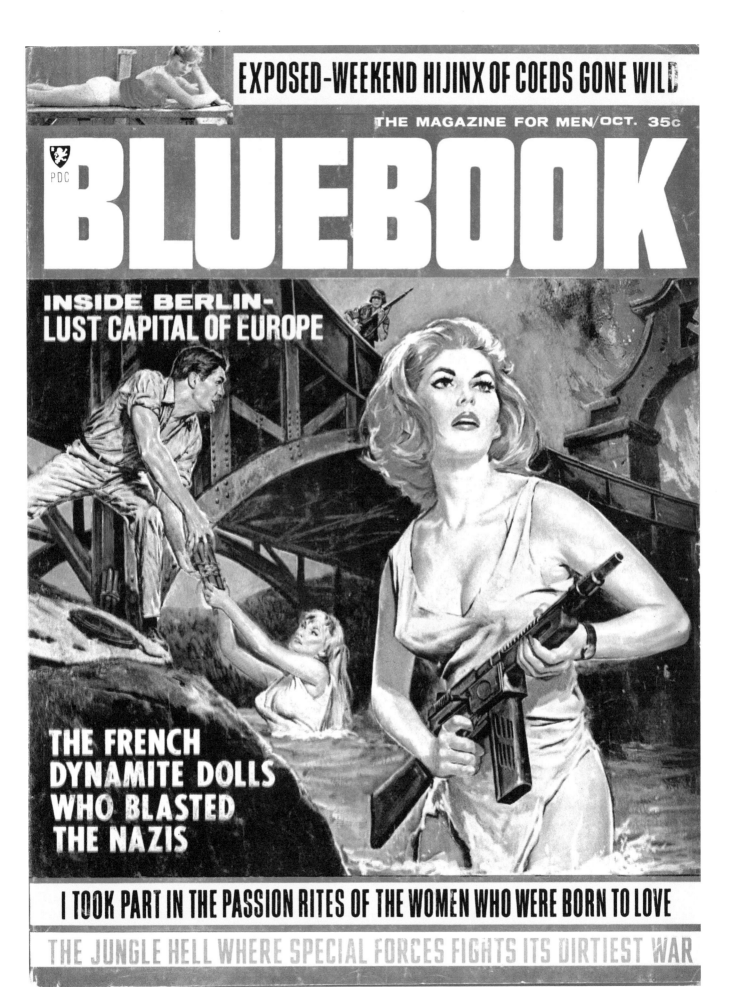

EXPOSED-WEEKEND HIJINX OF COEDS GONE WILD

THE MAGAZINE FOR MEN/OCT. 35c

BLUEBOOK

INSIDE BERLIN-
LUST CAPITAL OF EUROPE

THE FRENCH
DYNAMITE DOLLS
WHO BLASTED
THE NAZIS

I TOOK PART IN THE PASSION RITES OF THE WOMEN WHO WERE BORN TO LOVE

THE JUNGLE HELL WHERE SPECIAL FORCES FIGHTS ITS DIRTIEST WAR

BLUEBOOK, October 1966; art by Norm Eastman

Thom Ward

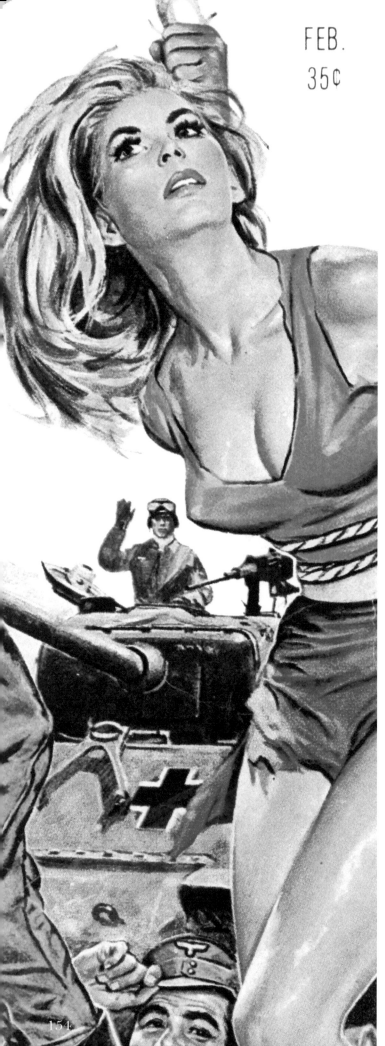

FEB.
35¢

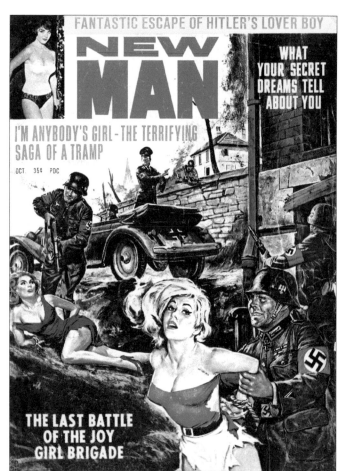

New Man, October 1966; art by Norm Eastman

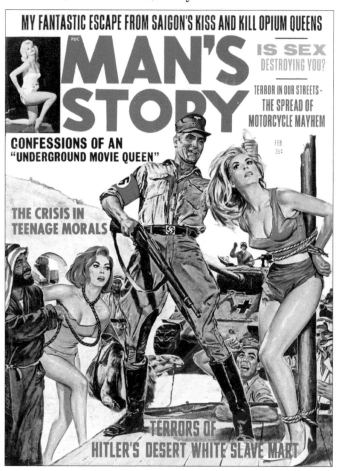

Man's Story, February 1967; art by Norm Eastman

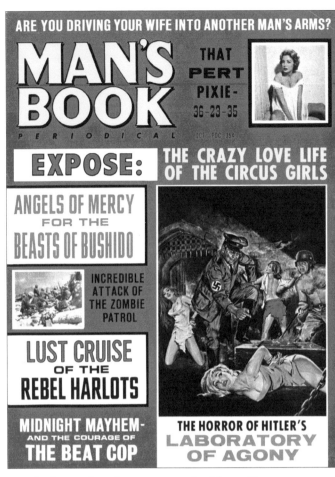

MAN'S BOOK, October 1966; art by Norm Eastman

Sometimes it is a challenge to identify me in the Eastman paintings, because he chose physically similar models. When I don't look exactly like me, my obvious tell-tale signs are:

- a slight bump on my left clavicle, caused by a fracture when I was 14
- my slightly cleft chin
- the necklace I wore in at least four of his paintings: a pendant on a chain, with a pearl on each end and three connecting sapphires
- hammer toes
- Norm painted what he saw, so no wrinkles on my forehead, except a slight suggestion of such in some paintings. (The reason I don't have forehead wrinkles *to this day* is because I trained myself *not* to wrinkle my forehead!)

Also, there is the time period. I didn't meet Norm Eastman until late 1963, so anything before that is not me. However, I worked for Al Rossi both in the late '50s and mid- to late '60s. Additionally, reprints appeared long after I stopped modeling.

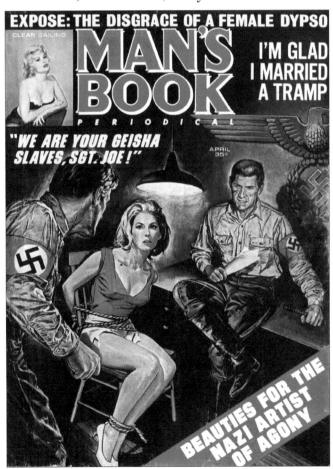

MAN'S BOOK, April 1967; art by Norm Eastman

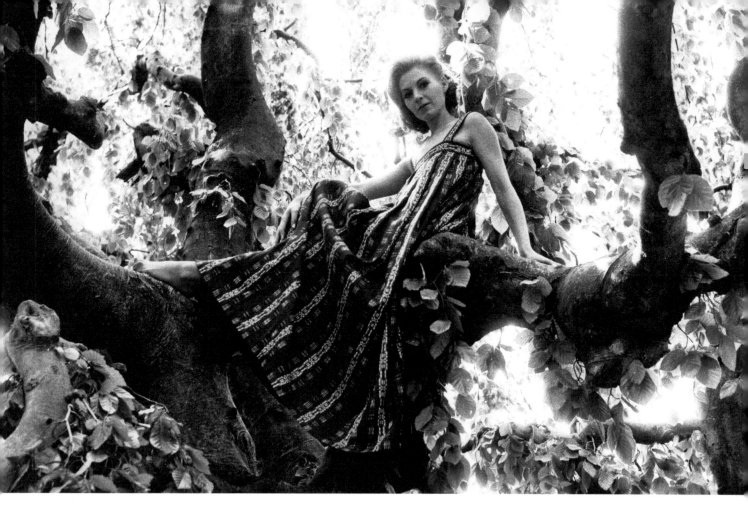

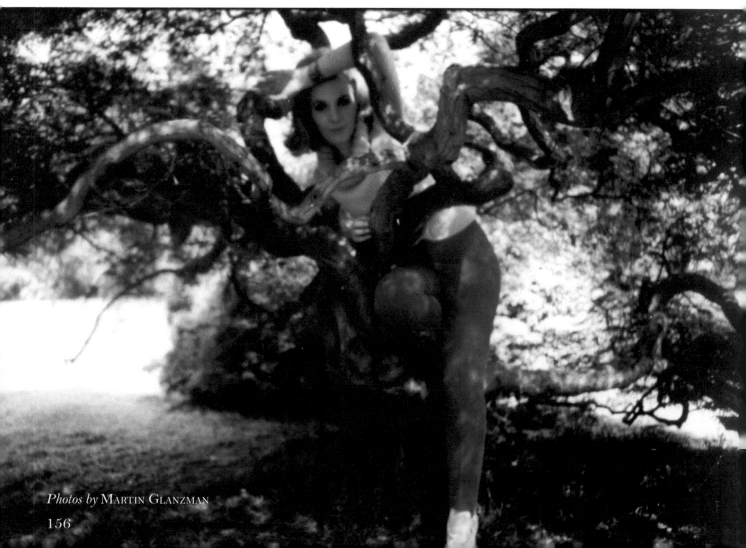

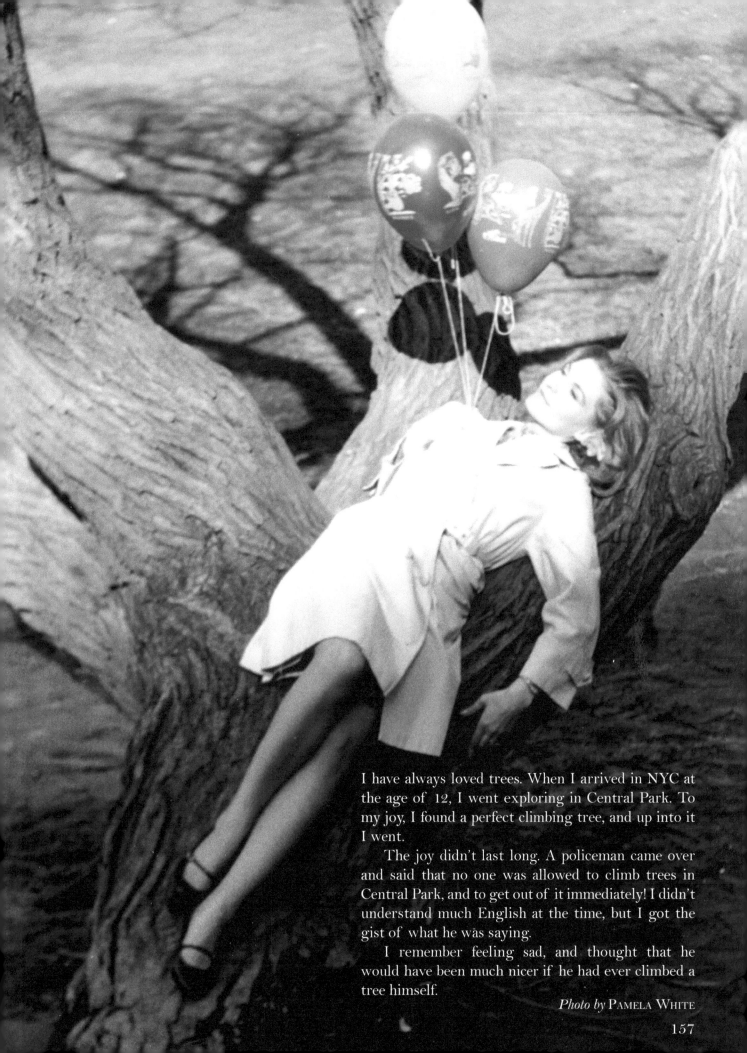

I have always loved trees. When I arrived in NYC at the age of 12, I went exploring in Central Park. To my joy, I found a perfect climbing tree, and up into it I went.

The joy didn't last long. A policeman came over and said that no one was allowed to climb trees in Central Park, and to get out of it immediately! I didn't understand much English at the time, but I got the gist of what he was saying.

I remember feeling sad, and thought that he would have been much nicer if he had ever climbed a tree himself.

Photo by PAMELA WHITE

157

MEN TODAY, March 1967; art by Norm Eastman

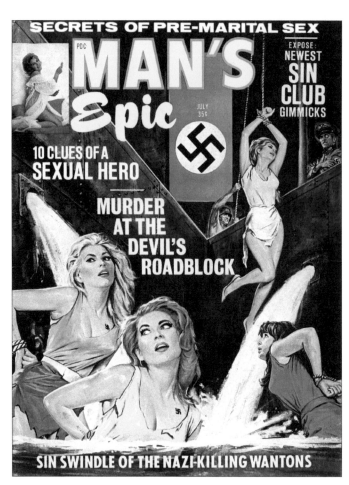

MAN'S EPIC, July 1967; art by Norm Eastman

MAN'S STORY, December 1967; art by Norm Eastman

Reference photo by NORM EASTMAN

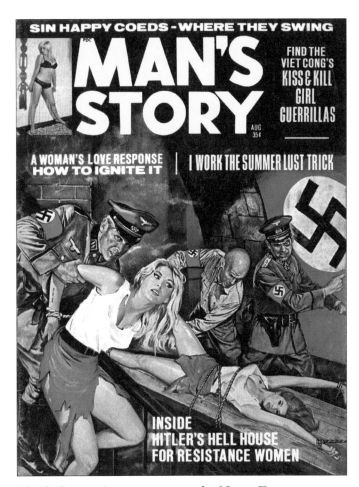

MAN'S STORY, August 1967; art by Norm Eastman

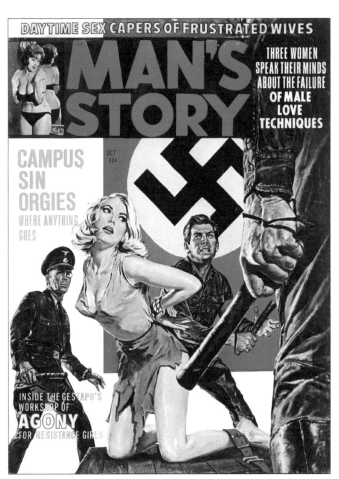

MAN'S STORY, October 1967; art by Norm Eastman

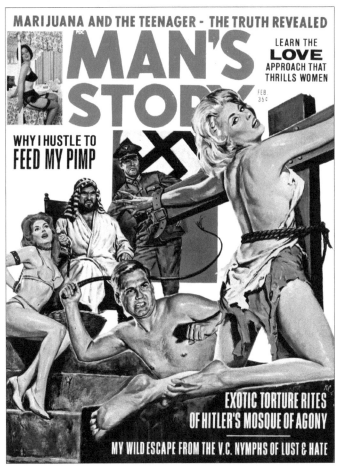

MAN'S STORY, February 1968; art by Norm Eastman

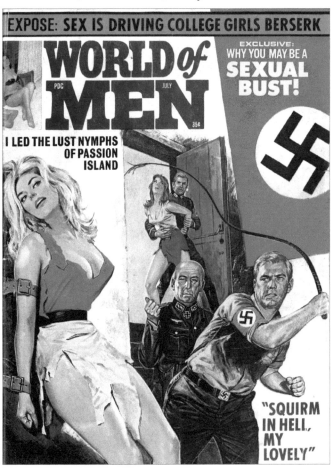

WORLD OF MEN, July 1968; art by Norm Eastman

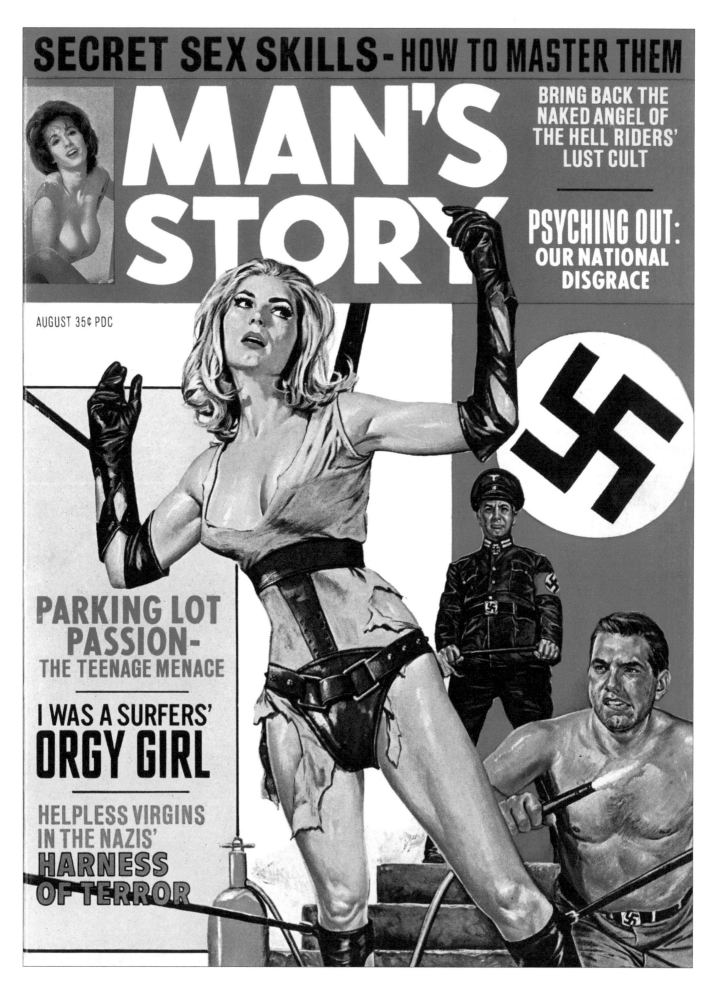

MAN'S STORY, August 1968; art by Norm Eastman

SELF TEST: SEX, ARE YOU RUINING YOUR LIFE FOR IT?

EXPOSE: THE PUNKS RUN WILD -
MID-SUMMER MADNESS, MURDER AND MAYHEM!

NEW MAN
PDC
AUG.
35¢

NEW LUST TECHNIQUE OF THE TEENAGE DIVORCEES

"SCREAM, MY SWEET, IN THE GESTAPO'S SEAT IN HELL!"

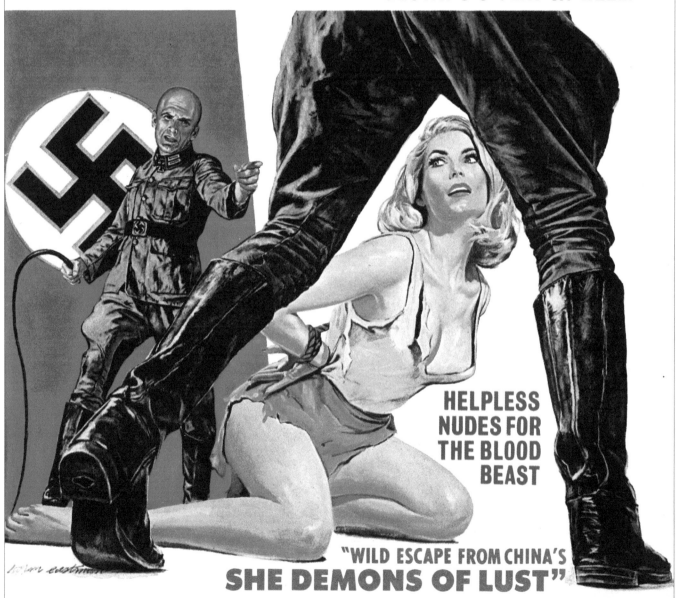

HELPLESS NUDES FOR THE BLOOD BEAST

"WILD ESCAPE FROM CHINA'S SHE DEMONS OF LUST"

THE WEST'S SIN WANTON WHO STRIPPED THE BOYS CLEAN

NEW MAN, December 1968; art by Norm Eastman

Whether portraying a heroine or a victim, you have to show the emotion of these situations. The heroine is strong and in charge; the victim, intimidated and frightened. As I have said, whatever you are thinking, and feeling will show up in the face and attitude of the person you are portraying. When doing a strong character, it seems that I stand up straighter, head held high, with thoughts of *"I am in charge of this."* There is a lot of positive energy that goes into those poses…feel-good energy.

Naturally, it is more fun being a heroine than a victim, but you have to give both the same emotional energy: one of positive strength, and the other of negative passivity. I suppose there has to be the a little of both of these characteristics in me for me to be able to portray these images. But it isn't anything I have really contemplated; it is just something that happens at the time of the photo session.

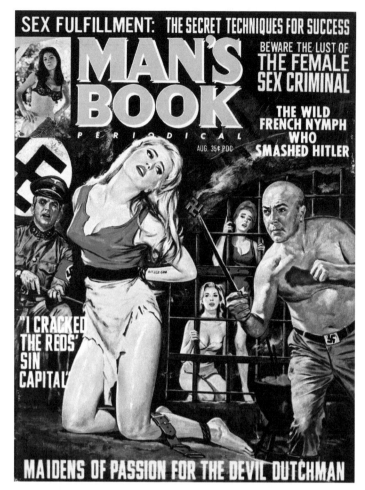

MAN'S STORY, August 1968; art by Norm Eastman

Reference photo by NORM EASTMAN

162

MAN'S CONQUEST, August 1968; art by Norm Eastman

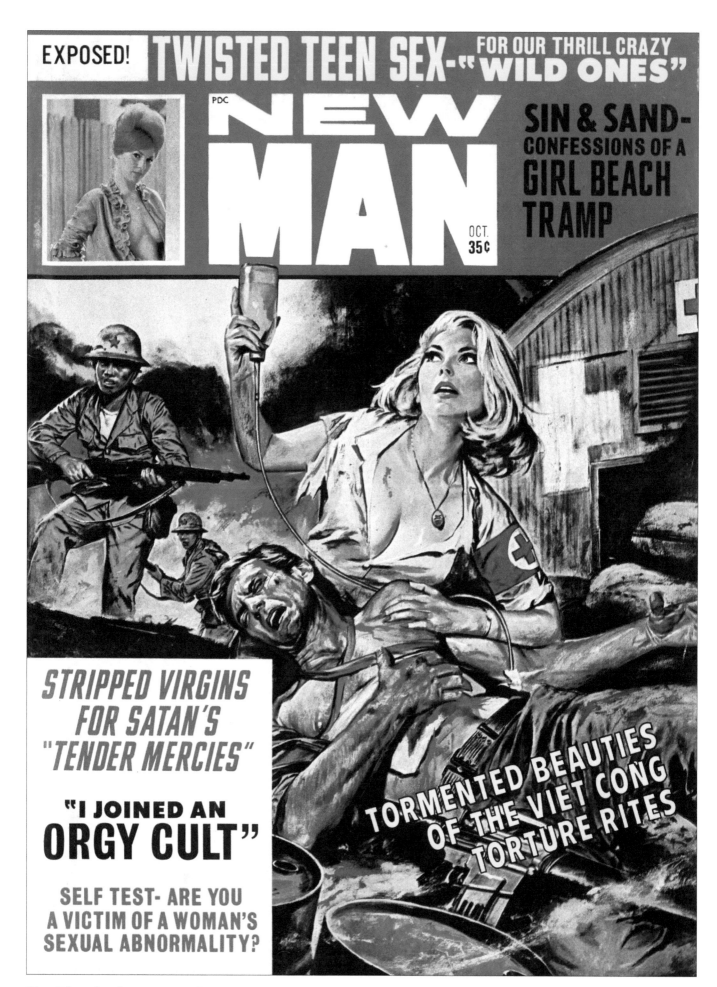

EXPOSED! **TWISTED TEEN SEX**—"FOR OUR THRILL CRAZY **"WILD ONES"**

PDC
NEW MAN

OCT.
35¢

SIN & SAND—
CONFESSIONS OF A
**GIRL BEACH
TRAMP**

**STRIPPED VIRGINS
FOR SATAN'S
"TENDER MERCIES"**

**"I JOINED AN
ORGY CULT"**

**SELF TEST- ARE YOU
A VICTIM OF A WOMAN'S
SEXUAL ABNORMALITY?**

**TORMENTED BEAUTIES
OF THE VIET CONG
TORTURE RITES**

NEW MAN, October 1968; art by Norm Eastman

164

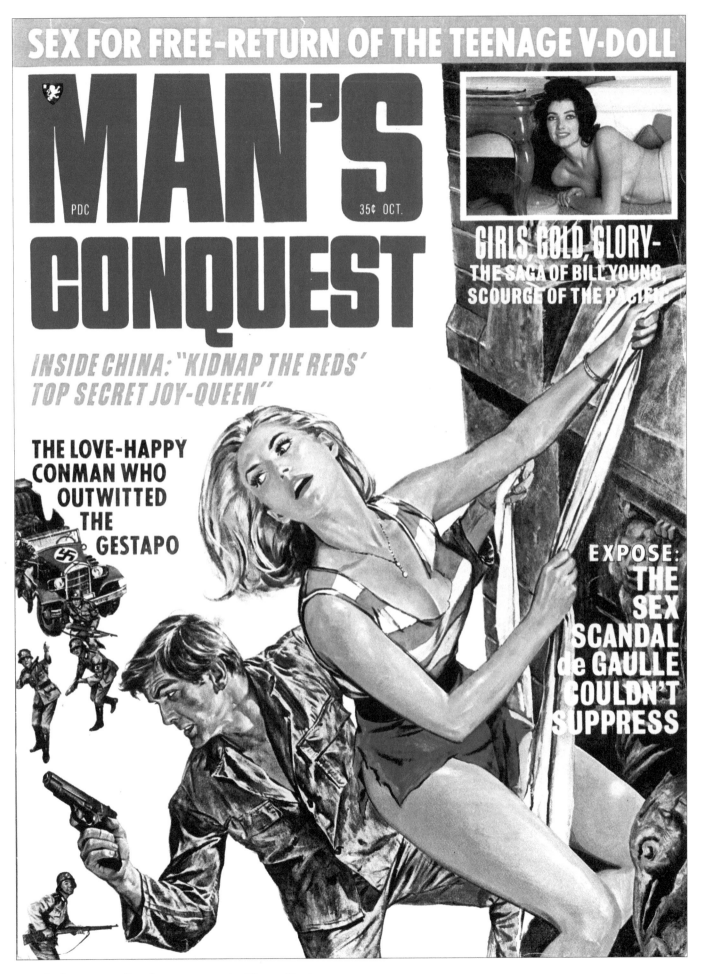

MAN'S CONQUEST, October 1968; art by Norm Eastman

DON BECK

We were hired for the day, probably for about $250, and we drove out somewhere on Long Island. It was a relaxed afternoon, because we were hired for the day and not for the hour; so there was no rush. There was a German Shepherd with us that must have belonged to Don. I remember that we had a good time, but I think it is the only time I worked with that male model.

I have never seen any of these photos in print, so I don't know what he had in mind. But that was a stiff modeling fee to pay just for the fun of it!

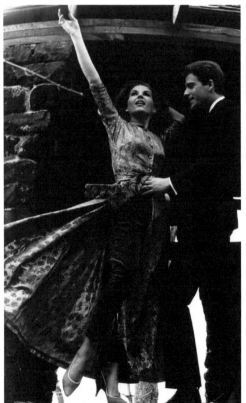
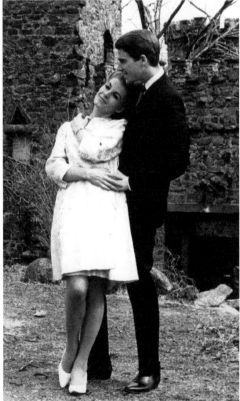
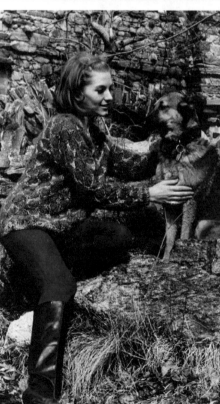

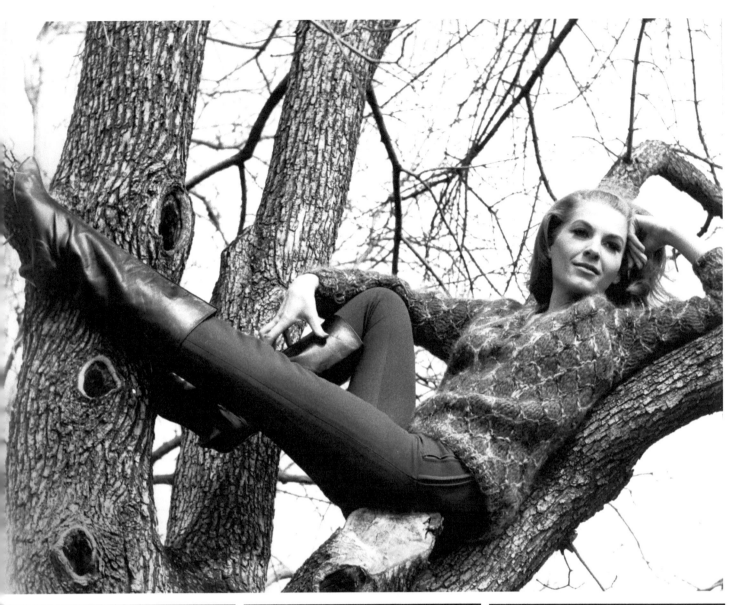

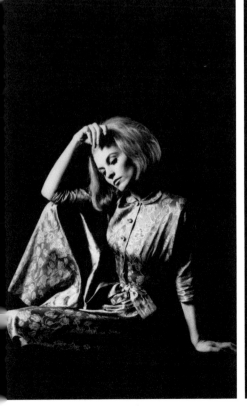

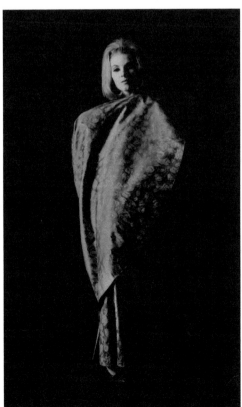

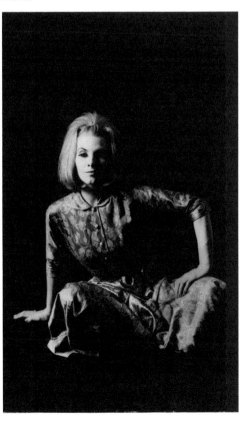

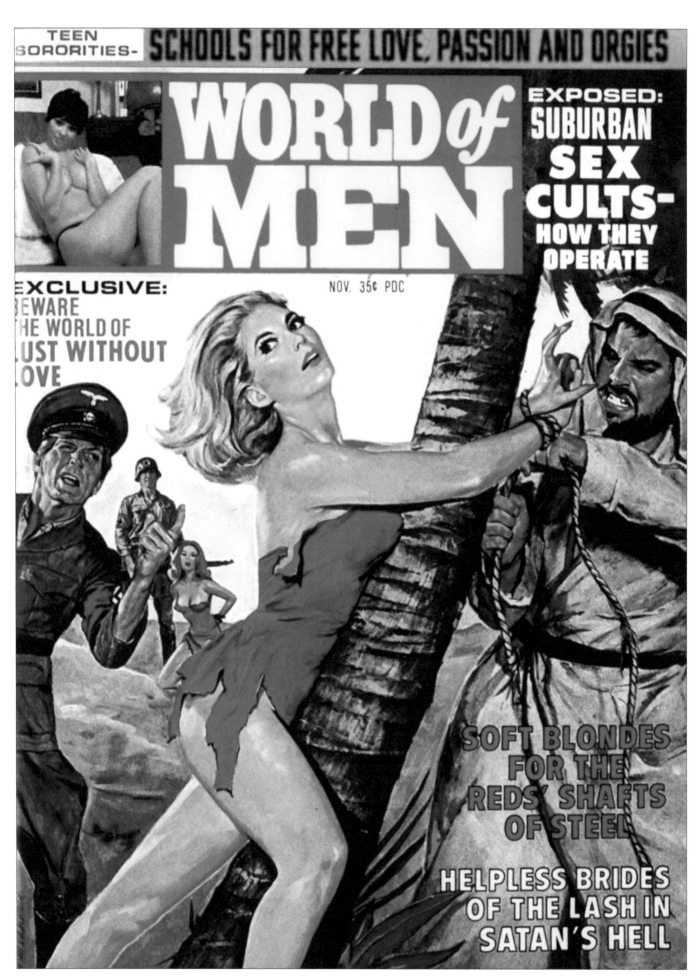

WORLD OF MEN, November 1968; art by Norm Eastman

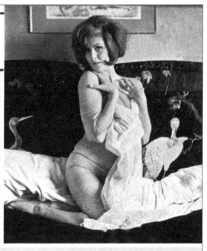

EXPOSED—SEX PILLS THAT ARE MAKING TEEN GIRLS NYMPHOS

THE "HELL" OF THE YOUNG WIFE

PDC

NEW MAN

DEC. 35¢

TRAPPED BY THE VIET CONG
MONSOON OF LUST

THE PASSION DECOYS
WHO BLASTED THE NAZIS

A CALL GIRL TELLS ALL:
"I CATER TO THE WEIRD WHIMS OF MY CUSTOMERS"

TORTURE RANCH FOR THE DEVIL'S DAUGHTERS

NEW MAN, December 1968; art by Norm Eastman

I don't remember when I first met **Steve Holland**, but it was probably the first time I worked for Al Rossi. I had no idea then that he was such a famous men's magazine model. (I also don't know if he knew who I was.) He and I would chat about this and that during the shoot, but he was always extremely busy, and would take off for another session elsewhere after we were done. We never spent time together when we were not working, and I have no idea what his private life was like. When we were done with a session, we went our separate ways. I just know that we worked together incredibly well.

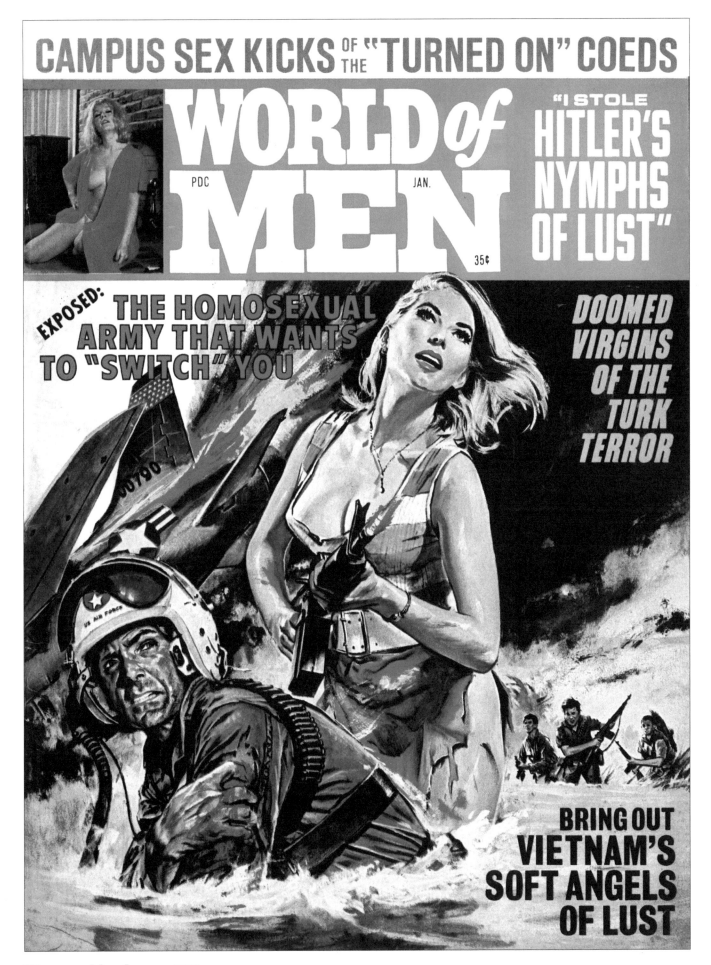

CAMPUS SEX KICKS OF THE "TURNED ON" COEDS

WORLD of MEN

PDC JAN. 35¢

"I STOLE HITLER'S NYMPHS OF LUST"

EXPOSED: THE HOMOSEXUAL ARMY THAT WANTS TO "SWITCH" YOU

DOOMED VIRGINS OF THE TURK TERROR

BRING OUT VIETNAM'S SOFT ANGELS OF LUST

WORLD OF MEN, January 1969

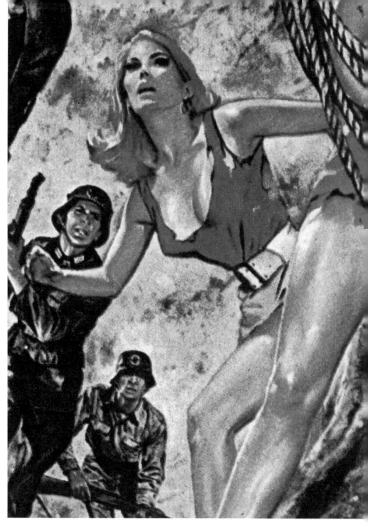

MAN'S STORY, February 1969; art by Norm Eastman

MAN'S CONQUEST, August 1969; art by Norm Eastman

Recycling of stories and artwork was common in men's adventure magazines, especially those with budgets on the lower end of the spectrum, like *Man's Story*. It was published from February 1960 to December 1975, making it one of the longest-running MAMs. But by the 1970s, the MAM genre was fading away, and the tight budgets of magazines like *Man's Story* became even more limited. This led to increased recycling of stories and artwork. One of the most blatant examples (featuring a cover Eva modeled for) is the April 1974 issue. It uses the same cover and the same cover stories as *Man's Story*, February 1970. It's not quite a complete duplicate, but only because there are some different pin-up photos and ads.

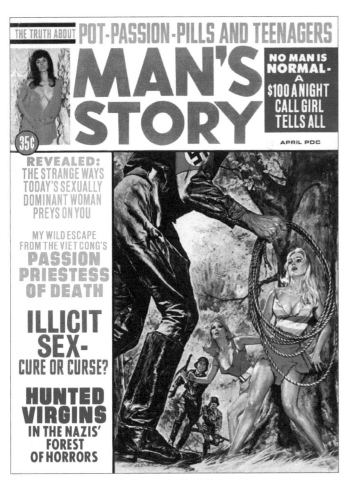

MAN'S STORY, April 1969; art by Norm Eastman

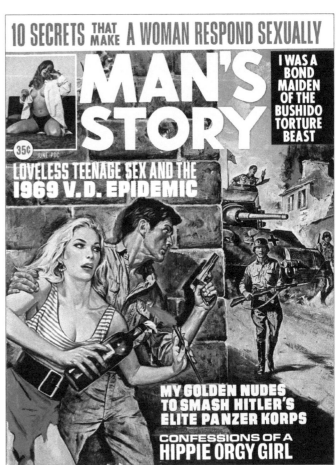

MAN'S STORY, June 1969; art by Norm Eastman

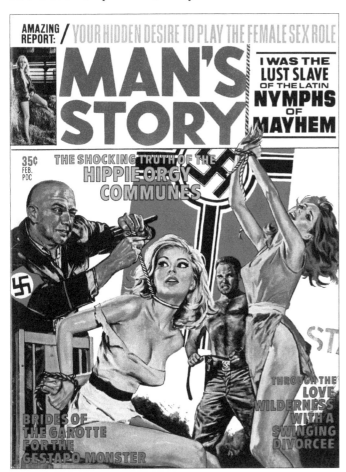

MAN'S STORY, February 1970; art by Norm Eastman

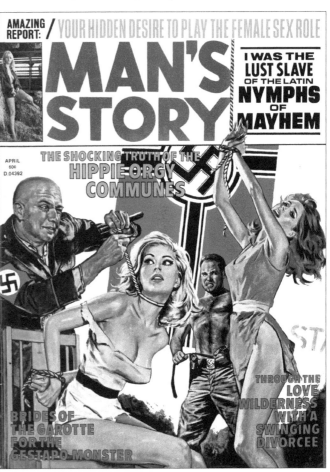

MAN'S STORY, April 1974; art by Norm Eastman

ALL ABOUT EVA

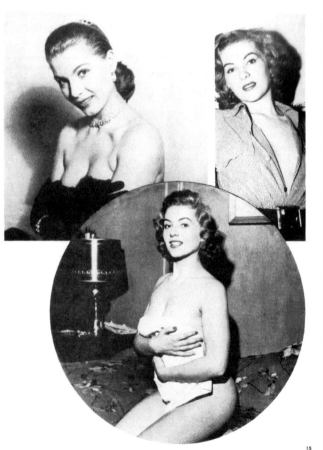

I did a lot of modeling for magazines in the late '50s, and those photos were reprinted throughout the '60s and even into the '70s. I only got paid for the initial modeling session, and not again for the resale of any of these photos. I had signed a release on the initial shoot, and the photographers could do with the photos as they pleased.

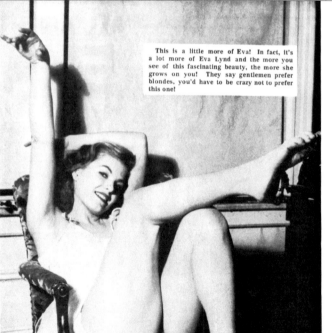

This is a little more of Eva! In fact, it's a lot more of Eva Lynd and the more you see of this fascinating beauty, the more she grows on you! They say gentlemen prefer blondes, you'd have to be crazy not to prefer this one!

14

15

WORLD OF MEN, January 1969; photos by Earl Leaf

174

Photos by MICHAEL KIDDON

175

I stayed in NYC until 1968. I had a small part in a Sidney Poitier film, *For Love of Ivy*, and I also stood in for one of the leads throughout the film.

I went back to Los Angeles to pursue my acting career, and I got one of the leads in *The Girl From Peking* (later changed to *That Lady From Peking*). I think I was recommended by a friend of mine. I went to talk to the producer, Reginald Goldsworthy, and he said, "Okay, fine." They were looking for somebody, and I got it. It was as simple as that, for once.

You know, it didn't go anywhere, that film, but it was great fun doing it. We shot it in 1969; we stopped shooting to watch the first moon landing on August 19th—or 20th, depending on where you in the world you were at the time.

Eddie Davis was the director. I had not worked with him before. When I first got there, he was absolutely, incredibly upset to see me, because he had wanted somebody like Natalie Wood—which I am totally the opposite of. And for the longest time, he did not direct me. I pretty much had to direct myself. And at the end of the film, he apologized for that, because he realized that I had done very well anyway.

Everybody was very nice. Carl Betz played the

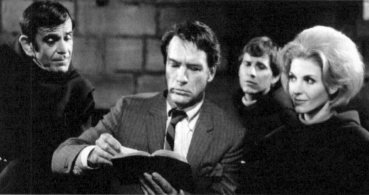

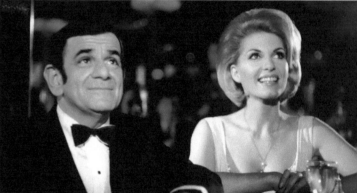

Clockwise from top right: Bobby Rydell and Eva; Sid Melton and Eva; *(l to r)* Sid Melton, Carl Betz, Bobby Rydell, Eva.

character that I fell in love with, and at the end, you know, it's assumed that we get together. He was very professional. He had done a lot of stuff at that point and he was a very pleasant person. He died a few years later, in 1978; too young. And Sid Melton died recently, just a couple of years ago.

Nancy Kwan was a very by-herself type of person, very hard to get to know. She wasn't incredibly social with anyone. But I never got to know anybody really well, because I mostly worked with Bobby Rydell—running around the countryside, trying to escape the bad guys.

Bobby Rydell was great. This was one of his first films. (He had done *Bye Bye Birdie*, of course.) He did two songs in the movie; he was very good. He was

a great singer. He still is! He still works. He's doing cruises and things with other guys from that time, and evidently he's very happy and very healthy and enjoying life. In fact, I think there's a picture from this film on his website—him and Sid Melton and me.

I shot about four weeks; I wasn't in the whole movie. They started filming in Hong Kong, I think? But I was only involved with the scenes in Sydney.

I loved Australia. I absolutely loved it. And the people seemed to really *like* Americans; everybody was very nice and accommodating. It was such a lovely, lovely time. It's one of the best times I've ever had.

Unfortunately, the movie didn't turn out to be very good, so it didn't help me so far as something to show off. However, I look pretty good in the photos.

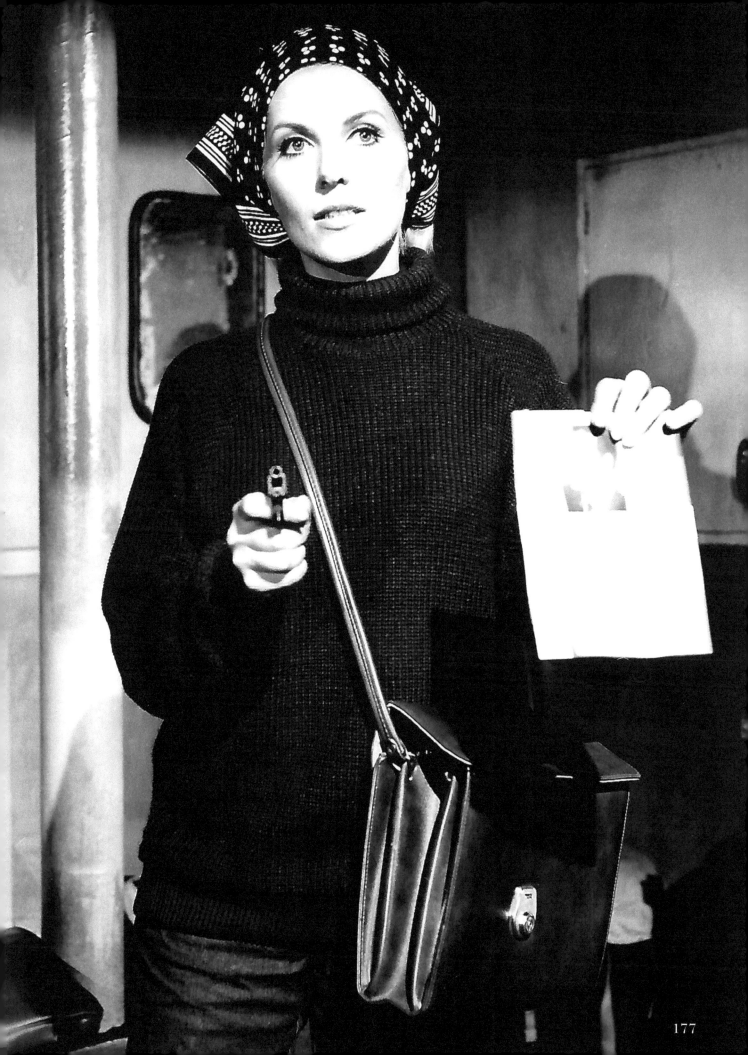

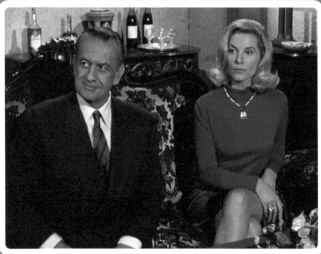

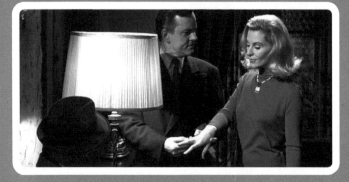

DAVE MORICK.as Lt. J.B. Miller

OSCAR BEREGI.as Herr Schneer

RAY HASTINGS.as Herr Mayerink

EVA von FIELITZ
..as Fraulein Kissinger
...And
ALAN BERGMANN
. . . as Major Martin

"The Meister Spy," *original airdate:* January 17, 1971

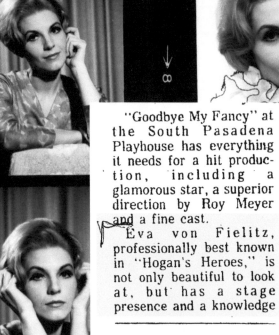

"Goodbye My Fancy" at the South Pasadena Playhouse has everything it needs for a hit production, including a glamorous star, a superior direction by Roy Meyer and a fine cast.

Eva von Fielitz, professionally best known in "Hogan's Heroes," is not only beautiful to look at, but has a stage presence and a knowledge

drama review

of how to read lines and build a climax that comes only with experience, along with that indefinable something known as charm.

She dominates the play and wins her audience from first word to final, telling gesture. As Agatha Reed, she portrays a woman returning to college for an honorary degree. After 20 years she is still in love with the man who is now president of the college. How she discovers him to be weak and spineless and turns elsewhere for love creates a romance with a theme worth taking home.

Photos by Tom Wilson

SOUTH PASADENA REVIEW
Wednesday, Nov. 24, 1976

"Goodbye, My Fancy"

PATRICIA BURR

If anyone can bring to life a seemingly un-revivable play, director Roy G. Meyer is the one to do it. His experience and creativity as a director are displayed in the South Pasadena Playhouse's production of Fay Kanin's "Goodbye, My Fancy."

The years of 1948 and 1949, which brought us such timeless masterpieces as "Death of a Salesman" and the "Madwoman of Chaillot," also brought us "Goodbye, My Fancy."

The plot involves a liberal congresswoman who returns to her alma mater for an honorary degree only to find that the college president is no longer the courageous and outspoken professor with whom she was in love some twenty years ago. An uplifting story, but it has not stood the test of time.

No matter. The production's the thing . . . and Eva von Fielitz as Congresswomen Agatha Reed rises above the limitations of the play and gives a stunning performance.

"Gosh, I felt like I was in church!" college student Mary Nell exclaims after her first encounter with the visiting congresswoman.

Mary Nell's sense of awe is shared by the audience every moment Miss von Fielitz is on stage. She has that luminescent quality rarely seen in community theater.

Miss von Fielitz is complemented by a talented supporting cast.

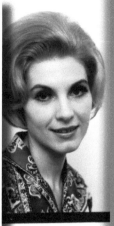
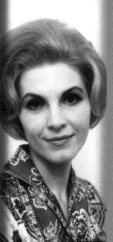
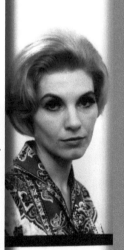

Pay dirt. Cuff the blonde in blue. I'll get him.

Featuring
CHARLES WALKER
LORINNE VOZOFF
JoANNA LEHMAN
NETA LEE NOY
EVA LYND

"Suffer the Children," *original airdate:* April 22, 1982

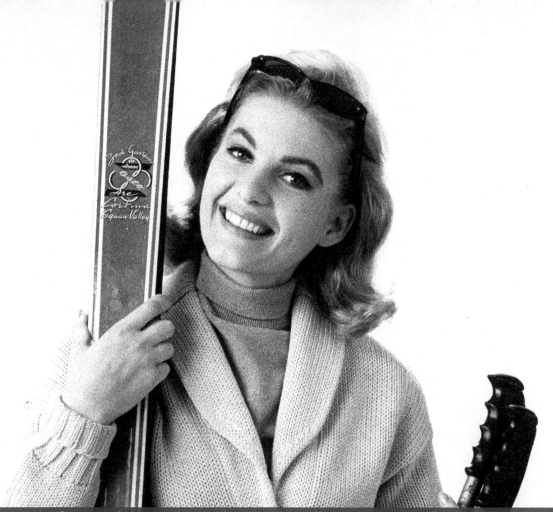

My favorite song is "She," written by Charles Aznavour and Herbert Kretzmer, and performed by Elvis Costello. The first time I heard it, I loved it. I loved the words, and I wished that someone would feel that way about me. And once, someone did.

Photo by CHARLES VARON

I'd decided to use *Eva von Fielitz* for a while, starting on that film (where it was misspelled!) and on *Hogan's Heroes* in 1972 (spelled correctly). By the time I saw my name was spelled wrong on *That Lady From Peking*, they told me that it would be too difficult and expensive to change it.

After that, I worked for a radio station, XEPRS, as continuity director for a couple of years. The station was owned by Wolfman Jack, who was quite a character.

Though I really enjoyed playing a role on *Hogan's Heroes*, nothing much happened after. So I returned to radio as continuity director at KBIG, and stayed there until I got married again.

I had been dating someone who was a lieutenant in the Army, and we seemed to get along well. When he was deployed to Germany, he asked me to marry him and go with him. I realized that if I didn't go, our relationship would be over. So we got married, packed up, and moved to the small German city of Bad Hersfeld, eight miles from the East German border.

I couldn't very well sit around and do nothing, so I got a job working as music and theatre director for the US Army. I produced and directed plays, and I also acted in some of them, playing the lead in *Blithe Spirit*, and a smaller part in *Barefoot in the Park*. I also did the set decoration, staging, makeup, and costuming. I wrote, produced and directed all kinds of programs, including skits for special occasions and holidays and fashion shows for the officers' wives. I helped organize the incoming USO shows, for which I got a certificate of appreciation.

I came back to Los Angeles in 1975, and got an apartment in Glendale. In 1976, I starred in *Goodbye My Fancy* at the South Pasadena Playhouse, and I got amazingly good reviews. (Joan Crawford did that role in the film.) But as my marriage had been on the rocks for a long time, I decided it was time to quit that one, too. What to do now?

In 1977, I went back to drama class, just to get myself going again and get back into the business. Film Industry Workshops is where I met my present husband, Warren Munson (a very good actor). We've now been married over 40 years.

In 1983, I did a day on *The Young and the Restless*, and I had a recurring role on another soap called *Capitol*, but after I had done four episodes, it was canceled. I hope not because of me!

I had a small part in one of the early episodes of *Cagney & Lacey*, with Meg Foster as Detective Cagney, before Sharon Gless took over the role. I played a thief who, with a partner, stole women's handbags when they were in restaurants and not paying attention.

But evidently the episode ran long, and they cut the scene where we were caught and brought to justice. So there was never any payoff to the theft!

I wrote screenplays with Clarke Lindsley, another friend I met at Film Industry Workshops. We won the bronze in 1987 and the silver in 1989 for our comedy screenplays at the Houston International Film Festival. We had one optioned, but it never made it to film. After being asked to rewrite a whole lot on scripts that they "just loved," we decided we'd had enough. We stopped writing, but not before we had written eight screenplays.

Eva and Warren Munson.

Warren and I have made several TV commercials, both separately and together: Visa, Naturemade, Campbell's… Commercials are definitely acting, not modeling; you have to tell a whole story in a matter of 15 to 30 seconds.

Our commercial agent sends us out on auditions, but since our theatrical agents retired, we've not been able to get a new one. Evidently, they prefer to work with young people who they can make into stars.

In 1996, I became a member of the Foreign Press, working for IFTN (International Film and TV News) in Germany, as their US correspondent. Starting in 1997, I wrote a column for *The Ashtabula Sentinel* called "With Love From Hollywood," which lasted a few years. Then in 2003, I wrote a film column for a fancy magazine in Croatia called *Zaposlena*. (They translated, since I don't speak the language.)

Recently, a friend showed me my image, borrowed from my 1957 ad in *Playboy (p. 44)*, on a makeup bag from Anne Taintor. A hotel had been added to the background, and the message I LOVE NOT CAMPING.

I found that my image was also on dishes, luggage tags, serving trays, and more. I personally have no problem with it. It is fun to see my image on these things after all these years, and it just proves that the work I did in the '50s and '60s can still be found out there someplace.

And so it goes….

It is very important to love whatever you are doing, because that makes you be the very best you can be. Even if you are doing something that is not much fun, I think that there is always something interesting about it you can focus on that makes it all worth it.

Everything I have ever done—and lived through—has played a role in my career. When something bad happened to me, I would think, *"Remember how this feels, because you may be able to use it in your acting someday."* We all have ways of surviving, and that was one of mine.

One thing that I can say I have finally learned is that it is important to know that you are in charge of yourself; nobody has the right to make you do something you don't want to do.

I don't remember who said this, but my favorite saying just now is:

Strive to die young…as late as possible.

Eva

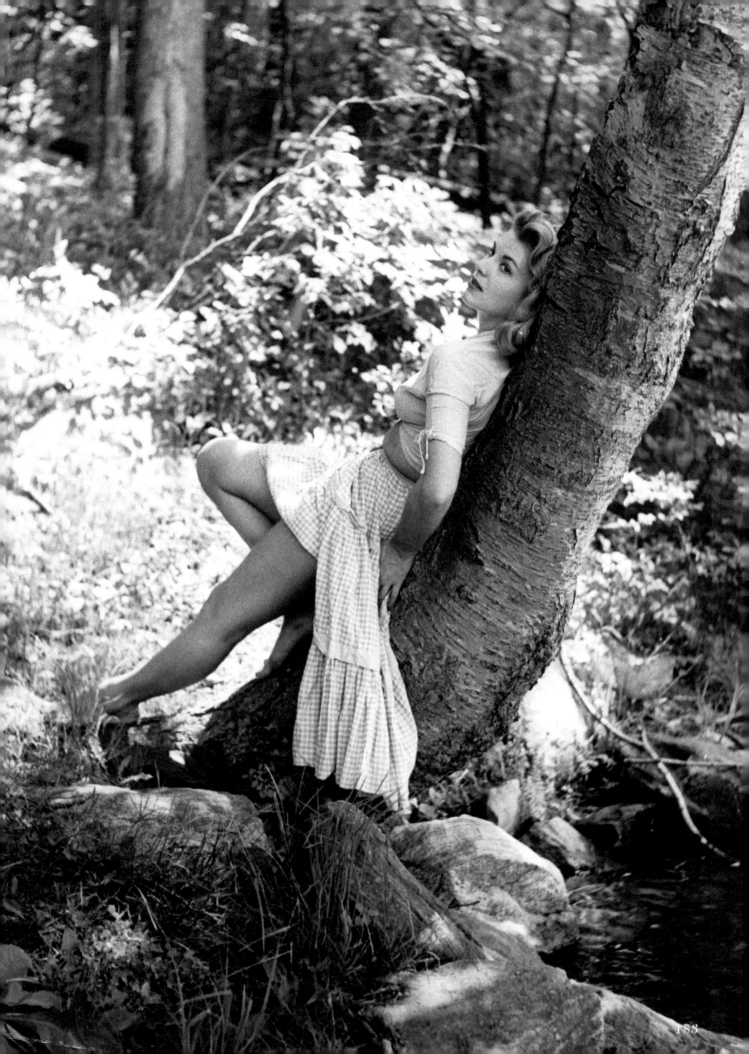

LOOKING FOR ACTION?

THE
MEN'S ADVENTURE
LIBRARY

WEASELS RIPPED MY FLESH!

TWO-FISTED STORIES FROM MEN'S ADVENTURE MAGAZINES OF THE 1950s, '60s & '70s

featuring
LAWRENCE BLOCK
JANE DOLINGER
ROBERT F. DORR
HARLAN ELLISON
BRUCE JAY FRIEDMAN
WALTER KAYLIN
KEN KRIPPENE
MARIO PUZO
ROBERT SILVERBERG
WALTER WAGER

edited by
Robert Deis
with Josh Alan Friedman & Wyatt Doyle

HE-MEN, BAG MEN & NYMPHOS

COLOR EDITION

classic men's adventure magazine stories by
WALTER KAYLIN

edited by Robert Deis and Wyatt Doyle

CRYPTO ZOOLO GY ANTHOLOGY

strange and mysterious creatures in men's adventure magazines

EDITED BY ROBERT DEIS,
DAVID COLEMAN & WYATT DOYLE

A HANDFUL OF HELL

CLASSIC WAR AND ADVENTURE STORIES BY
ROBERT F. DORR
EDITED BY ROBERT DEIS AND WYATT DOYLE

BARBARIANS ON BIKES

A high-octane visual archive from vintage men's pulp adventure magazines

BIKERS & MOTORCYCLE GANGS

EDITED BY
Robert Deis & Wyatt Doyle

AFTERWORD BY
Paul Bishop

THE MEN'S ADVENTURE LIBRARY JOURNAL

I WATCHED THEM Eat Me Alive

Killer Creatures in Men's Adventure Magazines

EDITED BY ROBERT DEIS & WYATT DOYLE

THE MEN'S ADVENTURE LIBRARY JOURNAL

CUBA

SUGAR, SEX, AND SLAUGHTER

Cuba and Castro in Men's Adventure Magazines

EDITED BY ROBERT DEIS & WYATT DOYLE

THE PAPERBACK ART OF GIL COHEN

ONE MAN ARMY

EDITED BY ROBERT DEIS AND WYATT DOYLE

Pollen's ACTION

THE ART OF SAMSON POLLEN edited by ROBERT DEIS & WYATT DOYLE

Pollen's women

THE ART OF SAMSON POLLEN edited by ROBERT DEIS & WYATT DOYLE

MANY TITLES AVAILABLE IN PAPERBACK, EBOOK, AND DELUXE HARDCOVER W/ADDITIONAL CONTENT

MensPulpMags.com

Words and Pictures and Music # new texture

new texture